PENGUIN CLAS

THE PENGUIN FREUD GENERAL EDITOR:
ADAM PHILLIPS

THE UNCANNY

SIGMUND FREUD was born in 1856 in Moravia; between the ages of four and eighty-two his home was Vienna: in 1938 Hitler's invasion of Austria forced him to seek asylum in London, where he died in the following year. His career began with several years of brilliant work on the anatomy and physiology of the nervous system. He was almost thirty when, after a period of study under Charcot in Paris, his interests first turned to psychology; and after ten years of clinical work in Vienna (at first in collaboration with Breuer, an older colleague) he invented what was to become psychoanalysis. This began simply as a method of treating neurotic patients through talking, but it quickly grew into an accumulation of knowledge about the workings of the mind in general. Freud was thus able to demonstrate the development of the sexual instinct in childhood, and largely on the basis of an examination of dreams, arrived at this fundamental discovery of the unconscious forces that influence our everyday thoughts and actions. Freud's life was uneventful, but his ideas have shaped not only many specialist disciplines, but also the whole intellectual climate of the twentieth century.

DAVID MCLINTOCK studied comparative philology, historical linguistics and medieval literature at Oxford, Münster and Munich. He published extensively in these fields while teaching successively at the universities of Oxford, London and Cambridge, before turning to translation. He has translated numerous works of fiction, history and art history. He was awarded an Austrian state prize for translation in 1986 and the Schlegel-Tieck Prize in 1990 and 1996.

HUGH HAUGHTON is a senior lecturer at the University of York. He has edited Gustav Janouch's *Conversations with Kafka* (1985), *The Chatto Book of Nonsense Poetry* (1988), Rudyard Kipling's *Wee Willie Winkie* (1988), Lewis Carroll's *Alice's Adventures in*

Wonderland and *Through the Looking-Glass* (Penguin Classics, 1998), and co-edited, with Adam Phillips, *John Clare in Context* (1994). His study of the poetry of Derek Mahon is due to be published in 2004.

ADAM PHILLIPS was formerly Principal Child Psychotherapist at Charing Cross Hospital in London. He is the author of several books on psychoanalysis including *On Kissing, Tickling and Being Bored*, *Darwin's Worms*, *Promises, Promises* and *Houdini's Box*.

SIGMUND FREUD

The Uncanny

Translated by DAVID MCLINTOCK
with an Introduction by HUGH HAUGHTON

PENGUIN BOOKS

PENGUIN BOOKS
Published by the Penguin Group
Penguin Group (USA) Inc., 375 Hudson Street, New York, New York 10014, U.S.A.
Penguin Group (Canada), 90 Eglinton Avenue East, Suite 700, Toronto, Ontario,
Canada M4P 2Y3 (a division of Pearson Penguin Canada Inc.)
Penguin Books Ltd, 80 Strand, London WC2R 0RL, England
Penguin Ireland, 25 St Stephen's Green, Dublin 2, Ireland
(a division of Penguin Books Ltd)
Penguin Group (Australia), 250 Camberwell Road, Camberwell, Victoria 3124,
Australia (a division of Pearson Australia Group Pty Ltd)
Penguin Books India Pvt Ltd, 11 Community Centre, Panchsheel Park,
New Delhi – 110 017, India
Penguin Group (NZ), 67 Apollo Drive, Rosedale, North Shore 0632,
New Zealand (a division of Pearson New Zealand Ltd)
Penguin Books (South Africa) (Pty) Ltd, 24 Sturdee Avenue, Rosebank,
Johannesburg 2196, South Africa

Penguin Books Ltd, Registered Offices: 80 Strand, London WC2R 0RL, England

Über Deckerinnerungen first published 1899 in *Minatsschrift für Psychiatrie und Neurologie 6*
Eine Kindheitserinnerung des Leonardo da Vinci first published 1910
(Leipzig and Vienna: Verlag Franz Deuticke)
Der Familienroman der Neurotiker first published 1909
in Otto Rank, *Der Mythus von der Geburt des Helden.*
Versuch einer psychologischen Mythendeutung (Leipzig and Vienna: Verlag Franz Deuticke)
Der Dichter und das Phantasieren first published 1908 in *Neue Revue* 1 (10)
Das Unheimliche first published 1919 in *Imago* 5 (5–6)
English translation first published in Penguin Books (U.K.) 2003
This edition published 2003

9 11 13 15 14 12 10 8

Sigmund Freud's German text collected in *Gesammelte Werke* (1940–52)
copyright © Imago Publishing Co., Ltd, London, 1941, 1943, 1947, 1953
Translation and editorial matter copyright © David McLintock, 2003
Introduction copyright © Hugh Haughton, 2003
All rights reserved

ISBN 978-0-14-243747-6
CIP data available

Printed in the United States of America
Set in Adobe New Caledonia

Contents

Introduction

Before the problem of the creative artist analysis must, alas,
lay down its arms (Freud, 'Dostoevsky and Parricide')

At the opening of his essay on 'The Uncanny' of 1919, Freud wrote
that 'only rarely does the psychoanalyst feel impelled to engage in
aesthetic investigations'. The comment raises two questions. One
is about Freud's reluctance to deal with art, the other about his
compulsion to deal with it. We might ask first why the psychoanalyst
writes about art so rarely? Literature looms large in early psychoana-
lytic literature, and Freud has had a huge impact on subsequent art
and writing about art. Taken together, his early books on jokes,
dreams and the 'psychopathology of everyday life' offered the twen-
tieth-century a radically new account of the aesthetics of everyday
life. Why then does Freud not commit himself more wholeheartedly
to aesthetic investigations? He wrote *The Interpretation of Dreams*
but nothing that could be described as *The Interpretation of Art*.
The second question is rather different. Why is it that Freud feels
'impelled' to write about art when he does? What is it that tempts
him to stray from the straight and narrow path of psychology to walk
the primrose path of aesthetic dalliance? Or, to put it another
way, why should he dramatize his reluctance to talk about art so
elaborately when he clearly has such an investment in it? However
we answer these questions, Freud's relatively few 'aesthetic investi-
gations' have uncannily changed the ways in which, for better and
worse, we now talk about art, and practise it.

Psychoanalysis began as a would-be science of the enigma. It
soon found itself, however, and as if inadvertently, deeply implicated

in the enigma of art. Increasingly caught between science and art, Freud's work can be seen as a series of enigma variations based on the theme of *Kinderszenen* (scenes from childhood). His first essay on a work of art as such was 'Delusions and Dreams in Jensen's *Gradiva*', which appeared in 1907. Although it is not included in the New Penguin Freud, it tells us a lot about Dr Freud's family romance about art, and his dreams (and possibly delusions) about a psycho-analytic approach to it. This is how he tells the story of how he came to write it:

A group of men who regarded it as a settled fact that the essential riddles of dreaming have been solved by the effort of the author of the present work found their curiosity aroused one day by the question of the class of dreams that have never been dreamt at all – dreams created by imaginative writers and ascribed to invented characters in the course of a story.

Freud picks up here on a discussion among early psychoanalysts of the ways writers use dreams in fiction. The discussion confirms his claim in *The Interpretation of Dreams* that, despite the scepticism of 'Science and the majority of educated people', 'dreams have a meaning and are capable of being interpreted'. Freud tells us that 'When an author makes the characters constructed by his imagina-tion dream, he follows the everyday experience that people's thoughts and feelings are continued in sleep and he aims at nothing else than to depict his heroes' states of mind by their dreams.' 'Creative writers', he says, 'are valuable allies and their evidence is to be prized highly, for they are apt to know a whole host of things between heaven and earth of which our philosophy has not yet let us dream.' Freud's variation of Hamlet's great line ('There are more things in heaven and earth than are dreamed of in your philosophy') wittily suggests that what philosophy does not let us dream is the idea that dreams have philosophical meaning. Philosophy and science are blind to the psychoanalytic equivalent of Pascal's wager, the claim writ large in Freud's *The Interpretation of Dreams* (1900), that dreams are riddles and can be interpreted. By presenting the dream as a riddle, Freud presents himself as solving 'the essential riddles

of dreaming'. By the same token, he gives a new definition of consciousness in embattled relationship to the larger, more primary and largely unknown phenomenon he called 'the unconscious'. In fact dreams are works of art, born of a compromise between the conscious and unconscious. They can only be understood by sustained historical investigation into the imaginative life and memory of the dreamer. Included in Freud's hermeneutic dream of the dream is the wish that psychoanalysis should cast light upon the riddle of art.

Freud repeatedly represents himself, like Oedipus, as a solver of riddles, a writer faced with an apparently insoluble problem of meaning. The great founding texts of psychoanalysis were written around the turn of the twentieth century. *Studies on Hysteria*, written with Joseph Breuer, came out in 1895, *The Interpretation of Dreams* in 1900, *The Psychopathology of Everyday Life* in 1901, and *Jokes . . . and Three Essays on the Theory of Sexuality* in 1905, on the threshold of Freud's fiftieth year. In these books Freud presents himself as tackling human phenomena hitherto resistant to meaningful interpretation – hysterical symptoms, dreams, everyday slips of the tongue, jokes and so-called sexual aberrations. He interprets all of them as riddling forms of meaning that can be decoded and deciphered. This involves showing that they are analogous to each other. Rather than seeing them as aberrant phenomena, he sees them as products of fundamental, central and normal psychic processes, processes that are 'unconscious'. Freud's theory of aberration seeks to demonstrate that enigmatic areas of language and behaviour hitherto classified as being below, above or beyond significance, are ultimately intelligible. They are subject to interpretation. In doing so, however, he affirms the fundamental ways in which the human mind in general – and not only the 'pathological' or 'abnormal' mind – is unintelligible or unknowable to itself. If psychoanalysis was invented as a hermeneutic as much as a therapeutic practice, it is because it is founded on a double commitment to interpretation and resistance to interpretation. In his bid to make apparently anomalous human behaviour intelligible, Freud was led to construct a theory which places unintelligibility at the heart

of mental processes. In fact, in an astonishing transformation of the Cartesian project, it made self-unintelligibility the paradoxical cornerstone of psychic identity. If the psychoanalyst envisaged and embodied by Freud in these texts is a virtuoso interpreter of riddles and dreams, it is because Freud has come to see the human mind itself as a virtuosic generator of riddles and dreams designed to elude conscious interpretation. In one sense, psychoanalysis greatly extends the domain of intelligibility, but it does so by rendering more and more areas of psychic life elusive or unintelligible, or presenting it as the product of a drive towards unintelligibility, disguise, secrecy and self-subversion inherent in psychic life. If in *Studies on Hysteria* Freud sought to resolve the riddles of hysterical behaviour in terms of the biographical history of the subjects, he also showed that both biography and the subject are stranger than had been dreamed of in previous philosophy. By the same token, his master work *The Interpretation of Dreams* turned everyone's dreams into esoteric texts, the unacknowledged poetic masterpieces of everyday life. As Lionel Trilling said in a pioneering lecture, 'of all mental systems, the Freudian psychology is the one which makes poetry indigenous to the very condition of the mind.'[1]

That said, Freud's early publications operate largely within the field of medicine and psychopathology, not poetics. Once they had been completed, however, their repercussions in other discursive fields became increasingly clear. In 1910, Freud told Jung that he was 'more and more convinced of the cultural value' of psychoanalysis, and that he 'could wish for a lucid mind that will draw from it the justified inferences for philosophy and sociology'.[2] Psychoanalysis in the hands of Freud refused to stay within territorial limits. If the dream was the 'royal road to the unconscious', it also opened up other roads, leading from the unconscious Rome all roads led to, towards all other aspects of culture.

In his early fifties – his fiftieth birthday was in 1906 – Freud set about drastically extending the cultural and historical scope of psychoanalysis. In 1907 he published 'Obsessive Actions and Religious Practices', his first venture into the psychoanalysis of religion, a project that would lead on to *Totem and Taboo* (1912)

and *Moses and Monotheism* (1938). And it was in the same year that he published 'Delusions and Dreams in Jensen's *Gradiva*', his first analytic account of a work of art. William Jensen's *Gradiva*, a fantastic tale of historical and erotic obsession, was first published a few years earlier, in 1903, and is now largely remembered because of Freud's essay. In *The Interpretation of Dreams* Freud wrote that *Oedipus Rex* 'can be likened to a psychoanalysis', and in his account of the dreams and delusions of the protagonist of Jensen's 'Pompeian fantasy', Norbert Hanold, he treats them in the same way, as textbook instances of Freudian theory.[3] In the course of the story, Norbert's childhood girl friend, Zoe Bertgang, is revealed to be the real subject of Hanold's fantasy in the numinously Freudian setting of Pompeii (a classic site that figures as a trope of both catastrophic amnesia and miraculous archaeological survival, like the Unconscious). By the end of the tale Zoe has cured her obsessional lover of his hang-ups and all's well that ends well. Happily for Freud, she does this by adopting a procedure which, according to him, 'shows a far-reaching similarity – no, a complete agreement in its essence – with the therapeutic method which was introduced into medical practice in 1895 by Dr Joseph Breuer and myself, and to the perfecting of which I have since then devoted myself'.[4]

With 'The Uncanny' of a decade later, 'Delusions and Dreams' is Freud's fullest excursion into literary criticism, but, for all his evident pleasure in finding confirmation of his own ideas in a work of contemporary fiction and giving a Sherlock Holmes-like demonstration of his powers, it doesn't really tell us much new about either psychoanalysis or art. Though Jensen disowned any prior knowledge of psychoanalysis, his story generates no dialectical resistance to Freud's reading. The story of Hanold's archaeological translation of his erotic obsessions does indeed seem an uncanny confirmation of *Studies in Hysteria* and *The Interpretation of Dreams*, but perhaps for that very reason it is less interesting than Freud's other excursions into aesthetics.

Freud's essay provides no explanation of why and how a contemporary novelist should so faithfully reproduce Freudian theory in depicting the dreams of his fictional protagonist. Looking back on

it, he said the point of the paper was to show that 'the unconscious mechanisms familiar to us in the "dream-work" are . . . also operative in the processes of imaginative writing'.[5] All Freud's later excursions into the world of art follow the same cue, though from different directions. The essay at first presents artists as 'allies' of psycho-analysis, but goes on to suggest that psychoanalysis might give us 'some small insight into the nature of creative writing'. The idea was taken up in the talk he gave later in the year called 'The Creative Writer and Daydreaming', first published in 1908. This is Freud's first informal attempt to sketch a theory of artistic creation built up around his dream theory. Not long afterwards, in 1909, Freud wrote to Jung, saying 'Biography, too, must become ours.' This cheerfully expansionist dream of annexing biography arose out of his response to another artist's dream, in this instance a childhood dream recorded in the notebooks of Leonardo da Vinci. 'The riddle of Leonardo da Vinci's character has suddenly become transparent to me,' he told Jung, 'That, then, would be the first step in biography.' The result, 'Leonardo da Vinci and a Memory of his Childhood' was published in 1910, and, if we except case-histories such as 'Fragment of an Analysis of a Case of Hysteria' of 1905, was the first sustained exercise in psychoanalytic biography. It was also the first concen-trated attempt to apply psychoanalytic insights to both the visual arts and an individual artist. Taking off from one recorded childhood dream of the Renaissance artist and scientist, Freud constructed a biographical story in which Leonardo's childhood experience of parental separation, erotic attachment to his mother and later homo-sexuality were all inscribed at the heart of his subsequent investment in art – and science. By its means, Freud sought to throw light on the 'uncanny, enigmatic character' (*'das unheimlichen und rätselhaften Charakter'*) of Mona Lisa's smile, which he sees as ultimately a fantastic reflex of Leonardo's mother's.

'Some of the grandest and most overwhelming creations of art are still unsolved riddles to the understanding,' Freud wrote in 'The Moses of Michelangelo'.[6] In the wake of Pater's essay in *The Renaissance*, the *Mona Lisa* had become the most famously enig-matic work of European painting. By the same token, Leonardo was

not only the most full-blown incarnation of 'Renaissance Man' but, with Michelangelo, the most developed version of Carlisle's figure of the Artist as Hero. He was also famously an enigma himself, and therefore a perfect target for Freud's attempt to capture both biography and art for psychoanalysis. If this was a one-off foray into the world of artistic biography, it was, like his later commentary on the 'inscrutable' Moses of Michelangelo (1914), a highly charged and paradigmatic one. This is not only because of their artistic status, but because they implicitly play out a Freudian childhood story. Unravelling the 'riddle' of the knot in Michelangelo's beard and the 'riddling' smile of Mona Lisa, Freud finds a composite Oedipal drama: the contained anger of Moses as frowning Jewish patriarch on the one hand, the seductive maternal smile of Leonardo's secular Florentine Madonna on the other.

Freud never collected together his miscellaneous essays on art and artists, or attempted to put them into systematic form.[7] Paradoxically this may be one reason for his protean impact on later art theory, criticism and aesthetics. 'The first example of an application of the analytic mode of thought to the problems of aesthetics', he tells us in his 'On the History of the Psychoanalytic Movement', 'was contained in my book on jokes.' If this is true, it is also a sign of the simultaneous elusiveness and pervasiveness of the aesthetic in his work. The book on jokes never presents itself as an exercise in philosophical aesthetics at all. The old Penguin Freud included a volume of Freud on *Art and Literature*. Useful as this was, it ran the risk of giving a misleadingly coherent impression about his thinking in these fields. In fact, his thinking about art is scattered and fragmentary, very much in line with the German Romantic philosophical tradition of Schiller, Schopenhauer and Nietzsche. It can equally be seen as a successor to the more experimental, essayistic tradition of Jean-Paul, Hazlitt, Heine, Emerson, Baudelaire, Pater and Freud's near-contemporary Wilde. Though signs of Freud's scientific and psychological training are in play, and the influence of professional papers in learned journals, Freud's essays on art give us a sense of the psychoanalyst on holiday, moonlighting in other fields. Most of Freud's 'aesthetic' essays

are simultaneously fragmentary and labyrinthine, and they are as palpably fascinated by fictiveness as by fact. 'Leonardo da Vinci and a Memory of his Childhood', for example, relies as heavily on a contemporary Russian novel about the Renaissance painter as on art historians such as Vasari. Likewise 'The Uncanny', while taking off from an article in a learned psychological journal, delves into the *Fantasiestücke* of E. T. A. Hoffmann and loses itself in the labyrinth of its own interpretations. This may be one reason for the peculiarly suggestive charge of the writings on art, memory and biography collected in this volume. They show Freud at his most cavalierly provocative.

The miscellaneousness is important. 'Leonardo da Vinci and a Memory of his Childhood' suggests something different from 'The Childhood of Leonardo', or 'Prelude to a Life of Leonardo da Vinci', or 'Leonardo, Fantasy and Knowledge'. This is an experimental fragment, a 'first step' in psycho-biography. 'The Creative Writer and Daydreaming', however wide-ranging the title, is little more than a theoretical daydream itself. 'Family Romances' (or 'Family Novels') tells a story about childhood stories and about the origins of one of the great romance plots, but it is nothing like a scientific or critical study. It is more like Charles Lamb's 'Witches and Other Night Fears' or 'The Sanity of True Genius' than a treatise. Despite this, Freud's papers about artistic subjects do have common ground. Like E. T. A. Hoffmann and the Romantic poets and philosophers, Freud puts childhood and the legacy of childhood fantasy and experience at the centre of mental life, and this shapes the assumptions he brings to the enigma of art. For Freud, however, as he showed in *Three Essays on the Theory of Sexuality*, the legacy of childhood is inherently a site of conflict. So is art. The story of culture for Freud is always a story of culture and anarchy.

'Screen Memories' (1899)

'Screen Memories' – the German word *Deckerinnerungen* literally means 'cover memories' – is a fascinating miniature. First published in 1899, two months before *The Interpretation of Dreams*, this short essay is like a sunlit iceberg, with little on its elegantly unruffled Socratic surface to advertise the potentially devastating force of its submerged implications.

In fact that is a way of describing its own argument about the screen memories named in the title. Though the essay – or vignette – is little more than an extended commentary on a single childhood memory, it is a work with great subversive force. Purporting to be a reflection on an aberrant form of memory, it sketches a theory of memory as such which has vertiginous consequences not only for psychoanalysis but for autobiography, biography, fiction and the whole literature of identity.

Studies in Hysteria, co-written with Joseph Breuer, was published in 1895. In it Freud argued that hysterics suffered from repressed memories, and that their symptoms were displaced representations of traumatic events and feelings surviving from early childhood. The following years yielded little in the way of publication, but were a time of obsessive intellectual investigation for Freud in which he first coined the word 'psychoanalysis' and, in his protracted and experimental 'self-analysis', laid the foundations of the whole controversial Freudian project. The word (in French) first materialized in his badly received paper on 'Heredity and the Aetiology of the Neuroses' published in May 1896, the only public record of his thought between *Studies in Hysteria* of 1895 and 'Screen Memories' and *The Interpretation of Dreams* of late 1899. The letters to his friend Wilhelm Fliess document the intertwined development of his self-analysis and psychoanalysis during these years, as Freud worked through the material in his and his patients' dreams, reading them as riddling palimpsests that re-work, indeed re-write, remote childhood memories and desires. The little paper on 'Screen Memories' was the first published fruit of Freud's long autobiographical

excavation during this time. In this sense it was the lyric prelude to the epic symphony of *The Interpretation of Dreams.*[8]

'Screen Memories', like nearly all of Freud's essays, begins with a puzzle, indeed a puzzle about beginnings. After noting that in psychoanalytic treatment of cases of hysteria and obsessional neurosis he often had to deal with 'fragments of memories that have stayed with individual patients from their earliest childhood years', he says:

No one doubts that our earliest childhood experiences have left indelible traces on our inner selves; but when we question our *memory* as to what impressions are destined to influence us till the end of our lives, it comes up with either nothing at all or a relatively small number of isolated reflections, often of questionable or perplexing significance.

In this way the essay dissolves the distinction between 'pathological' and 'normal' adults. Childhood experiences leave 'indelible traces' on us all, though we don't remember them – or don't remember them as we might expect to. In fact Freud's miniature *recherche du temps perdu* takes off from a paper published a couple of years earlier by the French psychologists V. and C. Henri entitled 'Enquête sur les premiers souvenirs d'enfance'. This was a paper that had nothing to do with pathology or psychiatry, being an account of the 123 answers they received to a questionnaire about people's childhood memories. Correspondents answered questions such as 'What is the first memory you have of your childhood?', 'Did the remembered event play a significant role in your childhood?', 'Can you explain it?', 'From what age do you date the continuous memory of your life in such a way that you can give a continuous history of it?' The Henris summarize and quote from the replies to the questionnaire, but their genial empiricism can give no dynamic account of the operations of either memory or forgetting. They certainly have no way of explaining the apparently arbitrary nature of most of the early memories recounted to them, or why, as Freud says, 'one correspondent reports that, from the age of two, she remembers various accidents that befell her dolls, but has no recollection of the

sad and serious events that she may have observed at the time'. The Henris' 'Enquête' in fact confirms the originality of Freud's essay, which finds a way to account for just that: 'Echoing a popular phrase, one might say that, if a certain childhood experience asserts itself in the memory, this is not because it is golden, but because it has lain beside gold.'

For Freud, the fragmentary, apparently 'unintelligible' and banal nature of the events we tend to remember can only be explained in terms of the dynamics of repression, and the compromise formations that result from it. He quotes the Henris' account of a professor of philology whose first memory, aged four, was of a 'table set for a meal and with a bowl of ice on it'. The memory goes back to his grandmother's death, which apparently had a shattering effect on him, leading him to take the flowers that were on her coffin, though the professor has no memory of that, only of the bowl of ice. Beside this Freud sets the case of a patient who heard voices repeating trivial and irrelevant quotations from a book but finds, in therapy, that other parts of the same book had evoked 'the most distressing thoughts' in her. For him, the process of 'conflict, repression, substitution involving a compromise' that was familiar to him from analysis offers the key to such memories. It applies as forcefully to the 'normal' people consulted by the Henris as to his patients.

Having established this in the first third of his essay and noted that such 'normal and pathological defence processes' have not been studied by psychologists, Freud makes an astonishing swerve. He steps sideways to talk about a completely different kind of apparently arbitrary memory, one resulting not from the amnesia of childhood but from a projection back into childhood of memories and fantasies of a later time, a version of what is nowadays called 'false memory syndrome'. To this end he introduces a fragmentary case history of his own, a memory of a 'man of thirty-eighty, with a university education, who has maintained an interest in psychological questions', and who Freud had relieved of a 'minor phobia'. The rest of the paper recounts his 'interlocutor's fragmentary first memory and their dialogue about its significance'. In the course of this Freud, who plays the role of Sherlock Holmes in relation to the baffled

client, explains that the memory apparently remembered *from* child-
hood was in fact projected back *onto* childhood during the boy's
adolescence. The patient remembers that the memory was first
aroused on a visit to the region where he spent his first three years
when he developed a crush on the fifteen-year-old daughter of the
house he was staying at. Freud tells him: 'So I would place the origin
of the childhood scene . . . in the period when you were struggling
for your daily bread – that is, if you can confirm that it was during
these years you made your first acquaintance of the Alps.' Like
Holmes's clients, he can indeed and Freud goes on to show that he
'projected the two fantasies on to one another and turned them into
a childhood memory', with 'the Alpine flowers' providing the 'date
mark for its construction'. The delicious bread at the end of the
memory refers to his anxieties about how to 'earn his bread-and-
butter' in the city, and the picked flower to his repressed wish to
'de-flower' the girl, safely displaced back into the innocent, appar-
ently pre-sexual world of his early childhood. Freud had noted
earlier that 'the case histories I write read like novellas' but this one
on 'Screen Memories' is more like a detective story.

As was noted by Siegfried Bernfeld as long ago as 1946, in a later
piece of detective work, this is a story where the doubling of two
fantasies onto one back-projected memory is accompanied by
another doubling. Freud screens the fact that the founding 'screen
memories' with which it deals are probably his own, fictionally
projected onto a patient. Freud is not only the analyst here but the
patient whose screen memory he is elucidating.[9] Freud, like the
patient whose 'life history' he tells, left the provincial backwater
where he was born, in his case Freiberg in Moldavia, as a result of
the collapse of his father's business, an event which led to years of
hardship in a 'big city', in his case Vienna. Like the patient, he
returned to Freiberg in his later teens, in his case aged 16, and fell
in love with the sister of a school friend, Gisela Fluss, whom he
described to his friend Eduard Silberstein as the object of his 'first
rapture'. Like the patient, three years later he went to stay with his
uncle, in his case in England, where he saw his 'first playmates
again', in fact his nephew and niece John and Pauline who had lived

in Freiberg. In one of the astonishing autobiographical letters to Fliess in late 1897, he alludes to John as his 'companion in evil deeds' between the ages of one and two, and has the two of them behaving cruelly to Pauline, saying that they and his younger brother 'have determined what is neurotic, but also what is intense, in all my friendships'.[10] In fact, in a later letter to Fliess of January 1899, he wrote to say he had completed 'a small bit of my self-analysis' which 'confirmed that phantasies are the products of later periods and are projected back from what was then the present into earliest childhood; the manner in which this occurs also emerged – once again by a verbal link.'[11] Under cover of an anonymous 'screen memory', he takes the opportunity of publishing most of his own childhood memories, as they had been described to Fliess in the letter of autumn 1897, the year of the Henris' paper on childhood memory. It is almost as if reading their essay on 'souvenirs d'enfance' precipitated Freud's investigation of his first memory and made him aware that what he had taken to be his earliest memory was in fact an elaborate compound fiction, just like the dreams he was deciphering at the same time. But though fictional, he suggests that it has its roots in childhood memories which it screens and overlays even as it screens its adolescent origins in the 'innocent' disguise of childhood memories. The notion of the 'screen' or 'cover' becomes increasingly many-layered and multi-directional.

Freud goes on to develop distinctions between 'retrogressive' and 'anticipatory' screen memories depending on the 'relation between the screen and what is screened off'. This leads him to point out 'what complicated processes are involved in producing our store of memories', processes which he says are, incidentally, 'wholly analogous to the formation of hysterical symptoms'. The notion of 'producing' a 'store' of memories here begins to break down the stability of all childhood memory, dissolving the distinction between memories and screen memories. At this point Freud develops an observation the Henris make but don't make anything of, the large number of 'unimpeachable' childhood memories in which 'one sees oneself as a child and knows that one is this child, yet sees the child as an outside observer would see him'. Freud suggests that 'wherever

one appears in a memory in this way, as an object among other objects, this confrontation of the acting self with the recollecting self can be taken as proof that the original impression has been worked over'. Indeed the piece ends with his apparently innocently remarking that 'it is perhaps ... questionable whether we have any conscious memories *from* childhood: perhaps we only have memories *of* childhood', as they appeared to us at later periods when the memories were aroused. 'At these times of arousal the memories of childhood did not *emerge*, as one is accustomed to saying, they were *formed*.' In other words, the 'raw material' of analysis, and indeed all autobiographical memory, is always retrospectively shaped. It is subjected to something like the same process of 'secondary revision' Freud found in dreams and hysterical symptoms. If this is anything like the elaborate compound forgery represented by the screen memory of three-year-old children picking yellow flowers in the meadow, then the distinction between memory and fiction is almost as slippery as that between memory and screen memory. How can the analyst, or indeed anyone, distinguish between 'real' memories and 'screen' memories?

The final twist in his fictional account of what appears to be his own autobiographical exploration has potentially devastating consequences for our reading of his and other people's life histories. It particularly affects the ways we might understand their accounts of childhood, the gold currency in the psychoanalytic memory bank. The first modernist excavation of childhood memory, 'Screen Memories' underlines the degree to which its successors, including Proust's epic *À la recherche du temps perdu*, Joyce's *Portrait of the Artist as a Young Man* and Woolf's *Moments of Being*, dissolve the difference between autobiography and fiction, screen and memory. It might make us wonder whether all stories of childhood are ultimately cover stories. Or whether all memories are screen memories. If this opens up a view of the past as screened – something screened from us but which is also a screen upon which we project memories from later life – it makes the analyst's, the biographer's and even the autobiographer's lives a hundred times more difficult.

It also, of course, makes it more interesting. It seems that with

memories, as with dreams, we are revealed by what we screen. Whatever else it does, the essay reveals the vertiginous complexity of a single childhood memory, the text of which the rest of this intricate text builds upon. Who before Freud had dreamed memory could be like this?

'The Creative Writer and Daydreaming' (1907)

'The Creative Writer and Daydreaming' is the script of an informal talk given to 90 or so non-psychoanalysts in late 1907. After the Jensen essay, it was his first essay on literature. 'We laymen', it begins, breaking down the distinction between Freud as doctor and his lay audience while insisting instead on the distinction between imaginative writers and non-specialist readers. It is precisely this distinction that the essay plays with and calls into question.

'*Der Dichter und das Phantasieren*' is a notoriously untranslatable title. '*Der Dichter*' refers primarily to 'the poet' though it includes other kinds of imaginative writer as well, while '*Phantasieren*' refers to 'fantasies' of many kinds. These include daydreaming (German '*Tagträume*') and adolescent 'castles in the air' ('*Luftschlosser*') but also more primarily children's fantasies and play.[12] Goethe entitled his autobiography *Dichtung and Wahrheit* ('Poetry and Truth'), whereas Freud in this romantic essay is interested in the poet and fantasy, something he takes as seriously as Goethe's 'truth' (he knows we disregard the reality of fantasy at our peril). All Freud's papers on art trace its origins back to childhood formations, as in the momentous re-readings of *Oedipus* and *Hamlet* at the heart of *The Interpretation of Dreams*, the account of jokes in *Jokes and their Relation to the Unconscious*, or the later biographical account of Dostoevsky in 'Dostoevsky and Parricide'. 'Should we look for the beginning of poetic creativity in childhood?' he asks here. His answer is to say that 'every child at play behaves like a writer, by creating a world of his own, or, to put it more correctly, by imposing a new and more pleasing order on the things that make up the world.' 'The opposite of play', he says with challenging seriousness, 'is not

seriousness – it is reality' (the equivalent of Goethe's 'truth'). Freud's essay is in fact a manifesto for art as play. In it he plays on the connection between art and play ('*Spiel*') enshrined in the German words for comedy ('*Lustspiel*'), tragedy ('*Trauerspiel*') and actor ('*Schauspieler*'), moving between the 'play of fantasy' ('*Spiele der Phantasie*'), 'childhood games' (*Kinderspiele*') and the way 'a writer plays his games for us' ('*der Dichter uns seine Spiele vorspielt*'). 'Scarcely anything is so hard to forgo as a pleasure one has known', this exponent of the pleasure principle affirms, and, as adolescent daydreaming replaces and transposes childhood play, so adult art replaces and transposes the erotic and ambitious daydreams of adolescence. It is this complicated game of substitutions that enables us to survive what we give up as we grow up.

In one sense, this merely recapitulates a familiar tradition of romantic aesthetics going back to Schiller and Jean-Paul, affirming the connection of art, dream and childhood. However, Freud's account of growing up involves a different developmental story of unresolvable conflict, repression and displacement, which transposes the terms of the discussion into a different, darker key. A child needn't hide its play, whereas we hide our daydreams from others because we are both ashamed of their wishfulness and embarrassed by the shamelessness of our wishes. By the same logic, in our night-dreams we hide our fantasies from ourselves. According to Freud, 'the meaning of our dreams usually remains obscure' because at night we are 'visited by desires that we are ashamed of and must conceal from ourselves'.[13]

It is not the dream-work or the art-work that primarily interests Freud here, however, but the fantasies that motivate both. Central to Freud's view of dreams is his insistence that they are driven by wish-fulfillment, like daydreams, and it is this tendentiousness of fantasy that he tendentiously projects into the aesthetic sphere. When a Romantic writer aligned art to dream or fantasy, the effect was to increase the potentially transcendental authority of the artist. Freud, less gratifyingly, relates art to the gratification of 'baser' erotic and competitive drives, masturbatory fantasies and infantile sexuality.[14] His test case of art here is not in the first place 'the epic

and tragic poets of classical times', not Sophocles, Shakespeare or Goethe, but 'the more modest authors of novels, romances and short stories' with a wide popular readership. In fact he offers a sketch towards a psychology of the kind of pulp fiction in which author and reader invest their attention in a 'hero who is the centre of interest', showing the 'tell-tale invulnerability' of 'his Majesty the Ego, the hero of every daydream and every novel'.

Freud's essay has an important place in the history of readings of popular culture, with applications to escapist movies and romantic bestsellers, but the claim that this is true of 'every novel' is bizarrely over-stated. Apart from a fleeting reference to the novels of Zola, Freud doesn't give any literary examples anywhere in the essay, leaving his polemical claim mischievously unanchored to particular texts. Though he does concede that many imaginative writings are far from such naïve daydreams, he suggests they could all be linked to them by 'an unbroken series of transitions'. He doesn't, all the same, spell out this unbroken series of transitions here nor ever attempt to do so elsewhere. He does, however, single out 'so-called psychological novels' where there is also 'only one person' and where 'the author sits, as it were, inside the hero's mind', suggesting that they are versions of daydreams 'in which the ego contents itself with the role of onlooker'. It is a tantalizing idea but it remains unclear how it might help us read Dostoevsky's *The Double*, Flaubert's *Madame Bovary* or James's *Portrait of a Lady*, where the outcomes are as far removed from his pulp fiction blueprint as can be imagined. Reading such novels we are closer to the world of the Freudian case-history than Walter Mitty.[15]

The idea that the pleasure we derive from reading a creative writer derives from primitive identifications and access to forbidden material is a compelling one. Freud does not, however, develop his conclusion that 'all the aesthetic pleasure that the creative writer gives us is in the nature of a fore-pleasure' comparable to erotic fore-pleasure, or the idea that 'the true *ars poetica* lies in the technique' by which the artist overcomes our natural repulsion towards other people's fantasies and releases the reader's forbidden pleasure by way of an aesthetic 'bonus'. Aesthetic pleasure, on this

reading, is always part of a larger history of censorship. In Freud's time, Arthur Schnitzler's plays and stories were charting the part played by the perversely erotic in the *fin-de-siècle* Vienna in which psychoanalysis was born. In our time Philip Roth's *Portnoy's Complaint* or *Sabbath's Theatre* show the world of forbidden erotic fantasy writ large. They can be read as works which gratify the secret sexual fantasies masked by our cultural piety, even as superbly crafted instances of authorial exhibitionism. Such works, though, are not only explorations of socially unacceptable fantasy but corrective visions of realities masked by conventional realism. Freud's theory of artistic pleasure here gives no leeway to either 'realism' – art devoted to the reality principle – or pain. What about our pleasure in a work of such painful exposure as Primo Levi's memoir of Auschwitz, *If This Was a Man*? There are inevitably other fantasies at work, even here, the fantasy of the witness, the un-masker, the survivor, all of which may have childhood roots, but how interesting is it to say so when so many other historical factors are at stake? And what about the pleasure in suffering which such art also inevitably brings into play? And our appetite for tragedy? One might recall here Iona and Peter Opie's story of children in a Nazi camp who were found playing a game called 'Going to the Gas-Chambers'.[16] Freud's theory of artistic play downplays the way that play itself is an attempt not only to express infantile fantasies but to master painful realities.

In fact his account over a decade later of the child's game in *Beyond the Pleasure Principle* is an attempt to deepen the possibilities of play.[17] The play of art has also, however, to do with the play of language and with form. 'There's no art without resistance of the medium', as Raymond Chandler says. What is most disappointing about Freud's treatment of art, unlike the dream, is his apparent resistance to the inspirational resistance of the medium.[18]

'Family Romances' (1909)

The little essay on 'Family Romances' has had an influence out of all proportion to its miniature scale. Originally meant to be part of Otto Rank's *The Myth of the Hero* (1909), it returns to the intimate relationship between childhood fantasies and fiction explored in 'The Creative Writer'. The German title '*Der Familienroman der Neurotiker*' means something more like 'The Family Novels [or Fictions] of Neurotics', but it has become so identified with its present title in English that it is easier to call it that. We should remember that the German term '*Roman*' applies to a novel by Thomas Mann as much as to a popular romance by Barbara Taylor Bradford, and the essay looks at a particular narrative archetype (or archetypal narrative) that recurs in quite different genres, including fairy tales, myths, romances and novels. Freud calls this the 'commonest' of all romances (or fictions), 'the replacement of both parents or just the father' of the hero or heroine 'by grander personages', often royal. Although Freud gives no examples, *Oedipus Rex* is a mythical one, the birth of Jesus a biblical one (apparently the son of an obscure carpenter, Jesus turns out to have a much higher pedigree), and *The Winter's Tale* a dramatic one, while fairy tales offer countless instances.

Oedipus Rex is a complex variant of the story in its negative form. Discovered in the wild by shepherds, Oedipus is brought up by one royal family only to find he is from another royal family altogether. He also finds out that he has killed his father and married his mother. Freud attributes the power and universality of this story to Oedipal ambivalences experienced by every child. In fact it was in the same letter to Fliess in which he first attributed the 'riveting power' of Sophocles' play to the fact that 'each member of the audience was once, in germ and in fantasy, just such an Oedipus', that he first floated the related idea of the family romance, talking of 'the romance of parentage in paranoia – heroes, founders of religions'.[19] The essay develops the claims of the letter, arguing that 'an essential feature of neurosis, and also of any considerable talent, is a special

imaginative activity which reveals itself first in children's games and then, beginning roughly in the pre-pubertal period, seizes upon the theme of family relations'. This special activity is related not only to the 'neurotics' of the German title, but any person of considerable talent. Freud himself certainly seized on the theme of family relations in his work, of course, but, as the essay suggests, stories of kinship that situate the hero or heroine in a different family from their given one go to the heart of Western fiction. Our culture is, of course, saturated with ideological idealizations and sentimental fantasies of the family, and no institution is more central to the fictions of Western literature from fairy tales such as Cinderella to sophisticated novels such as Jane Austen's *Mansfield Park*. Freud's blueprint offers us a new and complicated story about the genesis of such stories. For Freud the 'versatility and wide applicability' of the family romance in all its forms transposes into fictional form the unresolvable tangle of Oedipal desires and rivalries which lie at the heart of every child's experience of the family.

Freud makes us think about the centrality of the family to the development of both romance and the novel. He also makes us think about our need to displace and replace our parents, revealed by the special currency of stories of foundlings, orphans, bastards and noble lineage. It seems that children, like adults, need the idea of a double life in order to survive the family. By providing an alternative genealogy, the family romance enables the child to protest against the constitutional inadequacy of history and its real family by projecting itself into the Utopian bosom of that seductive phantasm, an elective family that confirms its own narcissistic self-evaluation. There is always, that is, an imaginary family as well as a real one. The family romance plays out and explores the discrepancies between one and the other, while confirming our 'overestimation of the earliest years of childhood' and the numinous and terrible idealizations of and disappointments with our parents which lie behind most of our stories of identity. Our desire for stories, Freud suggests, is inevitably rooted in our childhood stories of desire, not least the desire to be confirmed as someone else's child. As Roland Barthes notes, 'it is at the same moment (around the age of three)

that the little human "invents" at once the sentence, narrative, and the Oedipus'.[20] For Freud, however, it is in adolescence that the need to re-position oneself in the family, through such fictions of alternative parents, comes into its own, helping us imagine ourselves into becoming the heroes of our own life.

'A novel is a life in the form of a book,' wrote Novalis. According to Freud, from adolescence onwards, we increasingly dream our lives in the form of a particular romantic story, our own defiantly narcissistic myth of the hero. As Marthe Robert observes this is 'expressly conceived to account for the unaccountable disgrace of being un-aristocratic, unlucky and unloved'.[21] Robert's *Origins of the Novel* divides novelists and their fictional protagonists, from Cervantes and Defoe to Flaubert, Kafka and Joyce, into two archetypal figures from the Family Romance, the Bastard and the Foundling. Those broadly 'for reality', such as Balzac and Tolstoy, represent the Oedipal Bastard, while those out to 'deliberately create another world', such as Cervantes and Kafka, represent the Foundling. Both, she implies, answer our irresistible need to rise above our station. She argues speculatively that:

during the whole of its history the novel has derived the violence of its desires and its irrepressible freedom from the Family Romance; in this respect it can be said that this primal romance reveals, beneath the historical and individual accidents from which each particular work derives, more than simply the psychological origins of the genre; it is the genre, with all its inexhaustible possibilities and congenital childishness, the false, frivolous, grandiose, mean, subversive, gossipy genre of which each of us is indeed the issue (to his shame, say the philosophers; to his delight, says the novelist, speaking for himself and for his readers) and which, moreover, recreates for each of us a remnant of our primal love and primal reality.[22]

In his brief sketch, Freud doesn't do much more than float the idea of the kinship between childhood fantasy and cultural fictions. Like 'The Creative Writer', the essay doesn't so much as mention the title of a single story, play or poem. All the same the kinship it identifies and the familial theory of fantasy which it articulates, has

changed our story of the familiar and family stories which have shaped our culture. This is true of mythical stories of such founders as Moses, Jesus, Romulus and Remus, and also of our founding childhood stories of lost and found children such as *The Jungle Book*, Lewis Carroll's *Alice in Wonderland*, and *Great Expectations*. J. K. Rowling's Harry Potter is a dazzling contemporary example. Harry, initially trapped in the diminished world of the Dursleys in Privet Drive, turns out to be the orphaned child of heroic magicians. It is they who provide his *entrée* into the romantic world of Hogwarts and unlikely super-hero status.

The implication of Freud's story, however, is that the whole extraordinary system of narrative exchange that is involved in our need for fiction, is bound up with a child's need to re-read itself over and over, in relation to its own family. Every novel offers alternative genealogies, alternative identities and alternative struggles with the family. Freud's fragment doesn't tell us how to read such fictions, but it does suggest the ways that they might individually be shaped by, as well as shape, childhood fantasies, past and present. It also suggests a genealogy for our culture's undiminished romance with the novel.

'Leonardo da Vinci and a Memory of his Childhood' (1910)

Childhood memory and fantasy are at the heart of Freud's scandalous and controversial foray into the world of historical biography and art history, 'Leonardo da Vinci and a Memory of his Childhood'. Apart from his case histories, it represents his first exercise in biography of any kind. *The Interpretation of Dreams* might be said to be simultaneously the biography and autobiography of Oedipus, while Freud's final work, *Moses and Monotheism*, is, among other things, a biography of Moses; but his study of Leonardo represents Freud's fullest experiment in historical rather than legendary biography. Freud never suffered from undue modesty, but Leonardo as archetypal Renaissance man was a cultural hero Freud betrays a

huge investment in. As both an artist and a scientist, indeed an artist whose whole career for Freud represented a contest between art and science, he was an ideal target for Freud the would-be biographer and theorist of art.

Leonardo's contemporaries, according to Freud, found 'his relation to his art remained a riddle'. It is this notion of Leonardo as a biographical riddle and solver of riddles that dominates Freud's study. Freud construes Leonardo himself as a biographical riddle (*'Rätsel'*), calling him 'a great and enigmatic figure' (*'diesem grossen und rätselhaften Manne'*), a solver of 'the great riddles of nature' (*'der grossen Naturrätsel'*), and a lover of 'fables and riddles' (*'Fabeln und Rätseln'*). Of the *Mona Lisa*, Leonardo's most famous painting, he says it has an 'uncanny, enigmatic character' (*'unheimlichen und rätselhaften Charakter'*) and quotes the art historian Munther to the effect that 'No one has solved the riddle of her smile' (*'niemand hat irh Lächeln enträtselt'*). Freud takes up the gauntlet, and, like Oedipus, succeeds eventually in solving the riddle to his own satisfaction, if not to that of many art critics and historians. Once again, as in *The Interpretation of Dreams, Three Essays on the Theory of Sexuality, The Psychopathology of Everyday Life* and *Jokes . . .*, Freud sees the answer to the riddles of adult life in childhood. Given the paucity of evidence about Leonardo's childhood, his account of it is exhilaratingly speculative, depending as it does on one account of a remembered childhood dream, some financial accounts in a notebook and some meagre biographical facts about his parentage. Like a dream itself, it constructs its mesmeric story out of sparse and disparate historical residues. Freud's therapeutic practice of dream interpretation depended on his access to his patients' free associations. In the absence of a patient, Freud engages in some free association of his own. The result is an extended study of a creative artist and his daydreams (or fantasies), taking 'the minor oddities and riddles in his nature' (*'den kleinen Seltsamkeiten und Rätseln'*) as clues to his intellectual development. But it is also a powerful psychoanalytic fiction about aesthetic and scientific power.

Freud's 'Leonardo' pleased him from the outset. Though, in a sense, it stands on the sidelines of the main thrust of analytic

development (if there is such a thing), his letters show that it meant a lot to him. There is a joking mock-megalomania evident in his earliest references to it and one of the things it is about is greatness, the relation between desire for knowledge and sublimation. In a letter to Jung of 17 October 1909, Freud wrote:

I am glad you share my belief that we must conquer the whole field of mythology. Thus far we have only two pioneers: Abraham and Rank. We need men for more far-reaching campaigns. Such men are so rare. We must take hold of biography. I have had an inspiration since my return. The riddle of Leonardo da Vinci's character has suddenly become clear to me. That would be a first step in the realm of biography. But the material concerning L. is so sparse that I despair of demonstrating my conviction intelligibly to others. I have ordered an Italian work on his youth and am now waiting eagerly for it. In the meantime I will reveal the secret to you. Do you remember my remarks in the 'Sexual Theories of Young Children' [2nd *Short Papers*] to the effect that children's first primitive researches in this sphere were bound to fail and that this first failure could have a paralysing effect on them? Read the passage over; at the time I did not take it as seriously as I do now. Well, the great Leonardo was such a man; at an early age he converted his sexuality into an urge for knowledge and from then on the inability to finish anything he undertook became a pattern to which he had to conform in all his ventures: he was sexually inactive or homosexual. Not so long ago I came across his image and likeness (without his genius) in a neurotic.[23]

He told Ferenczi on 10 November 1909 that, having finished the American lectures, he was working on 'an analysis of – just marvel at the illustrious subject – Leonardo da Vinci'.[24] To Jung on 8 November he wrote: 'Since then, a noble spirit, Leonardo da Vinci, has been posing for me – I have been doing a little ψ A of him. Whether it will turn out to be a brief note or a number of the *Papers* I don't know yet.' The metaphor reveals Freud as would-be artist, the psychoanalyst as portraitist competing with his subject.

The idea of the 'illustrious subject', the 'noble spirit', Leonardo as a Renaissance incarnation of artistic and scientific genius, is

important to this 'first step' in biography, as it would be in 'The Moses of Michelangelo', Freud's next exercise in art criticism. Freud clearly revels in the idea of the painter of the *Mona Lisa* sitting for the Viennese Master in his studio-cum-consulting room. The essay opens with a disclaimer: 'Psychiatric research usually makes do with frail human material, but when it approaches one of the great representatives of the human race, its motives are not those that laymen so often impute to it.' Psychoanalysis has no wish, he says, to 'drag the sublime in the dust'. On the other hand, 'it believes no one to be so great that it would be a disgrace for him to be subject to the laws that govern both normal and pathological behaviour with equal rigour'. The subject of this biographical experiment, in other words, is to offer a retrospective psycho-portrait of the heroic artist, 'the precursor and by no means unworthy rival of Bacon and Copernicus', subjecting him to 'the laws that govern both normal and pathological behaviour' in the light of the radical revision of the relation of normal to pathological brought about by Freudian psychology.

Freud's fascination with Leonardo was part of a larger history. As Richard A. Turner wrote in *Inventing Leonardo: The Anatomy of a Legend* (1995), 'During the second part of the nineteenth century, Leonardo probably gave rise to more historical and critical literature than any other historical figure.'[25] This involved both literary mythologization and new art historical research, largely because of the publication of Leonardo's hitherto unpublished writings and notebooks. Michelet called him 'the Italian brother of Faust', Quinet called his *St John the Baptist* the incarnation of 'the new spirit who sees science and cries, I have found it', while Gautier, Baudelaire and others kept him in the forefront as a figure symbolic of the Renaissance itself and, in Turner's words, 'a hero of modernity'.[26] As the century went on, however, and in particular in the wake of Pater's essay in *The Renaissance*, Leonardo was 'co-opted by the literati as a morbid proto-decadent', a figure of mystery and creator of figures of mystery such as the *Mona Lisa*.

Freud quotes Pater at several points and the great English critic spoke of Leonardo in words that were calculated to arouse Freud's

own fascination. Calling him 'enigmatical beyond the usual measure of great men', he identified 'some seed of discontent which lay in the secret places of his nature' and an impulse for 'going deep, of tracking the sources of expression to their subtlest retreats'.[27] He wrote also of 'the fascination of corruption' evident in his work, recalling the legends of his being possessed of 'curious secrets and hidden knowledge'. 'Fascination', he says, 'is always the word descriptive of him', 'out of the secret places of a unique temperament he brought strange blossoms and fruits hitherto unknown'. Pater's essay climaxes with a reading of the *Mona Lisa*.

For Pater the *Mona Lisa* was not only a masterful portrait but embodied 'the unfathomable smile, always with a touch of something sinister in it, which plays over all Leonardo's work' and which, from childhood on, was defined on 'the fabric of his dreams'. Calling her 'his ideal lady, embodied and beheld at last', Pater puzzles about the relation between Leonardo's 'dream and the person' in the portrait. However, Pater doesn't only see her as representing something deeply rooted in the artist's personal history but as something histori-cally ancient that has survived across time, incarnate as 'Leda, the mother of Helen of Troy, and, as Saint Anne, the mother of Mary'. In fact she stands for the idea of 'modern philosophy' that 'humanity' sums up in itself 'all modes of thought and life'. This makes her for Pater 'the symbol of the modern idea'.

'Who', asked Oscar Wilde, 'cares whether Mr Pater has put into the portrait of the *Mona Lisa* something that Leonardo never dreamed of?' For Wilde it is not the artist but 'rather the beholder who lends to the beautiful thing its myriad meanings, and makes it marvellous for us, and sets it in some new relation to the age'.[28] The same might be said of Freud's essay, which takes off from very similar identifications to Pater's, though in the radically different style generated by early psychoanalysis. And it is precisely what Leonardo 'dreamed of' that, unsurprisingly, interested Freud. In the wake of the publication of Leonardo's notebooks after 1881, Leonardo's thoughts and writings were available as never before, provoking a new wave of biographies, including the fictional biog-raphy by Merezhkovsky that Freud named among his ten best books

in 1906.[29] The weird and meticulous cornucopia of the notebooks threw up, among the welter of scientific and artistic material, the account of one childhood dream. As Freud says, 'In a passage dealing with flight of the vulture he suddenly interrupts himself to pursue a memory from his early childhood that has sprung to mind.' The sentence, as Freud records it is, 'It seems that I was predestined to study the vulture so thoroughly, because I recall, as a very early memory, that when I was still in my cradle a vulture came down to me, opened my mouth with its tail and struck me many times with this tail against my lips.' The novelist Merezhkovsky, who has no qualms about recreating da Vinci's childhood, alludes to the dream only in passing, but Freud, like a hermeneutic vulture, swoops down upon it and makes it the key to what he calls the whole 'riddle' of Leonardo. As he had done for himself in 'Screen Memories' or his interpretation of 'The Dream of Irma's Injection' in *The Interpretation of Dreams*, Freud sets out, on the basis of this one minuscule piece of evidence, to uncover not only an image of da Vinci's childhood but the infantile fantasies at the heart of the Renaissance genius.

As Freud reviews the biographical riddle of Leonardo in the opening stages of the study, it resolves around three separate issues. These are: (1) his shift of interest from art to science in later life; (2) his peculiar reluctance to 'take up the brush' and the perfectionist tendency, remarked on by Vasari, to work slowly and leave works unfinished; and (3) his apparent rejection of sexuality, lack of romantic relationships with women and reputation for homosexuality (Leonardo was found not guilty of charges of homosexual conduct in court, but surrounded himself with pretty younger artists, who, Freud suggests, seem to have been chosen for their looks rather than their talents). These inhibitions of Leonardo's aesthetic and erotic instincts are related in Freud's account to what he sees as the overwhelming motivating force in his life, his 'thirst for knowledge', a thirst Freud reads as a sublimation of his homoerotic sexual desires. Freud's essay simultaneously normalizes Leonardo's homosexuality and paradoxically pathologizes his quest for knowledge.

Homosexuality is a central preoccupation in Freud's writing. It

is an offshoot of his belief in the constitutive bisexuality of human beings in general and of his own self-analysis, which made him acutely aware of his own homosexual feelings. 'Leonardo' is, among other things, a complex and moving portrait of a self-thwarted homosexual. Later, Freud was to write:

The most important of these perversions, homosexuality, scarcely deserves the name. It can be traced back to the constitutional bisexuality of all human beings and to the after-effects of the phallic primacy. Psycho-analysis enables us to point to some trace or other of a homosexual object-choice in everyone . . . Psycho-analysis has no concern whatever with judgements of value.[30]

Freud was writing in the period of galloping sexology, the heyday of Krafft-Ebing, Havelock Ellis and Otto Weininger, as well as the *risqué* fictions of Wilde, Wedekind and Arthur Schnitzler. The Leonardo essay is one of the most compelling psychological accounts of male homosexuality from the early twentieth century, though it contests the views of some of those he calls 'apologists for homosexuality', in particular those who appealed to the now abandoned notion of the third or intermediate sex. With Symonds's 'A Problem of Modern Ethics', Wilde's 'Portrait of Mr W.H.', Gide's *L'Immoraliste*, Thomas Mann's *Death in Venice* and Proust's *À la recherche du temps perdu*, it is a milestone among early twentieth-century studies of homosexual identity. It is also, though, a study of the homosexual as scientist, and of scientific research as sublimated perversion. And how, we might ask, does this affect our own reading of Freud's passion for research, including his research into the life of Leonardo?

Psychoanalysis is poised between science and art, between the natural and human sciences, and it has exponents and opponents on both fronts. Freud's study offers the first sustained experiment in psychoanalysis of an artist, but from the word go, paradoxically, it presents itself as both a quasi-scientific case history and a work of experimental fiction, a work of art. It is a quasi-scientific portrait of an artist who is not only an artist but a scientist, indeed an artist

who, despite himself (or because of himself), succumbs to science. Its subject, that is, is the problematic relationship of art and science – and of both to desire. The key in this study of 'Leonardo's double nature as artist and scientist' (*'Dopelnatur als Künstler und Forscher'*) is 'research' (*'Forschung'*). The essay is above all a piece of research into the idea of research itself, the *Forschertrieb* or *Forscherdranges* that drives artistic and, more primarily, scientific research. Its first words raise the idea of *'seelenärztliche Forschung'* (psychiatric research) and the essay that follows, while embodying this ideal and legitimating it, also in a sense pathologizes it, tracing it back to infantile sexual fantasies, and in particular 'infantile sexual research' (*'infantilen Sexualforschung'*). What baffles Freud is not only Leonardo's apparent inhibition about acting out his homosexual fantasies in erotic relations with boys, leading to the kind of artistic sublimation described in 'The Creative Writer and Daydreaming', but his even more puzzling replacement of the joys of painting by the analytic rigours of scientific research.

As both painter and scientist Leonardo represents, for Freud, the triumph of the secular scientific worldview with which he himself identified, in which research replaces faith in authority. Leonardo both 'became the first natural scientist of modern times' and as a painter 'took from the sacred figures the last remnant of their ties with the Church and drew them into the human world'. Freud alludes to Vasari's observation in the first edition of *Lives of the Painters* that he was said to have 'formed in his mind a doctrine so heretical that he depended no more on any religion, perhaps placing scientific knowledge higher than the Christian faith'.[31] But this scientism, in Freud's view, posed problems for him as an artist. 'His investigations extended to virtually every branch of natural science', he says, but as a result he also found that 'what interested him now in a picture was above all a problem, and behind this one problem he saw countless others emerging – an experience that was familiar to him from the endless, inexhaustible study of nature'. This would seem to be a mirror image of Freud's own way of working. All the more fascinating then is the fact that it is precisely Leonardo's devotion to scientific naturalism and problem-solving that Freud

sees as a problem. Towards the end of his essay, Freud notes that 'biographers are fixated on their heroes in a quite peculiar way', suggesting that this makes them prone to 'idealization', even to construing the subject in the infantile image of their own father. Where does this leave Freud's 'pathography' of his hero?

But if Leonardo is an intellectual hero for Freud, Freud also construes him as his anti-type. Freud's biographical fragment sets itself squarely against the Victorian traditions of Great Lives, which were being almost contemporaneously subverted in what Virginia Woolf called the 'new biography', as represented by Lytton Strachey's *Eminent Victorians*. This is marked by his insistence from the outset that biography must not keep silent about the subject's 'sexual activity and sexual individuality'. Freud's way of handling the problem is to try to explain, in terms of sublimated eroticism, Oedipal family politics, and he portrays Leonardo above all as a man hostile to both the erotic and psychology. He quotes a sentence of Leonardo's on the inherently 'disgusting' nature of the 'act of procreation' and notes, for all the encylopaedic range of his scientific curiosity, 'anything sexual is so resolutely shunned that it seems as though Eros alone, the preserver of all that lives, is unworthy to be the object of the scientist's thirst for knowledge' (*'kein würdiger Stoff für des Forschers'*). Though he was a discoverer, or at least a prophet and a pioneer in nearly every branch of science, Freud says, 'this urge for knowledge was always directed to the external world; something prevented him from studying the human mind' (*'der Erforschung des Seelenlebens der Menschen'*). 'There was little room', writes Freud, a natural scientist turned psychologist, 'for psychology.'

Just as Renaissance pictures included images of the donors or patrons, so Freud's study of Leonardo here reveals his own fantasy of being a pioneer of research into precisely the areas of experience rejected by Leonardo, that is, Eros and the human mind, and the roots of both in childhood experience. Freud treats Leonardo's 'vulture' memory as a 'screen memory' ('a latter-day fantasy'), using it as a key to unlock the whole of the artist's life: 'what a person thinks he remembers of his childhood is not a matter of indifference:

hidden behind these residual memories, which he himself does not understand, there are as a rule priceless pieces of evidence about the most significant features of his mental development'. He 'translates' Leonardo's memory of the vulture putting its tail into his baby mouth as both a coded homosexual fantasy of oral sex (the Italian word for 'tail', *coda*, can refer to the penis, as can the Italian word for bird, *ucello*) and a fantastic 'reminiscence of sucking, or being suckled, at his mother's breast', a fantasy that he suggests underlies the fantasy of fellatio. Unfortunately, as reviewers pointed out early on, the 'vulture' has been spawned by a German mistranslation of *nibio*, the Italian word for 'kite', and leads Freud to a disquisition on representations of the vulture in Egyptian mythology and the writings of the Church Fathers as being all female (or hermaphroditic) and able to procreate without sex, corroborating the story of the Virgin birth. For Freud, this points to Leonardo's fantasy of being a 'vulture's child', having in earliest life a mother and no father, and he suggests that this may lie behind his later representations of the Virgin and child.

The irrelevant mythical associations of the 'vulture' don't really affect Freud's reading of Leonardo's screen memory. When we discount it, Freud's translation remains challengingly tendentious nonetheless:

It is true that the unintelligible memories of a person's childhood and the fantasies that are built on them always bring out what is most important in his psychical development, then the fact Leonardo spent the first few years of his life with his single mother – a fact shaping the vulture fantasy – must have had the most decisive influence on the shaping of his inner life. An inevitable effect of this situation was that the child, who in his early years found he had one problem more to deal with than other children, began to brood on these riddles ['*Rätsel*'] with particular intensity and so, at a very early age, became a researcher ['*Forscher*'], tormented by the big question of where babies come from and what part the father plays in the process. An inkling of this connection between his research ['*Forschung*'] and the history of his childhood later drew from him the declaration that he had probably always been destined to immerse himself in the problem of bird

flight, as he had been visited by a vulture while still in his cradle. It will not be difficult, later on, to derive the curiosity that was directed to the flight of the bird from his infantile sexual researches.

A recent biographer of Leonardo, Serge Bramly, discounts the whole Freudian account, but draws attention to the number of the artist's riddles that 'turn on the identification of children', suggesting they might reflect 'the wounds suffered from illegitimacy and his parents' separation'.[32] While accusing Freud absurdly of 'denouncing' the artist's homosexuality, he acknowledges that Freud was the first to bring into the open his illegitimacy and his parents' separation soon after his birth. Little is known of Leonardo's childhood, and Freud's speculative reconstruction of his early life, caught between his father's wealthy family and his mother's poorer one, is based on the most meagre materials. Despite the vast output of notebooks and jottings, the artist left little in the way of personal documentation, and, apart from the memory (or 'dream'), Freud puts pressure on his jotted accounts of the cost of clothes bought for his apprentices to suggest his love for them, and of comparable numerical calculations for evidence of feelings about his mother Caterina's death and that of his father.

It is not, however, for its factual accuracy that anyone would now read Freud's extraordinary portrait of the artist as scientist, or scientist as artist (but then it is not for factual accuracy that we read dreams). There is little in it that we would recognize as art criticism of a plausible kind, but Freud gives a new psychological realism to the purple rhetoric of Pater, and in particular his claim that 'from childhood on, a face like Mona Lisa's mixed into the fabric of his dreams'. Vasari records that Leonardo's earliest works were pictures of beautiful children and laughing women, which Freud links to his 'vulture fantasy', suggesting 'the possibility that his mother may have possessed that mysterious smile, whose image he had lost, and that so captivated him when he found it again in the Florentine lady'. He devotes more time, though, to the probably contemporary *St Anne with the Madonna and Child*, suggesting that 'if the Gioconda's smile conjured up the memory of his mother, we can

understand that it at first impelled him to create a work that glorified motherhood and to restore to his own mother the smile that he had found in the face of the grand Florentine lady'. Freud suggests that the picture 'contains a synthesis of the story of his childhood', his two mothers, 'one who stretches out her arms to him and another in the background' (his real mother Caterina, and the grandmother Mona Lucia, who seems mainly to have brought him up). This is psychologically plausible, however little it is grounded in historical fact. The same smile is found on the lips of the John the Baptist and Bacchus, both 'handsome youths, endowed with feminine delicacy', Freud observes. 'It may be', he says, 'that in these figures Leonardo denies the unhappiness of his erotic life and has triumphed over it in his art, by showing how the desires of the boy who was once infatuated with his mother are fulfilled in this blissful union of the male and the female nature.' This is a remarkably celebratory account of the claim of 'The Creative Writer and Daydreaming', recapitulated here, that 'an artist's creative work also provides an outlet for his sexual desires'.

'Leonardo is the Hamlet of art criticism', Kenneth Clark said at the conclusion of his study, 'each of us must recreate him for himself.[33] In his own conclusion, Freud says 'I have yielded, like others, to the fascination of this great and enigmatic [*rätselhafte*] figure.' Leo Bersani speaks tellingly of the 'theoretical turbulence' of Freud's essay and emphasizes Freud's 'inability to be conclusive in his own investigation'.[34] Freud may not have made a contribution to art historical research as usually understood. We should think of 'Leonardo' rather as a Borgesian fiction about an artist, an exercise in the theory of research, an 'imaginary portrait' of a homosexual genius, a speculative experiment in psychoanalytic biography, or a fantastic intervention in the critical literature on Leonardo comparable to Wilde's 'Portrait of Mr W.H.' in Shakespeare studies. It is also, to some degree, a self-portrait in a convex mirror. Anticipating its reception, at the close, Freud says:

Should my exposition provoke the judgement, even among friends of psychoanalysis and experts in the field, that I have done no more than write

a psychoanalytic novel, I would reply that I certainly do not overrate the reliability of my findings. I have yielded, like others, to the fascination of this great and enigmatic figure, in whose nature one senses powerful instinctual passions, which can nonetheless express themselves only in a strangely subdued fashion.

This cuts both ways. Earlier Freud had praised the 'psychological novelist' ('*seelenkundigen Romanschreibers*') Merezhkovsky as offering more insight than the biographers and here he suggests his work could be read as 'a psychoanalytic novel' ('*psychoanalystischen Roman*'), that is, as art, not science. We might ask what a 'psychoanalytic novel' might be? Would it be like the account of an analysis or a case-history? Or like a dream?

None of this gets any acknowledgement from those anti-Freudians who from the time of the first reviewers to the present, see his 'Leonardo' as unscientific, unhistorical, and un-art-historical, an exercise in biography that fails to obey the rudimentary methodological rules of the genre. Its initial reception was mixed, but outside Freud's immediate circle, largely hostile. On 10 August 1910 Freud wrote to Jung that Löwenfeld 'wrote to me at length about the horror which my *Leonardo* aroused even in persons "favourably disposed". But on this score I feel quite easy in my mind, for I myself am very pleased with *Leonardo*, and I know that it has made an excellent impression on the few people who are capable of judging it: you, Ferenczi, and Pfister.'[35] Stekel and Havelock Ellis welcomed the book warmly, but many of the early reviews were scathing, particularly that by R. K. Neumann-Lankwitz in *Der Sturm* entitled 'The Spat-on Genius'. It described analysts like Freud as 'necrophiles and necrophagi', calling them 'psychoanalytic hyenas' who have 'invaded the literary churchyards'. Their 'latest victim', we are told, 'is Leonardo'. He tells us furthermore, in a curious reading of the paper, that though Freud 'doesn't dare to touch his paintings, he consoles himself by touching Leonardo's genitals' (this tells us as much about the fantasies of the reviewer as the author).[36] Neumann-Lanwitz is still smarting from reading Little Hans's case-history and, while avowedly grateful for the absence of references to erections

and horse shit in the new study, is particularly vexed by Freudian theories of bisexuality. A reviewer in *The Dial* notes that Leonardo, 'with his reputation for purity would seem unpromising material' for a psychoanalytic interpretation, and protests against the account of the *Mona Lisa* as 'the reproduction of his mother by a homosexual artist', since it 'was not painted so blindly, so instinctively as that'. Overall he found it 'too much of an attempt to explain a personality in terms of the reflexes of the spinal nerve centre'.[37] Clive Bell, writing in 1925, said 'Dr Freud had made himself slightly ridiculous by talking of things of which he knows nothing . . . Dr Freud may be an excellent psychoanalyst but I am sure he had better leave art alone'.[38]

Freud was not overly dismayed, but he showed some doubts. In November 1914 he told the German artist Hermann Struck, 'it takes for granted that the reader will not be shocked by homosexual topics and that he is fairly familiar with the devious ways of psychoanalysis. As a matter of fact it is also partly fiction. I wouldn't like you to judge the trustworthiness of our other discoveries by this example'.[39] Nevertheless he later told Lou-Andreas Salomé that 'Leonardo' was 'the most beautiful thing I have ever written'. In the final analysis, Freud ironically came to value it as much for its aesthetic beauty as its scientific truth.

'The Uncanny' (1919)

It was at the outset of 'The Uncanny' that Freud announced 'Only rarely does the psychoanalyst feel impelled to engage in aesthetic investigations.' The uncanny is, of course, about such obscure compulsions. One of the earliest psychological investigators of the aesthetic, Edmund Burke, opposed the economy of beauty, built up around positive experience of pleasure, to the sublime, built up around the negative experiences of awe, terror and dread. In this essay Freud, like Burke, moves beyond an idea of aesthetics 'restricted to the theory of beauty', as he puts it, to explore an aesthetics of anxiety. Leaving behind the scenarios of wishful fantasy sketched

out in 'Family Romances', 'The Uncanny' explores wishful fears. In this respect, it is part of the profound re-mapping of the whole psychoanalytic project during and after the First World War culminating in *Beyond the Pleasure Principle* (1920). Like the case of the Wolf Man published in 1918 as 'From the History of an Infantile Neurosis', Freud's essay on Gothic reveals the increasingly Gothic story of psychoanalysis itself as it starts to report back from the psychic underworld of the death drive. As the literature of Gothic developed in the wake of secular Enlightenment liberalism, revealing the haunting persistence of the architecture, religious beliefs and superstitious terrors of the un-Enlightened past, so psychoanalysis after the First World War increasingly conjures up a Gothic closet, an uncanny double, at the heart of modernity.

'The Uncanny' is one of Freud's strangest essays and it is about a particularly intense experience of strangeness. Hélène Cixous describes 'The Uncanny' as itself uncanny, treating it 'less like an essay than like a strange theoretical novel'.[40] At its heart, though, is the claim that the uncanny, like charity, begins at home. Freud had remarked on the 'uncanny, enigmatic character' (*'unheimlichen und rätselhaften Charakter'*) of Leonardo's *Mona Lisa*, and gone on to trace it back to the artist's earliest memories of his mother. This prefigures his fundamental tactic here, which, taking off from the German dictionary, is to trace the uncanny (*'das Unheimlich'*) back to the most familiar and homely (*'das Heimlich'*), and to see it as 'something that was long familiar to the psyche and was estranged from it only through being repressed'. With the death of the supernatural, it is our own and our culture's disowned past that haunts us. Setting out to unravel what he calls the 'puzzle of the uncanny' (*'das Rätsel des Unheimlichen'*), Freud casts himself, as is his wont, in the role of riddle-solver, and, as is his wont, sees the answers to the riddle in traces of early childhood.

'The Uncanny' takes off from a paper by the little known Otto Jentsch on this little-explored topic, and it revolves around a vertiginous reading of a vertiginous and hallucinatory story by the romantic writer, music critic and musician E. T. A. Hoffmann.[41] Though Freud's text, first published in *Imago* in 1919, was a reworking of

an 'old paper dug out of a drawer', perhaps going back to before the war, it belongs to a later stage of Freud's thought, drawing as it does on a draft of *Beyond the Pleasure Principle* (1920).[42] While devoted to a relatively marginal psychoanalytic topic, and one almost unexplored in earlier aesthetics, it is perhaps the most *compelling* of all his interventions in literary criticism. It has certainly had a huge impact on subsequent literary criticism and theory.[43] Much of it is a commentary on Hoffman's exercise in psychological Gothic, 'The Sand-Man', prompting Harold Bloom to say that 'for once Freud allows himself to be a useful practical critic of an imaginative story'.[44] However, he also claims that 'it is the only major contribution that the twentieth century has made to the aesthetics of the sublime'. For where the early essay on *Gradiva* used Jensen's Pompeian fantasy to reproduce Freudian ideas familiar from elsewhere in his work, the essay on 'The Uncanny' represents an exploration of unfamiliar territory, the sublime territory of unfamiliarity itself. Freud's account of it underpins much of the huge modern critical literature on both Gothic and the Sublime.[45] It is not only a theoretical commentary on the power of strangeness, but one of the weirdest theoretical texts in the Freudian canon.[46]

The essay on the uncanny interprets the uncanny as a return. Freud tells us in a letter that it is itself a product of his return to an essay of several years earlier. Freud also tells us that it is a return upon an earlier academic text on the same subject by Otto Jentsch, 'On the Psychology of the Uncanny', which, as Freud notes, is a rare, if not unique, study of the subject. From the outset Freud seeks to demolish the credibility of Jentsch's thesis that the uncanny derives from intellectual uncertainty, but he constantly returns to it as if haunted by an uncertainty about the uncertainty principle that he claims to have banished. Uncertainty is a more interesting subject than Freud is prepared to acknowledge, and this particular essay is riddled with it.

There's an uncertainty about the very form of the essay itself. As many critics have remarked, it is a strange amalgam of different genres. It cannot quite make up its mind what it is – literary criticism, autobiographical anecdote, etymological enquiry, aesthetic essay,

psychological study or fictional anthology. The second section of the essay begins with a sustained reading of 'The Sand-Man' in the context of other works by E. T. A. Hoffmann. This is a brilliantly tendentious reading of the story's various incidents in terms of repetition and doubling, built up around the central character, Nathaniel, and his fantasy of Oedipal castration. Thereafter, and without any return to Hoffman or the virtuosic exercise in reading Freud brings to bear on him, the essay swerves away from textual hermeneutics to reflect on the literary and cultural uncanny in more general ways, weaving between personal anecdote, case history and journalistic anthropological study, ranging from Shakespeare to Schnitzler, and from *Faust* to Ewer's *Student of Prague* that had featured in Otto Rank's 1914 paper on 'The Double'. If it re-tells Hoffmann's story, it is also, as Samuel Weber reminds us, remarkable for the multiplying '*Musterung*' of allusions and examples.[47] As a work 'The Uncanny' is an absolutely *sui generis* portmanteau work. Unlike 'The Creative Writer' and 'Family Romances', it is also packed with narrative and readings of narrative.

At its heart, though, are readings of two texts, the German dictionary and Hoffman's 'The Sand-Man'. As if to rebuff Jentsch's opening claim that 'it is a well-known mistake to assume that the spirit of languages is a particularly acute psychologist', the first section, a summary of the different definitions of the 'uncanny' in German dictionaries and in various foreign-language ones, is a virtuoso display of lexicographical research. It involves the most sustained close reading of the dictionary in all of Freud's writings.[48] Freud's survey of the lexical range of the term in German and other European languages makes the issue of translation central to the essay (it also makes it particularly hard to translate, forcing the translator to leave many terms in the original foreign form). This plays out the central issue of foreign-ness and familiarity that Freud treats as integral to the logic of uncanniness. The term 'uncanny' is the appropriate English translation for '*unheimlich*' (it's the English term Freud uses among his survey of foreign language equivalents) but it doesn't reproduce the semantic structure which provides the crux of Freud's account of the relation between the *Heimlich* and

the *Unheimlich*, which simply can't be domesticated into English.

One of the oddest features of Freud's treatment of Hoffmann's tale, by contrast, is his refusal to acknowledge the textuality of Hoffman's tale, and his elision of its heroine Clara.[49] Freud gives a compelling summary of Hoffmann's story but makes no reference to its complex narrative structure. Indeed, elsewhere he treats dreams as much more textual constructs than he does the Romantic writer's highly self-conscious literary text. One of the eeriest things now about Hoffmann's tale, which first appeared in his *Nackstücke* of 1816–17, a hundred years before Freud's essay, is its air of being so deeply influenced by Freud. Taking its title from a legendary nursery character, it maps the vagaries of the protagonist Nathaniel's love-life against his traumatic early family life, childhood dreams and experience of his father's death. It begins with three letters, the first of which is from Nathaniel to his childhood friend and beloved's brother Lothair, which, in a classic Freudian slip, he sends by mistake in his 'distracted frame of mind' to his beloved Clara.[50] It tells of his horrified identification of a peddler of glasses called Giuseppe Coppola whom he had met recently with the nightmare figure of Dr Coppelius, a friend of his father's who had threatened to pluck out his eyes in his childhood and who was present at his father's death (in fact he accuses him of killing his father). Nathaniel is as neurotically haunted a German Romantic as one could invent, a poet with a taste for the supernatural, the melancholic and the daemonic, who, like Hazlitt in *Liber Amoris*, later finds himself as a modern Pygmalion falling in love with an automaton called Olimpia. He goes on to bore and offend his fiancée with a long poem about 'his dismal presentiment that Coppelius would ruin his happiness'. The second letter, from Clara to Nathaniel, shows her as a shrewd secular psychologist, who argues that 'all the horrors' of which he speaks are in his 'own self, and that the real true outer world had but little to do with it'. She finds it natural that 'the gruesome Sand-Man of the old nurse's story' was associated in his 'childish mind with old Coppelius' who, even though he had not believed in the Sand-Man, would have been to him 'a ghostly bugbear'. If there is a 'dark and hostile power', she says, prophesying the reign of

Freud, then 'it must assume a form like ourselves, nay, it must be ourselves'. There follows a letter from Nathaniel to Lothair, which speaks of Clara's 'very deep philosophical letter', and shows his attention being diverted away from Clara to the doll Olimpia. Ironically, the doll later proves a much better listener than the philosophical Clara to his 'poems, fancy sketches, visions, romances, tales' and growing heap of 'aimless sonnets, stanzas, canzonets'. Having quoted these three letters in lieu of a 'Once upon a time', the self-conscious narrator of the story says that 'nothing is more wonderful, nothing more fantastic than real life, and that all a writer can do is to present it as "in a glass darkly"'. He then proceeds to tell the story of his 'poor friend, the young student Nathaniel' himself, being 'powerfully impelled' to narrate his 'ominous life', with its 'elements of marvel and alienness'.

Hoffmann's story is not only a highly literary performance but a grotesque parable of the Romantic artist as lover. If it begins as dialogue, it continues via a series of contested, unstable readings of the present in terms of the past, and an account of Nathaniel's obsessional reading of his life in terms of 'dreams' and unconscious destiny. It is shot through with the kind of shifting hesitation between psychological and supernatural interpretations which Todorov sees as implicit in the genre of 'fantasy literature' as a whole.[51] Freud notes that Hoffmann plays on the 'uncertainty' as to whether the doll Olimpia is 'animate or inanimate', but argues that in the course of the story 'this uncertainty disappears'. 'We realize', he says, 'that the author wants us too to look through the spectacles or the spyglass of the demon optician', but that by the end there is 'no question' of intellectual uncertainty. We know, he says, that 'what we are presented with are not figments of a madman's imagination' but 'sober truth'. The uncanniness of the story, then, has nothing to do with intellectual uncertainty on Freud's account, but the infantile terror of castration based on 'the substitutive relation between the eye and the male member that is manifested in dreams, fantasies and myths'. It is this that explains that the Sand-Man, so mysteriously associated with the father, is also 'the disruptor of love' and, in the person of Coppola, comes between Nathaniel and Clara, precipitating his

murderous violence towards her and himself at the end of the story.

As Freud sees so brilliantly, Hoffmann's tale about vision and blindness is indeed built up around the motive of eyes and eye-lessness. But when, in a comprehensive footnote, Freud comes to summarize 'the story of Nathaniel's childhood' in terms of his relationship with his father and the castration complex, he displays a certain blindness himself. Noting that 'the writer's imaginative handling of his material has not thrown the constituent elements into such wild confusion that their original arrangement cannot be reconstructed', Freud proceeds to reconstruct the 'original' sequence of Nathaniel's neurotic history, quite as if it were analogous to the 'dream thoughts' distorted by the dream work, and recoverable via free association. But how can this be true of a fictional figure? The idea of the 'original arrangement' here is utterly phantasmal. On Freud's reading, the automaton 'cannot be anything other than a materialization of Nathaniel's femine attitude towards his father in his early childhood. Her fathers, Spalanzani and Coppola, are merely new versions – re-incarnations – of Nathaniel's two fathers.' On another level, however, we might argue that Nathaniel is a kind of automaton himself, a fictional creation which Freud takes as real, just as Nathaniel takes Olimpia to be real. If the optician Coppola sells Nathaniel a distorting telescope Freud's re-reading forces us to see the story through comparably distorting and artificial psycho-analytic eye-glasses. Hoffmann's story is itself both a study of imagin-ative artifices (represented by his father's alchemical studies, the Professor's scientific interest in automata, and Coppola's eye-glasses and telescopes), and a portrait of a would-be artist in the grip of a doctrine of romantic inspiration who 'went so far as to maintain that it was foolish to believe that a man could do anything in art or science of his own accord'. Nathaniel, that is, is converted to a doctrine of psychic automatism. We might ask whether Freud is as well? Freud relates Nathaniel's inspired but ridiculous blindness to the constructed nature of his beloved's beauty to his terror of his father, a terror revealed in the multiplying 'father series' of the narrative, who prevent him consummating his love. For him, this dramatizes 'the psychological truth that a young man who is fixated

on his father by the castration complex becomes incapable of loving a woman', a truth, he says, that is 'demonstrated by many analyses of patients'. When Freud treats the story as 'sober truth' in this way, without any 'intellectual uncertainty', he discounts something of the vertiginous complexity of Hoffmann's narrative machinery, with its capacity to generate material of uncertain epistemological status.

Nevertheless Hoffmann's story lends itself to Freudian interpretation so uncannily because it deals in so many of the same tropes that Freud uses of seeing and failing to see, reading and failing to read, generating a series of double translations between past and present, real and artificial, psychological and supernatural. After Freud's hermeneutic translation of this story of artificial substitutions in terms of a series of psychic substitutions, the structural analysis of fantastic narratives would never be the same. It became clear that comparable mirror structures of the *Heimlich* and the *Unheimlich* could be read out in other Gothic works of the same period, including Coleridge's *Christabel*, Mary Shelley's *Franken-stein* and Charlotte Brontë's *Jane Eyre*. In all of them daemonic or *unheimlich* encounters could be read as encounters with the repressed and *heimlich* familial life of their protagonists. The question Freud's essay raises but does not answer is: whose repressed childhood returns in the uncanny in works of this kind? That of fictional characters such as Nathaniel or Frankenstein, Jane Eyre or the governess in *The Turn of the Screw*? Or that of their authors, Hoffmann, Shelley, Brontë or Henry James? In 'Leonardo da Vinci and a Memory of his Childhood', Freud traces the riddle of the art-work back to the early life of the creator, reading the uncanny smile of the *Mona Lisa* as a complex reflex of Leonardo's infantile erotic memories of his mother sublimated into art. In 'The Uncanny', he does briefly in a footnote relate Nathaniel to the biography of his creator, E. T. A. Hoffmann, but that is obviously not the burden of the reading as a whole. In fact, Freud treats the story, as he had done Jensen's *Gradiva* earlier, very much as a Freudian case history.[52] But whereas Jensen, like Schnitzler, lived in the Freudian era, nothing in the essay explains the uncanny likeness of Hoffmann's story to a Freudian case history. Unless we choose to see the Freudian

case-history as a transposition of a Gothic tale into everyday Viennese life.[53]

Having discussed Hoffmann as 'the unrivalled master of the uncanny in literature', Freud leaves the Sand-Man behind. Thereafter he wanders between different textual and empirical instances of the uncanny. Though strangely, in this text of returns, he does not return to Hoffmann again, he suggests that the literary uncanny 'is above all much richer than what we know from experience' but also intensely different from it, mainly because of our historical consciousness of genre. The supernaturalism of the fairy tale does not inspire a sense of the uncanny because there is no conflict of judgement, no clash of different models of the real in it. The same, Freud argues, is true of the supernatural in Homer or Shakespeare. Since we adapt our judgement to the conditions of a writer's 'fictional reality' ('*vom Dichter fingierten Realität*'), 'the souls in Dante's *Inferno* or the ghostly apparitions in Shakespeare's *Hamlet, Macbeth* or *Julius Caesar* may be dark and terrifying but at bottom they are no more uncanny than, say, the serene world of Homer's gods'. The uncanny, that is, unlike Burke's Sublime, is a paradoxical mark of modernity. It is associated with moments when an author, fictional character or reader experiences the return of the primitive in an apparently modern and secular context. For Freud as uncanny theorist, however, this is also a survival from the abandoned psychic culture of our own childhood, bearing the Gothic signature of our own earliest terrors and desires. For the author of *The Interpretation of Dreams*, childhood is where the repressed, archaic pre-Enlightenment world of primitive religion, returns in perpetually re-invented home-made forms, forcing us in some sense to repeat or recapitulate such primal myths as those of Oedipus or Moses, and such beliefs as animism and 'the omnipotence of thoughts'. For Freud, though, those nightmarish myths and primitive beliefs themselves are only estranged childhood fantasies writ large. 'The Uncanny' reminds us not only that there is no place like home, but that, in another sense, there is no other place. For Freud, our most haunting experiences of otherness tell us that the alien begins at home, wherever that may be. Incidentally, during the time he wrote

the essay, his sense of home was itself changing. In March 1919, after Austria was compelled to give up South Tyrol, Freud wrote that 'To be sure, I'm not a patriot, but it is painful to think that pretty much the whole world will be foreign territory.'[54]

At the outset, Freud 'pleads guilty' to being resistant to the uncanny, as if it really were foreign territory to him. Almost as if he wanted to disqualify himself from writing about it, he says 'it is a long time since I experienced or became acquainted with anything that conveyed the impression of the uncanny'. On the other hand, the essay has a distinctly personal edge. Amid a welter of literary references, for example, it includes two allusions to his personal reading. One of these is a story he had read during the war in the *Strand Magazine* which he had found 'extraordinarily uncanny'. The other is Arthur Schnitzler's story 'The Prophecy', which aroused a particularly keen sense of dissatisfaction in him for the way the author promises us 'everyday reality' and then goes 'beyond it'.[55] It also records two arresting and highly autobiographical accounts of the uncanny involving Freud on his travels. The two autobiographical anecdotes give the essay an uncanny first-person feel. In the first, he finds himself strolling among the 'unfamiliar streets of a small Italian town' and then 'in a district about whose character I could not long remain in doubt' (nothing Jentschian there!). Leaving hastily, he finds himself repeatedly returning to the same red light district by different routes: 'I was now seized by a feeling that I can only describe as uncanny, and I was glad to find my way back to the piazza that I had recently left and refrain from any further voyages of discovery.' Freud's 'unintentional return' occurs as a result of the pedestrian equivalent of free association. It is this that, in his wandering, appears to guide his feet repeatedly to the red light district rather than piazza. The second personal anecdote occurs in a footnote, where Freud in the sleeping apartment of a train sees 'the door of the adjacent toilet swung open and an elderly gentleman in a dressing gown and travelling cap' enter his apartment. In fact, Freud soon realizes, to his astonishment, that 'the intruder was my own image, reflected in the mirror on the connecting door'. Both of these incidents clearly involve a repetition of a kind, an inadvertent

return to the same place that he is avoiding, and the shocking sight of his own alienated features in the toilet door. Both, too, involve associations with strange sleeping quarters – and the shameful possibility of being caught in a compromising situation. The images of Freud the intruder and street-walker, Freud in the red-light district and Freud in the toilet, have a certain eeriness, revealing more about the author than you would expect of a couple of casual anecdotes.

It is when he starts to pursue the idea of 'repetition' that the first autobiographical incident makes its appearance. It is cited as one of a number of cases where an 'unintentional return' may produce 'the same feeling of helplessness, the same sense of the uncanny', such as being lost in a wood but returning to a familiar spot, or 'groping around in the dark in an unfamiliar room' and colliding with 'the same piece of furniture'. Freud postpones discussion of 'how the uncanny element in the recurrence of the same things can be derived from infantile psychology', saying he treats it elsewhere as part of the 'compulsion to repeat' that dominates the unconscious mind' (i.e. he will return to this compulsion to return). After Freud, repetition will never be the same.

Taking off from the idea of the double in *Die Elixiere des Teufels*, he begins to consider the processes whereby 'a person may identify himself with another and so become unsure of his true self, or he may substitute the other's self for his own', processes in which 'the self may . . . be duplicated, divided and interchanged'. Alluding to Otto Rank's *The Double*, with its theory of the double as an insurance against the extinction of self, the essay goes on to give the uncanny idea of the double an eerily central place in the whole experience of modern selfhood:

In the civilization of ancient Egypt it became a spur to artists to form images of the dead in durable materials. But the ideas arose on the soil of the boundless self-love of childhood that dominates the mental life of both the child and primitive man, and when this phase is surmounted, the meaning of the 'double' changes: having once been an assurance of immortality, it becomes the uncanny harbinger of death.

'Anything that can remind us of this inner compulsion to repeat', he says, 'is perceived as uncanny.' Looking back to the anthropological speculations of *Totem and Taboo* (1912) and forward to the specu-lations about the 'compulsion to repeat' of *Beyond the Pleasure Principle* (1920), which he was working on at the same time as the essay, Freud traces the double to 'a primitive phase in our mental development', and the uncanniness it evokes to repetition of child-hood fantasies or beliefs surviving from an earlier stage of cultural development, which have been discarded or repressed. Nothing in the Freudian world is ever given up and, as the double becomes 'an object of terror, just as the gods become demons after the collapse of their cult', as Heine shows in 'Die Götter im Exil', so it is the most familiar (*heimlich*) childhood fantasies, which lie behind the apparently shockingly unfamiliar (*unheimlich*) figures, that evoke the feeling of the uncanny. Freud quotes his earlier essay 'On the Omnipotence of Thoughts', where he wrote that 'it seems that we ascribe the character of the uncanny to those impressions that tend to confirm the omnipotence of thoughts and animistic thinking in general, whereas our judgement has already turned away from such thinking'. Returning to his familiar anthropological theory that the development of modern childhood continues to recapitulate the history of the species, Freud says: 'It appears that we have all, in the course of our individual development, been through a phase corresponding to the animistic phase in the development of primitive peoples, that this phase did not pass without leaving behind in us residual traces that can still make themselves felt, and that everything we now find "uncanny" meets the criterion that it is linked with these remnants of animistic mental activity and stimulates them to express themselves.' This concerns in particular 'anything to do with death, dead bodies, revenants, spirits and ghosts', since 'in hardly any other sphere has our thinking and feeling changed so little since primitive times or the old been so well preserved, under a thin veneer, as in our relation to death'.

The subliminal shadow of post-war Vienna falls across the pages of 'The Uncanny' a number of times, and it may be that part of its power to haunt derives obliquely from the aftermath of war in which

it was written.[56] 'The times we live in' make it impossible for him to research the subject thoroughly, he tells us at the beginning. Later he says 'During the isolation of the Great War, I came across a number of the English *Strand Magazine*', providing him with an instance of a modern story that, however 'naïve', was 'extraordinarily uncanny'. The story in question was entitled 'Inexplicable' and ended with a question ('Does any explanation of it all occur to you?') that Freud was only too happy to take up.[57] It's a peace-time story of cosy English domesticity invaded by a creature from the outer reaches of Empire, chronicling the eruption of a creature from New Guinea swamps into '119, Glazebrook Terrace in the very unromantic suburb of Prisbury' where a newly married couple go to live. When he read it, however, Freud cannot fail to have registered the shadow of war that falls over the opening pages of the particular issue of the *Strand Magazine* in which it occurs. Its first story, 'Plain German', is fronted by a caricature Hun, and opens with an account of a bellicose hotel guest reading in an official German communiqué about the Somme and saying '*Gott strafe England*'. Incidentally, 'Inexplicable' makes a reference in its opening paragraph to 'the depths of my subconscious self', suggesting that the shadow of popular Freudianism is beginning to fall on English fiction. Towards the end of 'The Uncanny', Freud alludes to post-war conditions once again when he tells us that 'Placards in our big cities advertise lectures that are intended to instruct us in how to make contact with souls of the departed.' It reminds us that, although Freud's essay is not a contribution to the post-war vogue for the psychic, it is indirectly a commentary on it. For the uncanny is not only about the souls of the departed, but the departed, or departing, idea of souls, something that haunted all of Europe in these years. Looking at the factors which turn the 'frightening' into 'the uncanny', Freud notes that 'to many people the height of the uncanny is represented by anything to do with death, dead bodies, revenants, spirits and ghosts'. Instances where beliefs about the survival of the dead rise up from the dead are particularly uncanny in Freud's view, 'when we are faced with the reality of something that we have until now considered imaginary' and 'when a symbol takes on the full function

and significance of what it symbolizes'. At such moments, it is not only the dead we glimpse, but dead beliefs about the dead (what he calls 'the superannuated workings of our mental apparatus').[58] Post-war Europe was ripe for this particular version of the uncanny.

Freud's reference to those 'placards in our big cities' advertising lectures and 'the isolation of the Great War', are reminders that this essay, as much as 'Mourning and Melancholia' or 'Thoughts for the Times on War and Death' of 1915, is a response to the war and written in its immediate aftermath. The same moment threw up those great modernist masterpieces of the poetic uncanny, Yeats's 'The Second Coming' (1919), with its apocalyptic final question about a nightmarish 'return' ('What rough beast, its hour come round again, Slouches towards Bethlehem to be born?'), and Eliot's equally repetition-haunted *The Waste Land*, where post-war London is seen as the site of a hallucinatory modernity which uncannily recapitulates the archaic past of Frazerian anthropology and Dante's afterworld. *The Waste Land* and 'The Second Coming' are about a fragmented, post-war Europe, haunted by 'the blood-dimmed tide' and a sense of apocalyptic foreboding linked to religious crisis. Freud's desire to trace the uncanny back to infantile terrors and desires might seem trivial in the face of this. What have such poems to do with Yeats's or Eliot's childhoods? Yeats's poem, though, involves a travestied repetition of the heroic birth myth of Christian culture, relating its vision of 'the blood-dimmed tide' to a primal scene of Sphinx-like copulation ('moving its slow thighs'), and projecting the terror of history back to the nursery ('vexed to nightmare by a rocking cradle'). Eliot's poem too inter-cuts apocalypse and domesticity. *The Waste Land* is haunted by the post-war dead ('so many, I had not thought death had undone so many') and the Oedipal spectre of a father's death ('the king my father's death before me') while at its heart is the bisexual vision of Tiresias, a creature with a genealogy that includes both Ovid and Oedipus, and whose life is utterly devoted to uncanny repetition: 'I Tiresias have fore-suffered all/ Enacted on the same divan or bed/ I who was at Thebes below the wall and walked among the lowest of the dead.'

According to Freud, however, this uncanny sense is intimately

related to the antiquated primitive beliefs and forces that psycho-analysis identified as surviving in modern childhood and the uncon-scious. Noting that 'the pious Gretchen's intuition that Mephisto has such hidden powers is what makes him so uncanny', Freud goes on to attribute a certain Faustian uncanniness to psychoanalysis itself. 'It would not surprise me', he says, 'to hear that psychoanalysis, which seeks to uncover these secret forces, had for this reason come to seem uncanny to some people.' Starting out as a trip down a puzzling aesthetic by-way, 'The Uncanny' ends up reflecting on the eeriness of the psychoanalytic account of the world he has himself invented.

At the outset of his study, Freud noted that what he called the riddle of the uncanny, unlike hysterical symptoms, dreams or jokes, was a relatively marginal aesthetic problem. As he ingeniously winds his way into the lexicon and literature of *Das Unheimlich*, not only does psychoanalytic writing itself become uncanny, but the subject acquires increasing cultural centrality. Freud's haunted essay cer-tainly put the uncanny onto the aesthetic map in ways not even he could have predicted. 'The Uncanny' has come back to haunt subsequent commentary on literature, film, photography and art ever since. And not only commentary. From the period of Kafka's *The Trial, The Cabinet of Dr Caligari* and Max Ernst's *Une semaine de bonté*, the Freudian uncanny has also haunted art and artists. Though written under the sign of the returning past, the Freudian uncanny, as both theory and narrative, shows every sign of persisting in new forms into the foreseeable future.

Notes

1. Lionel Trilling, 'Freud and Literature', *The Liberal Imagination*, 1950.
2. Freud to Jung, 5 July 1910, *The Freud–Jung Letters: The Psychoanalytic Correspondence between Sigmund Freud and C.G. Jung*, ed. William McGuire and trans. Ralph Mannheim and R. F. C. Hull, 1974, p. 340.
3. Sigmund Freud, *The Interpretation of Dreams*, quoted in Cynthia Chase,

'Oedipal Textuality', in Maude Ellmann, *Psychoanalytic Literary Criticism*, 1994, p. 57.

4. Sigmund Freud, Penguin Freud Library 14, *Essays on Art and Literature*, trans. James Strachey, 1985, pp. 111–12.

5. *An Autobiographical Study* (1925), in Peter Gay (ed.) *The Freud Reader*, 1995, p. 40.

6. 'The Moses of Michelangelo', Sigmund Freud, *Essays on Art and Literature*, op. cit., p. 253.

7. 'The first thing to observe about Freud's writings on art', Richard Wollheim notes, 'is that some of them are only peripherally about art.' Richard Wollheim, 'Freud and the Understanding of Art', in Jerome Neu, *The Cambridge Companion to Freud*, 1991, p. 252.

8. Like the latter it plays a crucial role in Didier Anzieu's attempted reconstruction of Freud's theoretically impossible but also theoretically indispensable self-analysis, the paradoxical founding event of psychoanalysis. See Didier Anzieu, *Freud's Self-Analysis*, trans. Peter Graham, with a Preface by Masud Khan, 1986.

9. See Didier Anzieu, op. cit., p. 405.

10. Letter to Fliess, 3 October 1897, *Complete Letters of Sigmund Freud to Wilhelm Fleiss 1887–1904*, trans. and ed. Jeffrey Moussaieff Masson, 1985, p. 268.

11. Letter to Fliess, January 1899.

12. In fact Freud doesn't allude to 'daydreams' ('*Tageträume*') until the fourteenth paragraph. The key term for him is 'fantasies'.

13. A popularized version of the elaborate theory outlined in *The Interpretation of Dreams* (1900).

14. See the near contemporary essay on 'Hysterical Phantasies and their Relation to Bisexuality' (1908), where the fantasies of his neurotic patients are again related to the daydreams of adolescents and their perverse erotic nature made explicit.

15. Later critics have developed more sophisticated Freudian models for reading fiction and poetic creativity, including Peter Brooks in *Reading for the Plot*, and Harold Bloom in 'Freud and the Poetic Sublime: A Catastrophic Theory of Creativity'. In general they have taken off from other Freud texts. See Peter Brooks, *Reading for the Plot*, 1984, and Harold Bloom, *Agon: Towards a Theory of Revisionism*, 1982.

16. See Iona and Peter Opie, *The Lore and Language of Schoolchildren*, 1959.

17. Freud returns to the artist as fantasist in *Introductory Lectures* (1922): 'There is in fact a path from phantasy back again to reality – and that is art.'

The artist, he says there, 'opens to others the way back to the comfort and consolation of their own unconscious sources of pleasure, and so reaps their gratitude and admiration; then he has won – through his fantasy – what before he could only win in phantasy: honour, power, and the love of women', pp. 314–15.

18. See Freud's *Autobiographical Study* (1925) where he wrote that the layman might find that analysis throws no light on 'the two problems which probably interest him most. It can do nothing towards elucidating the nature of the artistic gift, nor can it explain the means by which the artist works – artistic technique.' In Peter Gay (ed.) *The Freud Reader*, 1995, pp. 39–40.

19. Letter to Fliess, 15 October 1897.

20. Roland Barthes, 'Introduction to the Structural Analysis of Narratives' (1966) in Susan Sontag (ed.) *Barthes: Selected Writings*, 1983, p. 295.

21. Marthe Robert, *The Origin of the Novel*, trans. Sacha Rabinovitch, 1980, p. 24.

22. Marthe Robert, op. cit., p. 31.

23. *The Freud–Jung Letters*, p. 255.

24. *The Correspondence of Sigmund Freud and Sándor Ferenczi*, 1993, p. 98.

25. Richard A. Turner, *Inventing Leonardo: The Anatomy of a Legend*, 1995, p. 100.

26. Quoted in Turner, pp. 100–31.

27. Walter Pater, *The Renaissance: Studies in Art and Poetry*, edited, with Textual and Explanatory Notes by Donald L. Hill, 1980, pp. 77–101.

28. Oscar Wilde, *Complete Works*, ed. Vivyan Holland, 1966, p. 1028.

29. See 'Contribution to a Questionnaire on Reading' (1906), in Peter Gay (ed.) *The Freud Reader*, p. 540. The footnotes to Freud's essay refer not only to established sources such as Vasari, Burckhardt and Pater but to a host of more recent researchers including Richter, Solmi, Scognamiglio, von Seidlitz, Müntz, Bottazzi and Herzfeld, who published on Leonardo between 1880 and 1910.

30. Freud, *An Autobiographical Study* (1925), in Peter Gay (ed.) *The Freud Reader*, 1995, p. 24.

31. In these ways Leonardo is an intellectual hero for Freud – as in a different way he is for his contemporary Valéry, the author of a study of Leonardo, which turns out to be a modern Discourse on Method. See Paul Valéry, *Oeuvres*, 1, 1950, pp. 1153ff.

32. One of the riddles quoted by Bramly goes: 'The time of Herod will return, for innocent children will be snatched from nursing mothers and will die of great wounds inflicted by cruel men.' The joke answer is 'baby

goats'. See Serge Bramly, *The Artist and the Man*, trans. Sian Reynolds, 1992, p. 48.

33. Kenneth Clark, *Leonardo da Vinci: An Account of his Development as an Artist*, 1939, p. 181.

34. Leo Bersani, *The Freudian Body: Psychoanalysis and Art*, 1986, p. 44.

35. *Freud–Jung Letters*, 306.

36. In Norman Kiell (ed.) *Freud without Hindsight: Reviews of his Work (1893–1939)*, 1988, pp. 372–4.

37. Louis Bredvold, *The Dial*, 1917, vol. 62, pp. 143–5; reprinted in Norman Kiell (1988).

38. Clive Bell (1925), quoted in Kiell (1988), p. 369.

39. Quoted in Kiell (1988), p. 368. Likewise, *Moses and Monotheism* (1939) was originally to have been entitled *The Man Moses: A Historical Novel*. See Peter L. Rudnytsky, 'Freud's Pompeian Fantasy' in Sander L. Gilman, Jutta Birmele, Jay Geller and Valerie D. Greenberg (eds) *Reading Freud Reading*, 1994, p. 213.

40. Hélène Cixous, 'La fiction et ses fantômes', *Poétique* III (1972), p. 199, translated as 'Fiction and its Phantoms: A Reading of Freud's *Das Unheimliche*', *New Literary History* (spring 1976).

41. Otto Jentsch, 'Zur Psychologie des Unheimlichen', *Psychiatrisch-Neurologische Wochenschrift* 8 (1906) vols. 22–23. See Otto Jentsch, 'On the Psychology of the Uncanny', translated by Roy Sellars, *Angelaki: A Journal of the Theoretical Humanities* 2(1)(1996). Hoffmann is the only author mentioned by name in Jentsch's article, which is largely pre-occupied by non-literary versions of the uncanny. Jentsch only devotes one sentence to Hoffmann, which Freud quotes.

42. Freud, Letter of May or April 1919. Cited in Hertz, *The End of the Line: Essays on Psychoanalysis and the Sublime*, 1985, p. 98.

43. See Jacques Derrida, *Dissemination*, trans. Barbara Johnson, 1981.

44. Harold Bloom, 'Freud and the Poetic Sublime: A Catastrophic Theory of Creativity', in *Agon: Towards a Theory of Revisionism*, 1982, reproduced in Maud Ellmann (ed.) *Psychoanalytic Literary Criticism*, 1994.

45. See Terry Castle, *The Female Thermometer: Eighteenth-Century Culture and the Invention of the Uncanny*, 1988; Paul Edmundson, *Nightmare on Main Street: Angels, Sadomasochism and the Culture of the Gothic*, 1997.

46. See Neil Hertz, 'Freud and the Sandman', in *The End of the Line: Essays on Psychoanalysis and the Sublime*, 1985; and Samuel Weber, 'The Sideshow' in *The Legend of Freud*, expanded edn, 2000.

47. Samuel Weber, *The Legend of Freud*, 2000, p. 211.

48. There's no trace in any of these of the dialectical relationship between *heimlich* and *unheimlich*, or even of the 'uncanny' in our modern sense. The early uses are Scottish, and the *OED*'s first four senses relate to the Scottish dialect term 'canny', with 'uncanny' meaning 'mischievous', 'careless', 'unreliable' and 'not quite safe to trust to'. It is the *OED*'s fifth sense that Freud is concerned with: 'partaking of a supernatural character; mysterious, weird, uncomfortably strange or unfamiliar (common from circa 1850)'. *OED* quotes Bulwer Lytton ('If men, gentlemen born, will read uncanny books . . . why they must resolve to reap what they sow') and Emerson, who describes visiting England's most famous prehistoric survivals at Stonehenge ('We walked in and out, and took again and again, a fresh look at the uncanny stones'). I have found no examples of 'uncanny' in this sense prior to the nineteenth century. It gains its spectral aesthetic currency after 1850, during the period in which the modern ghost story developed. Like the ghost story, born in the era of Poe, Henry James, M. R. James and Vernon Lee, the feeling of the uncanny seems to be an experience that postdates belief in the supernatural.

In fact most of the early literary examples are Scots, from Sir Walter Scott ('Now this wad be an uncanny night to meet him in'), Galt '(Hogmanae, for it was thought uncanny to have a dead corpse') and Hogg ('maist part of foils countit uncanny, had gane awa'). Thereafter it flickers through the developing literature of the uncanny itself. After figuring in Hogg's *The Private Memoirs and Confessions of a Justified Sinner*, surely one of the most uncanny works in modern literature, it crops up in Charlotte Brontë's *Jane Eyre* when Jane, while learning German, feels herself transfixed by the blue eye of St John Rivers ('so keen was it and yet so cold, I felt for the moment superstitious – as if I were sitting in the room with something uncanny'). It then recurs in landmark late nineteenth-century Gothic texts such as Le Fanu's *Uncle Silas* ('eyeing those thievish and uncanny neighbours'), R. L. Stevenson's *Kidnapped* ('a picture of that uncanny instrument came into my head'), Rider Haggard's *She* ('the whole scene was an uncanny one'), Bram Stoker's *Dracula* ('all so strange and uncanny that a dreadful fear came') and Henry James's primal modern ghost story, *The Turn of the Screw*, where the narrator speaks of the story as being marked by 'general uncanny ugliness and horror and pain'. It also figures in the archetypal fable of colonial Gothic, Conrad's *The Heart of Darkness*, where the narrator Marlow finds in an old woman knitting in Belgium an eerie pre-figurement at home of the *unheimlich* darkness at the heart of European imperialism in Africa ('She seemed uncanny and fateful').

49. See Phillip McCaffrey, 'Freud's Uncanny Women', in Sander L. Gilman,

Jutta Birmele, Jay Geller and Valerie D. Greenberg (eds) *Reading Freud's Reading*, 1994.

50. E. F. Bleiler (ed.) *The Best Tales of Hoffmann*, edited and with an introduction by E. F. Bleiler, 1967, pp. 183–214. The translation is by J. T. Bealby.

51. See Tristan Todorov, *The Fantastic: A Structural Approach to a Literary Genre*, trans. Richard Howard, 1973.

52. Indeed he sees Nathaniel's story as a case history strangely similar to Jensen's story of a neurotic traveller, who, in the midst of a love-affair in the present, finds himself caught up in a hallucinatory repetition of infantile experiences. This led Lis Muller to ask: is it mere coincidence that Freud's chief literary example of the uncanny could be characterized by the uncanny return of *Gradiva*?'

53. Freud offers some dazzling readings of the play of names in the tale, and curiously Nathaniel has a fierce dialogue with a sceptical friend called Siegmund, whose eye is resistant to the 'divine charms' of Olimpia.

54. Quoted in Peter Gay, *Freud: A Life for Our Time*, 1988, p. 380.

55. See Arthur Schnitzler, *Selected Short Stories*, trans J. M. Q. Davies, 1998, p. 122, for this.

56. In 1919, he wrote: 'Now we are really eating ourselves up. All four years of war were a joke compared to the bitter gravity of these months.' 'We are passing through bad times', he told his nephew the same year, 'as you know by the papers, privations and uncertainty all around.' Peter Gay, *Freud: A Life for Our Times*, vividly documents the Freud family's deprivations and anxieties in post-war Vienna (1988, pp. 361ff).

57. L. G. Moberly, 'Inexplicable', *Strand Magazine*, 54, December 1917, p. 572.

58. He quotes an earlier paper on 'The Omnipotence of Thoughts' to the effect that: 'It seems that we ascribe the character of the uncanny to those impressions that tend to confirm the omnipotence of thoughts and animistic thinking in general, where our judgement has already turned away from such thinking.'

Translator's Preface

Freud's study of Leonardo da Vinci proceeds from the belief that art and literature can not only reveal the unconscious workings of a great mind – which may not differ much from those of a normal mind, or even of a sick mind (a notion that some find offensive) – but can themselves be illuminated by the insights of psychoanalysis.

The starting point of this study, presented after a survey of the information contained in Vasari's *Vite* and other sources, is the artist's own account, inserted into his notes on the flight of birds, of what he took to be a very early childhood memory, but Freud interpreted as a later fantasy, which was then transmuted into a memory, not unlike the 'screen memories' (*Deckerinnerungen*) discussed in an earlier paper. In this memory (or fantasy) Leonardo was visited in his cradle by a large bird, a kite (*nibio*, modern Italian *nibbio*), which opened his mouth with its tail and struck his lips many times on the inside. Freud rendered the Italian bird-name incorrectly by the German word *Geier* ('vulture'), which he may have taken over from Marie Herzfeld's translation and the German version of Merezhkovsky's novel about Leonardo, the original text of which gives the bird its correct Russian name. The error may have arisen because one of the German names for the kite is *Hühnergeier* ('chicken vulture'), although its commonest designation is *Milan*, a word borrowed from French. We should have been much the poorer if Freud had consulted an Italian–German dictionary instead of relying on fallible translators, for he would then have had no occasion to explore the role of the vulture in ancient Egyptian mythology and to trace the route by which knowledge of this could have reached Leonardo through the writings of the Church Fathers. He could

still of course have discussed the bearing of Leonardo's 'memory' on his illegitimate birth, his relationship with his mother, his supposed sexual precocity and subsequent sexual orientation, as well as the sublimation of much of his libido into a craving for scientific knowledge.

Apart from his reliance on translations, which is at odds with his immense erudition, Freud can be faulted on another count. Discussing the Egyptian mother goddess Mut, he surmises that her name may be related to the German word for 'mother' (*Mutter*). Had he questioned a comparative linguist, he would have learnt that phonetic similarity between words in different languages is no proof of relationship unless the languages in question have a common ancestor (which German and ancient Egyptian almost certainly do not), or unless there has been lexical borrowing, perhaps at several removes. Given the amount of cultural cross-fertilization that has always gone on in the eastern Mediterranean, such borrowing is at least conceivable, but not very probable.

The Leonardo study contains many ideas that may be unfamiliar to the general reader, even after nearly a century, but on the whole they are presented with Freud's usual clarity and without resort to obscure technical terms derived from Greek or Latin. An exception is the term 'perseveration', which the author uses, but also explains, in section V. More problematic are those technical terms in which common German words are used in special senses or contexts and customarily rendered in English by hellenisms or pseudo-hellenisms, with which no general reader is likely to be conversant. One such is the German word *Besetzung* (the action noun from *besetzen*, 'to occupy'). In the note with which she prefaces her admirable translation of *The Interpretation of Dreams* (Oxford 1999) Joyce Crick speaks of the 'famously ordinary "Besetzung" ("occupation", "investment", "charge", with their latent military or electrical metaphors)' and opts for 'charge'. Following her example, I have translated Freud's phrase '*trotz aller Affektbesetzung*' (in his essay on 'The Creative Writer and Daydreaming') as 'for all the emotion it is charged with' (where 'it' refers to the child's world of play); I. F. Grant Duff had previously rendered this as 'in spite of all the emotion

with which he cathects his world of play'. 'Cathect' is a do-it-yourself back-formation from the abstract noun 'cathexis', which actually exists in Greek (καθεξις) and means 'holding, retention'; this is an abstract noun derived from the verb κατέχειν, one of whose senses is 'to occupy'. In the *Oxford English Dictionary* (2nd edn, 1989, II, 985 and 987) 'cathect' is defined as 'to charge with mental energy; to give (ideas, etc.) an emotional loading', and 'cathexis' as 'the concentration or accumulation of mental energy in a particular channel'. Few readers are likely to have come across either word before.

The main problem facing the translator of the essay on *Das Unheimliche* arises from the order in which Freud presents his findings. He tells us that the study arose from a collection of individual cases and that the conclusions to which these pointed were corroborated by linguistic usage, yet he goes on to say that he will now work in the reverse order. Accordingly, after briefly adumbrating his conclusions, he sets out the corroborative evidence; this is followed by psychological interpretations of two fictional works by E. T. A. Hoffmann. Only then are we given scattered evidence from the case histories that prompted the study. This curious procedure is justified by the fact that the essay was written in German and that the German reader would be able to follow the argument, for German usage does indeed appear to support the author's conclusions, while English usage does not. Had he been writing for an English public he would have done well to present the psychological and literary evidence first, and then show how it appeared to point in the same direction as German linguistic usage. However, the translator cannot *rewrite* the piece; he has to confine himself to making it comprehensible to English readers.

Although the word *uncanny* was once the antonym of *canny*, a word of Scottish and northern English provenance, it no longer is. Moreover, no English pair is semantically comparable with the German pair *heimlich/unheimlich*, which is so important for Freud's linguistic argument: English *'homely/unhomely'* (which I have inserted tiresomely often in square brackets) are etymologically and morphologically comparable with the German words, but not

semantically equivalent. In the Leonardo study it was possible to find fault with Freud's handling of the linguistic evidence, but no such criticism can be entertained with regard to this piece, published nine years later, in which he provides a masterly analysis of the linguistic data and their relevance to the psychological findings.

Freud's linguistic argument relies mainly on a long excerpt from Daniel Sanders's fine German dictionary of 1860; this is reproduced *in extenso* and supplemented by data from the German dictionary of the Brothers Grimm. It seems to me imperative that the English reader should have access to all the evidence that Freud makes available to the German reader. Yet in the Standard Edition the sources of the quotations are withheld; English translations are offered, but the key words (*heimlich* etc.) are left untranslated. In order to reproduce the linguistic evidence in full, as Freud intended, I repeat all the German quotations, with their sources; each is followed by a full English translation (which is admittedly at times somewhat gauche), including renderings of the key words. In the case of passages from the Bible, where Freud simply gives the biblical reference and does not quote the text, I give the wording of the Luther Bible (with an English translation) and that of the Authorized Version; in one case, where it seems appropriate, I also cite the New English Bible and the Vulgate. Freud includes two references to biblical passages (I Chronicles 12, 25; Wisdom 8, 4) in which the word *heimlich* is missing. Can this be an error on the part of the author?

It may be helpful to comment briefly on some of the titles in this volume. Translated literally, 'Der Familienroman der Neurotiker' would be 'The Family Novel of Neurotics', but the accepted English title is 'Family Romances'. The full title recurs in the third paragraph, though with the first noun now in the plural. In a modern literary context the German word *Roman* denotes a novel, a long work of fiction written in prose; in a medieval context it denotes a romance, a long work of fiction written in verse, and usually based on a French source. In the present piece it sometimes alternates with *Phantasie* ('fantasy', 'imagination'). The essential feature of a novel or a romance is that it is a fictional construct that does not directly reflect

reality. When the child imagines – and perhaps convinces himself – that his mother has had a number of liaisons or love affairs, we say that he is 'romancing'. We might call such liaisons 'romances'; a corresponding German word would be *Romanzen*, but Freud does not use it.

'Der Dichter und das Phantasieren' is customarily translated as 'Creative Writers and Daydreaming', though in the German title the first noun is in the singular. The common translation of *Dichter* is 'poet', and I. F. Grant Duff used this word in his version of 1925. Yet whereas an English poet usually writes in verse, a German writer may be called a *Dichter* even if his sole medium is prose. The usual German word for a writer is *Schriftsteller*; a *Dichter* is a superior kind of writer, here called a 'creative writer'. In the body of the translation the word 'creative' is often redundant and therefore omitted.

Screen Memories

In connection with my psychoanalytic treatment (of hysteria, obsessional neurosis, etc.) I have often had to deal with fragments of memories that have stayed with individual patients from their earliest childhood years. As I have indicated elsewhere, we must insist on the great pathogenic importance of impressions from this period of our lives. However, psychological interest in the subject of childhood memories is assured in all cases, because here it becomes strikingly evident that the psychical behaviour of children differs fundamentally from that of adults. No one doubts that our earliest childhood experiences have left indelible traces on our inner selves; but when we question our *memory* as to what impressions are destined to influence us till the end of our lives, it comes up with either nothing at all or a relatively small number of isolated recollections, often of questionable or perplexing significance. Not before our sixth or seventh year – and in many cases not until after our tenth – are our lives reproduced by the memory as a coherent chain of events. From then on, however, a constant relation is established between the psychical significance of an experience and its persistence in the memory. What seems important, by virtue of its immediate or almost immediate effects, is remembered; what is deemed of no consequence is forgotten. If I can remember an event over a long period, this very fact proves to me that it made a profound impression on me at the time. I am usually surprised if I have forgotten something *important*, and perhaps even more so if I have remembered something of apparently no consequence.

Only in certain pathological mental states does the relation that obtains in normal adults between the psychical importance of an

impression and its retention in the memory once more cease to apply. A hysteric, for instance, will regularly suffer loss of memory with regard to all or some of the experiences that led to the onset of his sufferings, and that have nevertheless become important to him owing to this causal link, or that may be important to him, irrespective of this link, by virtue of their content. I should like to take the analogy between such pathological amnesia and the normal amnesia relating to our earliest years as a valuable pointer to the close connections between the psychical content of neurosis and the lives we led as children.

Being so used to the absence of childhood memories, we usually misunderstand the problem it conceals and are inclined to explain it as a self-evident consequence of the rudimentary way in which the infantile mind functions. Yet the truth is that any child who has developed normally already exhibits, at the age of three to four, a great many highly complex mental acquirements – an ability to make comparisons, to draw conclusions, to express his feelings – and there is no obvious reason why these mental performances, which are no less valuable than those that come later, should be subject to amnesia.

Before we start work on the psychological problems that attach to our earliest childhood memories, it is of course essential to collect material, to find out, by means of a survey, what kinds of memories a fairly large number of normal adults can report from this period of their lives. A first step in this direction was taken by V. and C. Henri in 1895, when they drew up and distributed a questionnaire, then published their highly interesting results – they had 123 respondents – in *L'Année Psychologique* III (1897) under the title 'Enquête sur les premiers souvenirs de l'enfance'. At present, however, I do not intend to treat the subject in its entirety, and shall concentrate on the few points from which I can go on to introduce the notion of what I call 'screen memories'.[1]

The time of life to which the content of our earliest childhood memories is allocated is usually the period between the ages of two and four. (This is true of 88 of the Henris' respondents.) But there are a few individuals whose memories go back further, even to the

period before their first birthday. On the other hand there are some whose earliest recollections date only from their sixth, seventh or even eighth year. It is not possible at present to say what else is linked with these individual differences; but according to the Henris it is to be noted that a person whose earliest recollection belongs to a very tender age – to the first year of his life, let us say – also has further isolated memories from subsequent years, and that he begins to reproduce his experiences as a continuous chain of memory earlier than others, say from his fifth year. In individual cases, then, it is not only the appearance of the first recollection that is precocious or retarded, but the whole functioning of the memory.

Particular interest will attach to the question of what constitutes the normal content of these earliest childhood memories. A knowledge of adult psychology would lead us to expect that, from the material of our experience, certain impressions would be selected as worth remembering – namely, those which produced a powerful affective impact or were soon seen to be significant by virtue of their consequences. Indeed, some of the experiences collected by the Henris seem to confirm this expectation, for, as the most frequent content of the earliest childhood memories, they list on the one hand things that gave rise to fear, embarrassment, physical pain and so on, and, on the other, important events such as illnesses, deaths, fires, births of siblings, etc. One would therefore be inclined to assume that the principle of selection was the same for the child as it is for the adult. It should be expressly stated, of course – though it is fairly obvious – that our memories of childhood are bound to testify to the impressions that preoccupied the child, rather than the adult. It is therefore easy to explain why one respondent reports that, from the age of two, she remembers various accidents that befell her dolls, but has no recollection of the sad and serious events that she may have observed at the time.

Now, it is grossly at odds with this expectation, and bound to cause justifiable surprise, when we hear that the content of some people's earliest memories consists of everyday impressions that are of no consequence and could not have affected the child emotionally, but were nevertheless noted in copious detail – with excessive

exactitude, one might say – whereas other, roughly contemporaneous, events are not remembered, even though the parents testify that the child was profoundly affected by them at the time. For instance, the Henris recount the story of a professor of philology, whose earliest memory, assigned to the age of three or four, was of a table set for a meal and with a bowl of ice on it. During that period the child's grandmother had died, and according to his parents her death had had a shattering effect on him. Yet the professor of philology, as he now is, knows nothing of this death; all he can recall from that period is a bowl of ice.

Another respondent reports, as his earliest childhood memory, an episode that took place during a walk, when he broke off a branch from a tree. He thinks he can still identify the spot where this happened. Several other people were present, and one of them helped him.

The Henris describe such cases as rare, but in my experience – admittedly mainly with neurotics – they are common enough. One of the Henris' respondents ventured to explain these memory images, whose banality makes them so hard to understand, and I have to say that I find his explanation entirely apposite. He thinks that in such cases the scene in question is retained in the memory in an incomplete form; this is why it seems meaningless. The parts of the impression that have been forgotten probably contained everything that made it memorable. I can confirm that this is really so, but rather than speak of elements of the experience having been 'forgotten', I would say that they had been 'omitted'. By means of psychoanalysis I have often been able to unearth the missing fragments of an infantile experience and so prove that the original impression, of which only the torso has remained in the memory, actually accorded, when restored, with the presumption that the memory holds on to what is most important. Admittedly this does not explain the curious selection it makes from the component parts of an experience. We must first ask ourselves why it suppresses what is significant, but retains what is of no consequence. It is only when we penetrate more deeply into the mechanism of such processes that we arrive at an explanation. We then conceive the idea that two psychical forces

are involved in producing these memories. One of them takes the importance of the experience as a motive for wanting it remembered, but the other – the force of resistance – opposes this preferential choice. The two contending forces do not cancel each other out, nor does the one motive overpower the other, with or without loss to itself. Instead, a compromise is reached, rather like the resultant in a parallelogram of forces. The upshot of this compromise is that it is not the experience itself that supplies the memory image – in this respect the resistance carries the day – but another psychical element, which is closely associated with the one that proved objectionable. Here again we see the power of the former principle, which seeks to establish important impressions by creating reproducible memory images. Hence, the result of the conflict is that, instead of the memory image that was justified by the original experience, we are presented with another, which is to some extent associatively *displaced* from it. Since it was the *significant* components of the impression that made it objectionable, these must be absent from the memory that replaces it, and so it may well seem banal. We find it unintelligible because we would like to see the reason for its retention in its intrinsic content, when in fact it resides in the relation between this content and another, which has been suppressed. Echoing a popular phrase, one might say that, if a certain childhood experience asserts itself in the memory, this is not because it is golden, but because it has lain beside gold.

Among the many possible cases in which one psychical content is replaced by another (all of which are realized in various psychological constellations) the one we have been considering in connection with childhood memories – in which the inessential components of an experience stand in for the essential – is obviously one of the simplest. It is a case of displacement along the plane of association by contiguity, or, if one views the process as a whole, a case of repression, accompanied by the replacement of what is repressed by something in its (spatial or temporal) vicinity. I once had occasion to report a very similar case of substitution that occurred in the analysis of a patient suffering from paranoia.[2] This was a woman who heard voices repeating to her long passages from Otto Ludwig's

Heiterethei, the most trivial and irrelevant passages in the work. Analysis revealed that other passages in the story had actually aroused the most distressing thoughts in the patient. The distress they caused was a motive for putting up a defence, but there was no way of suppressing the motives for pursuing them, and so a compromise was reached in which the innocuous passages emerged in the patient's memory with pathological force and distinctness. The process that is recognized here – *conflict, repression, substitution involving a compromise* – recurs wherever there are psychoneurotic symptoms and supplies the key to our understanding of how they arise. It is not without significance, then, that it can be shown to operate in the mental life of normal individuals too. The fact that in normal people it influences the selection of childhood memories seems to be yet another pointer to the intimate links, already emphasized, between the mental life of the child and the psychical material of neuroses.

The normal and the pathological defence processes, together with the displacements they lead to, are clearly of great importance, but as far as I know they have not been studied at all by psychologists, and it remains to be ascertained in what strata of mental activity they assert themselves, and under what conditions. This neglect may well be due to the fact that our mental life, in so far as it becomes an object of *conscious* internal perception, reveals nothing of these processes, except in those cases that we classify as 'faulty reasoning' or in some mental operations designed to produce a comic effect. When it is claimed that a psychical intensity can be shifted from one idea (which is then abandoned and remains so) to another (which now takes over the psychological role of the former), we find this bewildering, rather like certain features of Greek myth – as, for instance, when the gods clothe a human being with beauty, as with a veil, while the only transfiguration we know of is brought about by a change of facial expression.

Further investigation of these banal childhood memories has taught me that they can arise in other ways too, and that an unsuspected wealth of meaning usually lies hidden behind their apparent harmlessness. But on this point I shall not confine myself to a mere statement of opinion, but give a detailed account of a particular

instance, which seems to me the most instructive among a fairly large number of similar cases, and will undoubtedly be all the more appreciated because it relates to an individual who is not neurotic, or only very slightly so.

This is a man of thirty-eight, with a university education, who has maintained an interest in psychological questions – though they are remote from his professional concerns – ever since I was able to relieve him of a minor phobia by means of psychoanalysis. Last year he drew my attention to his childhood memories, which had already played some part in his analysis. Having become acquainted with the investigation conducted by V. and C. Henri, he gave me the following summary account of his own experience.

'I can draw upon a fair number of childhood memories, which I can date with great certainty. For at the age of three I left the small town where I was born and moved to a large town. Now, all my memories are set in the place where I was born, so they fall in the second or third year of my life. They are mostly short scenes, but they are very well preserved and incorporate every detail of sense perception, by contrast with the memory images from my mature years, which are devoid of any visual element. From my third year onwards the memories become scantier and less distinct, and there are gaps that must cover more than a year. I think it's only from my sixth or seventh year that the stream of memory becomes continuous. I would further divide the memories from the period up to my leaving my first place of residence into three groups. The first comprises those scenes that my parents repeatedly told me about later; where these are concerned, I'm not sure whether I had the memory image from the start, or only created it after hearing one of these accounts. However, I note that there were some occurrences that have no corresponding memory images, even though my parents described them to me more than once. I attach more importance to the second group; this is made up of scenes that – as far as I know – I was not told about, and some that I *couldn't* have been told about, because I haven't seen the participants since – my nursemaid and my playmates. I'll come to the third group later. As far as the content of these scenes – and hence their claim to be retained in the memory

– is concerned, I would say that here I'm not wholly at a loss. Admittedly I can't say that the memories I've retained correspond to the most important events of my life at that time, or what I should now regard as the most important. I know nothing of the birth of a sister, who is two-and-a-half years younger than I am; our leaving home, my first sight of the railway, and the long carriage drive that preceded it have left no trace in my memory. On the other hand, I remember two small incidents during the train journey; as you will recall, these came up in the analysis of my phobia. What ought to have made the biggest impression on me was an injury to my face, which caused me to lose a lot of blood and was stitched up by the surgeon. I can still feel the scar, which testifies to the accident, but I have no recollection that would directly or indirectly point to this experience. Incidentally I was probably not yet two at the time.

'So I'm not surprised by the pictures and scenes from the first two groups. They are of course displaced memories, in which the essential element is mostly missing; but in some of them it is at least hinted at, and in others I can easily fill in the gaps by following certain pointers. If I proceed in this way, a sound connection can be established between the separate fragments of memory, and I can see clearly what childish interest recommended these particular events to my memory. But it's different with the content of the third group, which I've refrained from discussing so far. Here I'm faced with material – a longish scene and several small pictures – that I can really make nothing of. The scene seems to me fairly inconsequential, and I can't understand why it should have become fixed in my memory. Let me describe it to you. I see a square, rather steeply sloping meadow, very green and lush; among the greenery are lots of yellow flowers, clearly common dandelions. At the top end of the meadow is a farmhouse; standing outside the door are two women, engaged in earnest conversation – the farmer's wife, wearing a head-scarf, and a nursemaid. In the meadow three children are playing; one of them is myself, aged between two and three; the others are a male cousin, a year older than myself, and a female cousin, his sister, who is exactly my age. We are picking the yellow flowers, and each of us has a number of them. The little girl

has the nicest bunch, but we two boys, as if by prior agreement, fall upon her and snatch her flowers from her. She runs up the meadow in tears, and the farmer's wife consoles her by giving her a big slice of black bread. No sooner have we seen this than we throw the flowers away, run up to the house, and also ask for bread. And we are given some. The farmer's wife cuts the loaf with a long knife. I remember that this bread tasted absolutely delicious. At this point the scene breaks off.

'What is there about this experience to justify the expenditure of memory that it put me to? I've racked my brains over this, but to no avail. Does the accent lie on our unkindness to the little girl? Am I supposed to have been so greatly attracted then by the yellow of the dandelion, a flower that I naturally don't find the least bit attractive today? Or did the bread taste so much better than usual, after all the romping around in the meadow, that it made an indelible impression on me? I can't find anything to connect this scene with the fairly obvious interest that forms the link between the other child-hood scenes. Altogether I have the impression that there's something not quite right about this scene: the yellow of the flowers is far too prominent in the overall picture, and the delicious taste of the bread seems exaggerated, as though it were part of a hallucination. I can't help being reminded of some pictures I once saw in a parodistic exhibition. Certain parts of them were not painted, but applied in relief – naturally the most improper ones, such as the bustles of the painted ladies. Now, can you show me the way to an explanation or an interpretation of this pointless childhood memory?'

I thought it advisable to ask how long he had been exercised by this childhood memory. Did he think it had recurred periodically since childhood, or had it emerged at a later date, prompted by some occasion that he could recall? This question was all I needed to contribute to the solution of the problem: my interlocutor, who was no novice in the field, discovered the rest by himself.

He replied: 'That's something I've never thought about. But now that you ask, I'm almost certain that this memory didn't occupy me at all in my younger years. And I can also recall the occasion that aroused it, along with many other memories of my earliest years. As

a schoolboy of seventeen, I went back to my home town for the first time and spent the holidays with a family who had been friends of ours since the early days. I can well remember what a multitude of emotions took hold of me at the time. But I see that I shall now have to tell you a good deal of my life history. It belongs here, and your question has conjured it up. So listen! My parents were originally well-to-do, and I think they lived a comfortable enough life in that little provincial backwater. But when I was about three, disaster struck the branch of industry that my father was concerned with. He lost his fortune, and we were forced to move to a big city. There then followed long years of hardship; I don't think there was anything about them worth remembering. I never felt really at ease in the town. I don't think I ever ceased to long for the glorious woods of my childhood, in which I would escape from my father when I could barely walk; this is confirmed by a memory I still have from that period. This holiday, when I was seventeen, was the first I'd spent in the country, and, as I said, I was staying with friends who had come up in the world since we moved away. I was able to compare the comfort that prevailed there with the life we led in the city. But it's probably no good avoiding the subject any longer: I have to admit that there was something else that greatly excited me. I was seventeen, and in the family I was staying with was a fifteen-year-old daughter, whom I at once fell in love with. It was my first infatuation, and very intense, but I kept it absolutely secret. After a few days the girl went back to her school, which she too had left for the holidays, and our parting, after such a short acquaintance, really brought my longing to a high pitch. I spent hours going for solitary walks in the lovely woods I had rediscovered, and building castles in the air – but these, curiously, were not directed to the future, but sought to improve the past. If only the crash hadn't occurred! If only I'd stayed in my home town, grown up in the country, and become as strong as the young men of the house, the brothers of the girl I loved! I could then have taken up my father's profession and finally married the girl, whom I'd have been bound to get to know intimately over all these years! I naturally didn't doubt for a moment that, in the circumstances created by my imagination, I should have loved her

just as ardently as I actually felt I did then. The strange thing is that when I see her occasionally – she happens to have married someone near here – I'm extraordinarily indifferent to her, yet I well remember how long I went on being affected by the yellow colour of the dress she was wearing at our first meeting, whenever I saw the same colour again somewhere.'

That sounds rather like your passing remark that you now no longer like the common dandelion. Don't you suspect a connection between the yellow of the girl's dress and the excessively bright yellow of the flowers in your childhood scene?

'Possibly, but it wasn't the same yellow. The dress was more of a yellowish brown, like the colour of wallflowers. But I can at least supply you with an intermediate idea that would serve your purpose. Later, in the Alps, I saw that some flowers that have light colours in the plain take on darker shades on the high ground. Unless I'm much mistaken, there's a flower one often sees in the mountains that's very much like a dandelion, but it has a dark yellow colour, exactly like the dress worn by the girl I was in love with. But I haven't finished. I now come to a second occasion, from about the same period of my life, that stirred up impressions of my childhood. At seventeen I had revisited my home town. Three years later, again during the holidays, I went to stay with my uncle, and so I saw my first playmates again – my male cousin, who was a year older than myself, and my female cousin, who was my age – both of whom figure in the childhood scene in the field with the dandelions. This family had left my home town at the same time as we had, and had once more become prosperous in the distant city.'

And did you fall in love again, this time with your cousin, and weave fresh fantasies?

'No, this time it turned out differently. I was already at the university, and wedded to my books. I had no time for my cousin. As far as I know, I invented no fantasies of that kind. But I think my father and my uncle, between them, had a plan for me: that I should switch from the abstruse subject I was studying to one that was of more practical use, and that, on completing my studies, I should settle in the town where my uncle lived and marry my cousin. When

13

they realized how much I was absorbed in my own plans, they probably dropped theirs, but I'm sure my guess was right. It was only later, as a young scholar – when the hardships of life closed in on me and I had to wait so long for a post in the city – that I may sometimes have reflected that my father had meant well when he wanted to see me compensated, by this marriage project, for the loss that the earlier catastrophe had brought upon my life.'

So I would place the origin of the childhood scene we are discussing in this period of your life, when you were struggling for your daily bread – that is, if you can confirm that it was during these years that you made your first acquaintance with the Alps.

'That's right. Climbing holidays were the only pleasure I allowed myself in those days. But I still don't quite understand you.'

I'll come to the point right away. As the most intense element in your childhood scene you single out the delicious taste of the country bread. Don't you see that this imagined experience, which you feel to be almost hallucinatory, corresponds with the idea contained in your fantasy: about how comfortable your life would have turned out to be if you'd stayed in your home town and married that girl – or, to put it metaphorically, how tasty you would have found the bread that you later had to struggle hard for? And the yellow of the flowers points to the same girl. Besides, the childhood scene contains elements that can only relate to the second fantasy – that of being married to your cousin. Throwing away the flowers for a piece of bread seems to me not a bad disguise for the plan your father had for you. You were to renounce your unpractical ideals in favour of 'bread-and-butter' studies, weren't you?

'So it seems that I fused the two sets of fantasies about how my life might have been more comfortable; I took the "yellow" and the "country" bread from the one, and the discarding of the flowers and the actual people concerned from the other?'

Yes. You projected the two fantasies on to one another and turned them into a childhood memory. So the feature of the Alpine flowers is, so to speak, the date-mark for its construction. I can assure you that such things are very often constructed unconsciously – almost like works of fiction.

'But then it wouldn't be a childhood memory at all, but a fantasy that I've transposed into my childhood. But I have a feeling that the scene is genuine. How can that be reconciled with what you say?'

There's no guarantee whatever for what our memory tells us. But I'll gladly concede that the scene is genuine; if so, you singled it out from countless others of a similar or differing kind, because it was suited, by virtue of its essentially indifferent content, to the representation of the two fantasies, which were significant enough to you. Such a memory, whose value consists in the fact that it represents thoughts and impressions from a later period and that its content is connected with these by links of a symbolic or similar nature, is what I would call a *screen memory*. In any case you will cease to be be surprised by the frequent recurrence of this scene in your memory. It can no longer be called a harmless one if, as we have discovered, it is intended to illustrate the most important turning-points in the history of your life, the influence of the two most powerful motive forces – hunger and love.

'Yes, it represented hunger well enough – but love?'

In the yellow of the flowers, I think. But I can't deny that the representation of love in this childhood scene of yours lags far behind what I should have expected from my previous experiences.

'No, it doesn't at all. The representation of love is the main thing about it. At last I understand! Just think: to take away a girl's flower – that means to deflower her. What a contrast between the impudence of this fantasy and my shyness on the first occasion and my indifference on the second!'

I can assure you that such bold fantasies form the regular complement to juvenile shyness.

'But then the fantasy that's transformed itself into these childhood memories wouldn't be a conscious one that I can remember, would it, but an unconscious one?

Unconscious thoughts that continue the conscious ones. You think to yourself, 'If I'd married this girl or that girl,' and behind the thought there arises an urge to picture what being married would have been like.

'I can go on from there myself. For the young good-for-nothing

the most enticing thing about this whole topic is the idea of the wedding night. What does he care about what comes afterwards? But this idea doesn't venture into the open; the prevailing mood of modesty and respect for girls keeps it suppressed. So it remains unconscious . . .'

And *escapes* into a childhood memory. You're right: the coarsely sensual element in the fantasy is the reason why it doesn't develop into a conscious fantasy, but has to be satisfied with being taken up into a childhood scene, as an allusion dressed up in a *flowery* disguise.

'But why into a childhood scene, I wonder?'

Perhaps because of the innocence of childhood. Can you imagine any greater contrast to such wicked, aggressive sexual designs than the pranks played by children? In any case there are more general reasons that determine why repressed thoughts and desires should escape into childhood memories, for you can quite regularly point to the same reaction in persons suffering from hysteria. It also seems that the recollection of things long past is in itself facilitated by some pleasurable motive: '*Forsan et haec olim meminisse juvabit.*'[3] ['Perhaps even this will one day be pleasant to recall.']

'If that is so, I've lost any faith I had in the genuineness of the scene with the dandelions. I see it like this: on the two occasions I've mentioned, and supported by very real, palpable motives, the idea has occurred to me: "If you had married this or that girl your life would have become much pleasanter." Now, the sensual current in me repeats the thought contained in the conditional clause in images that can offer satisfaction to this sensual current. This second version of the same thought remains unconscious owing to its incompatibility with the prevailing sexual disposition, but for this very reason it is able to live on in my mental life when the conscious version has long since been removed by changes in the real situation. In accordance with a general law, you say, the clause that has remained unconscious seeks to transform itself into a childhood scene, which is allowed to become conscious because of its innocence. To this end it has to undergo a fresh transformation, or rather two: one of them removes the objectionable element from the

protasis by expressing it in ideal terms, while the second presses the apodosis into a form that is capable of visual representation, using for this purpose the intermediate notions of "bread" and "bread-and-butter studies". I realize that by producing a fantasy like this I have, as it were, achieved a fulfilment of the two suppressed desires – to deflower the girl and to secure material comfort. But now that I can fully account to myself for the motives that led to the emergence of the dandelion fantasy, I have to assume that I'm dealing here with something that never happened at all, but has been illegitimately smuggled in among my childhood memories.'

Now I have to act as counsel for the defence and vindicate its genuineness. You're going too far. You've heard me say that every suppressed fantasy of this kind has a tendency to escape into a childhood scene. Now, add to this the fact that it can't do so unless a memory-trace is present, whose content offers points of contact with the fantasy, which meets it halfway, as it were. Once such a point of contact is found – in the present case it is the deflowering, the taking away of the flower – the remaining content of the fantasy is remodelled by the addition of any admissible intermediate idea – think of the bread! – until new points of contact with the content of the childhood scene have emerged. It is quite possible that during this process even the childhood scene itself will be subject to modifications; I think it is certain that memories can be falsified in this way. In your case the childhood scene appears to have undergone a little extra chasing; think of the over-emphasis on the yellow and the excessively delicious bread. But the raw material was usable. Had this not been so, the memory could not have emerged into consciousness from among all the others. You wouldn't have had such a scene as a childhood memory, or perhaps you would have had a different one, for of course you know how easily the brain can build connecting bridges in all directions. The authenticity of your dandelion memory is incidentally supported not just by your feeling – which I wouldn't want to underrate – but by something else. It contains features that can't be explained by what you've told me and don't fit in with the meanings that derive from the fantasy. For instance, the fact that your male cousin helps you steal the flowers from the little girl. Can

you make sense of such cooperation in the act of defloration? Or of the two women, the farmer's wife and the nursemaid, up there in front of the house?

'I don't think I can.'

So the fantasy doesn't coincide entirely with the childhood scene; it only relies on it at certain points. That speaks in favour of the authenticity of the memory.

'Do you think that such an interpretation of seemingly innocent childhood memories is often appropriate?'

Very often, in my experience. Do you want to amuse yourself by trying to see whether the two examples the Henris report can be interpreted as screen memories for later experiences and desires? I mean the memory of the table that's set for a meal and has a dish of ice on it, which is supposed to be connected with the grandmother's death. And the second one, of the child breaking off a branch during a walk and being helped by another person?

He reflected for a while, then said, 'I can't make anything of the first one. It's very probable that a displacement is involved, but there's no way of guessing what the intermediate elements are. For the second I'd venture an interpretation if the person reporting it as his own were not a Frenchman.'

Now I don't understand you. What difference does that make?

'A big difference, since the linguistic expression probably supplies the link between the screen memory and the one being screened. In German the phrase "to tear one out" is a fairly well-known vulgarism for masturbation. The scene would transpose a later seduction into masturbation into early childhood, as someone helps him to do it. But even so it doesn't work, because so many other people are present in the childhood scene.'

Whereas the seduction into masturbation must have taken place in secret, with no one else around. It's this very contradiction that seems to me to support your view; yet again it serves to make the scene innocent. Do you know what it means when we see 'a lot of strangers' in a dream, as so often happens in dreams of nakedness, in which we feel so terribly embarrassed? Nothing other than – secrecy, which is then expressed by its opposite. In

any case this interpretation remains a joke, for we really don't know whether a Frenchman would see an allusion to masturbation in the phrase *casser une branche d'un arbre* or in some modified version of it.

The foregoing analysis, which I have reported as faithfully as possible, may to some extent have clarified the notion of a *screen memory* as one that owes its value as a memory not to its intrinsic content, but to the relation obtaining between this content and some other, which has been suppressed. According to the varying nature of this relation it is possible to distinguish different classes of screen memories. We have found examples of two of these classes among our so-called earliest childhood memories – that is, if we allow the incomplete childhood scene, whose incompleteness ensures its harmlessness, to count as a screen memory. It is to be expected that screen memories will also be formed from remnants of memory that date from later periods of our lives. Anyone who bears in mind their main characteristic – a high degree of memorability together with a wholly banal content – will have no difficulty in identifying many examples of this sort in his own memory. Some of these screen memories – those which deal with experiences from later in life – owe their significance to a connection with experiences of early youth that have remained suppressed; this connection is thus the reverse of the one in the case I analysed above, in which a recollection of childhood is accounted for by later experiences. Depending on which of these chronological relations holds between the screen and what it screens off, a screen memory can be described as either *retrogressive* or *anticipatory*. From another point of view we can distinguish between positive and negative screen memories (or *refractory* memories), whose content stands in a contrary relation to the suppressed content. The subject probably deserves more thorough examination, but here I will confine myself to pointing out what complicated processes are involved in producing our store of memories – processes, incidentally, that are wholly analogous to the formation of hysterical symptoms.

Our earliest childhood memories will always be an object of special interest, because the problem that was mentioned at the

beginning of this article – why it is that those impressions that have the most powerful effect on our whole future need not leave a memory image behind – leads us to reflect on the emergence of conscious memories in general. We shall no doubt be inclined at first to eliminate the screen memories we have been discussing as foreign bodies among our surviving childhood recollections; as for the remaining images, we shall probably adopt the simple view that they arise simultaneously with the experiences they relate to and as a direct consequence of the effect these produce, and that from then on they recur from time to time in accordance with the known laws that govern the reproduction of such images. Closer observation, however, reveals individual features that accord badly with this view. Foremost among these is the following: in most of the significant and otherwise unimpeachable childhood scenes that one recalls, one sees oneself as a child and knows that one is this child, yet one sees the child as an outside observer would see him. The Henris do not fail to point out that many of their respondents expressly emphasize this peculiarity of childhood scenes. Now, it is clear that this memory image cannot be a faithful replica of the impression that was received at the time. For the subject was then in the middle of the scene, paying attention not to himself, but to the world outside himself.

Wherever one appears in a memory in this way, as an object among other objects, this confrontation of the acting self with the recollecting self can be taken as proof that the original impression has been edited. It seems as though a memory-trace from childhood had here been translated back into a plastic and visual form at a later date, the date at which the memory was aroused. But no reproduction of the original impression has ever entered our consciousness.

In favour of this alternative view there is another fact that carries even greater conviction. Among our childhood memories of significant experiences, all of which appear equally clear and distinct, there are some scenes that turn out, when checked – against the recollections of adults, for instance – to have been falsified. It is not that they have been freely invented; they are incorrect insofar as

they transfer an event to a place where it did not happen (as in one example reported by the Henris), merge two people into one, substitute one person for another, or reveal themselves as combinations of two discrete experiences. Simple inaccuracy of recall plays no significant part in this, given the great sensory intensity of the images and the efficient functioning of the memory in the young. Detailed investigation shows rather that such falsifications are of a tendentious nature; that is to say, they serve to repress and replace objectionable or disagreeable impressions. So even these falsified memories must have arisen at a time when such conflicts and the impulse to repression could already assert themselves in a person's mental life – in other words, long after the period to which their content relates. But here too the falsified memory is the first one of which we have any knowledge, since the raw material out of which it was forged – the earliest memory-traces – has remained inaccessible in its original form.

In our estimation, the recognition of this fact diminishes the gap between screen memories and other memories from childhood. It is perhaps altogether questionable whether we have any conscious memories *from* childhood: perhaps we have only memories *of* childhood. These show us the first years of our lives not as they were, but as they appeared to us at later periods, when the memories were aroused. At these times of arousal the memories of childhood did not *emerge*, as one is accustomed to saying, but *were formed*, and a number of motives that were far removed from the aim of historical fidelity had a hand in influencing both the formation and the selection of the memories.

(1899)

Notes

1. [Translator's note: This is the standard translation of Freud's term *Deckerinnerungen*, a compound of the stem of the verb *decken* ('to cover') and the noun *Erinnerungen* ('memories'); a more literal rendering would be 'cover memories'.]

2. 'Weitere Bemerkungen über die Abwehr-Neuropsychosen', *Neurologisches Zentralblatt*, 1896, no. 10 (to be found in this volume of the collected works [*Gesammelte Werke*, vol. I]).

3. [Virgil, *Aeneid*, I.203.]

*The Creative Writer and
Daydreaming*

We laymen have always been greatly intrigued to know where the creative writer, that strange personality, finds his subjects – which is much the same question as a certain cardinal once put to Ariosto – and how he contrives to enthral us with them, to arouse in us emotions of which we might not even have thought ourselves capable. Our interest is only heightened by the fact that the writer himself, when questioned, gives us no explanation, or no satisfactory explanation, and it is in no way affected by our knowledge that even the best insight into what determines the writer's choice of material and into the nature of literary composition would do nothing to make creative writers of *us*.

If we could only discover in ourselves, or the likes of us, an activity that was in some way akin to creative writing! An examination of such an activity might then allow us to hope for some initial enlightenment in the matter of literary creation. And there is actually some prospect of this. For writers themselves are fond of playing down the gap between what is peculiar to them and what characterizes humanity in general, and so often assure us that there is a poet in each of us and that poets will only die out with the last human being.

Should we not look for the beginnings of poetic creativity in childhood? The child's favourite and most intense occupation is play. We may perhaps say that every child at play behaves like a writer, by creating a world of his own or, to put it more correctly, by imposing a new and more pleasing order on the things that make up his world. It would therefore be wrong to think that he did not take this world of his seriously; indeed, he takes his play very seriously

and expends a great deal of emotion on it. The opposite of play is not seriousness – it is reality. For all the emotion it is charged with, the child is well able to distinguish his world of play from reality and likes to connect the objects and situations he imagines to palpable and visible things in the real world. This link alone distinguishes the child's 'play' from 'fantasizing'.

Now, the creative writer acts no differently from the child at play: he creates a fantasy world, which he takes very seriously; that is to say, he invests large amounts of emotion in it, while marking it off sharply from reality. Moreover, the language itself captures the relation between children's games and literary creation by applying the word *play* to those of the writer's inventions that need to be linked to tangible objects – that can be performed or acted – and the word *player* to the person who performs or acts in them.[1] However, the unreality of the writer's world has important consequences for artistic technique: there are many things that could afford no enjoyment in reality, but can do so in the play of fantasy, and many excitations that are in themselves painful, but can give pleasure to the writer's audience.

Let us, for the sake of a different consideration, stay for a moment with the contrast between reality and play. When the child has grown up and ceased to play, after putting years of mental effort into understanding the realities of life, together with all the seriousness they call for, he may one day find himself in a frame of mind in which the opposition between play and reality is once more suspended. The adult can recall the high seriousness that he once brought to his childhood games, and now, by equating his ostensibly serious concerns with these games, he throws off the all too oppressive burden of life and wins the great bonus of pleasure afforded by *humour*.

The adolescent, then, gives up playing and seemingly forgoes the bonus of pleasure he once derived from it. But anyone familiar with the human mind knows that scarcely anything is so hard to forgo as a pleasure one has known. The truth is that we cannot forgo anything, but merely exchange one thing for another; what seems like a renunciation is in fact the invention of a substitute, a surrogate. And

so the adolescent too, when he ceases to play, gives up nothing but the link with real objects. Instead of *playing*, he now *fantasizes*, building castles in the air and fashioning what are called daydreams. Most people, I believe, construct fantasies at certain times in their lives. This fact has long been overlooked and its importance insufficiently appreciated.

People's fantasies are less easy to observe than children's games. True, the child too plays by himself or enters into a closed psychical system with other children in order to pursue his games, but while he does not play to an audience of grown-ups, he does not hide his games from them either. The adult, on the contrary, is ashamed of his fantasies, hiding them from others and guarding them as his most personal intimacies; as a rule he would rather admit to his wrongdoings than disclose his fantasies. It may be that for this reason he thinks he is the only person to construct such fantasies and has no idea that quite similar constructs are widespread among others. This differing behaviour – between those who play and those who fantasize – is easily explained by the different motives behind the two activities, even though the one is consequent upon the other.

The child's play is governed by its desires, in fact by the one desire that contributes to its upbringing – the desire to be big and grown up. The child constantly plays at being grown up, imitates in play what it has gathered about grown-up life. Now, the child has no reason to conceal this wish. Not so the adult: *he* knows what is expected of him – that he should no longer play or fantasize, but take an active part in the real world. On the other hand, among the desires that give rise to his fantasies there are some that it is imperative to conceal; hence, he is ashamed of his fantasizing because it is both childish and illicit.

You will ask how such precise knowledge about people's fantasies is possible when they are veiled in secrecy. Now, there is one category of people who have been charged, admittedly not by a god, but by a stern goddess – Necessity – with the task of telling what they suffer and what they enjoy.[2] These are the victims of nervous illness, who are obliged to confess even their fantasies to the psychiatrist from whose treatment they hope for a cure; this is the

source of our soundest knowledge, and we have since arrived at the well-founded conjecture that what our patients tell us is no different from what we might otherwise learn from the healthy.

Let us now acquaint ourselves with some of the typical features of fantasizing. It may be said that those who are happy never fantasize – only the dissatisfied. Unsatisfied desires are the motive forces behind fantasies, every fantasy being a wish-fulfilment, correcting an unsatisfactory reality. The motivating desires vary according to the sex, character and circumstances of the fantasist, but they fall easily into two main categories: either they are ambitious, serving to elevate the subject's personality, or they are erotic. In a young woman, erotic desires predominate almost exclusively, as her ambition is usually swallowed up in the quest for love; in a young man, selfish and ambitious desires are well to the fore, beside the erotic. However, it is not the contrast between the two categories that we wish to emphasize, but the fact that they often combine. Just as a large number of altar-pieces display a portrait of the donor in a corner of the picture, so, in some corner of the most ambitious fantasies, it is possible to descry the lady for whom the fantasist performs all these heroic deeds, and at whose feet he lays all his successes. As you see, there are many powerful motives for conceal-ment: a well-brought-up woman is permitted only minimal erotic needs, and a young man must learn to suppress any excessive self-regard that may be left over from his spoilt childhood, so that he can take his place in a society that teems with individuals who nurse equal pretensions.

We must not consider the products of such fantasizing – the individual fantasies, the castles in the air, the daydreams – to be rigid and unalterable. They match the subject's varying impressions of life, changing with every shift in his circumstances and receiving what might be called a 'date mark' from every effective new impres-sion. The relation of the fantasy to time is altogether very significant. One could say that a fantasy hovers, as it were, between the three periods involved in our ideation. The subject's mental activity attaches itself to a current impression, an occasion in the present that has succeeded in arousing one of his major desires. From

here it harks back to the memory of an earlier experience, usually belonging to his childhood, in which this desire was fulfilled. It now invents a situation, lodged in the future, that represents the fulfilment of this desire. This is the daydream or the fantasy, which has its origin in present experience and the recollection of the past: so that past, present and future are strung together on the thread of one desire that unites all three.

The most banal illustration may clarify what I am suggesting. Let us take the case of a poor orphaned youth to whom you have given the address of someone who might employ him. On his way to visit this prospective employer he may indulge in a daydream arising from and appropriate to his situation. Its content will be roughly this. He is taken on, finds favour with his new employer, makes himself indispensable in the business, is taken into the family, marries the charming young daughter of the house, and takes over the running of the business, first as her father's partner and then as his successor. In this fantasy the dreamer has regained what he possessed in his happy childhood – a protective home, loving parents, and the first objects of his tender affections. An example like this shows how a person's desire uses an occasion in the present in order to construct a vision of the future modelled on the past.

Much more could be said about fantasies, but I will confine myself to the briefest outlines. When fantasies proliferate and become over-powerful, the conditions are given for a lapse into neurosis or psychosis; moreover, fantasies are the immediate mental precursors of the painful symptoms that our patients complain of. Here a broad byway branches off towards pathology.

However, I cannot fail to consider the relation between fantasies and dreams. Our night-dreams too are nothing other than fantasies, like those we have been discussing, as we can demonstrate by our interpretation of dreams.[3] Language, in its matchless wisdom, long ago settled the question of the nature of dreams by applying the term 'daydreams' to the airy creations of the fantasists. Yet if, despite this pointer, the meaning of our dreams usually remains obscure, the reason is that at night we are visited by desires that we are ashamed of and must conceal from ourselves, that have for this very

reason been repressed, pushed into the unconscious. Such repressed desires and their derivatives can be allowed to express themselves only in a grossly distorted form. When once scientific research had succeeded in clarifying the phenomenon of *dream distortion* there was no longer any difficulty in recognizing that night-dreams were wish-fulfilments, just like our daydreams, the fantasies so familiar to us all.

So much for fantasies – now for the writer! Are we really justified in attempting to compare him with the 'dreamer in broad daylight' and his creations with 'daydreams'? Here we should probably make an initial distinction between those writers who, like the epic and tragic poets of classical times, take over ready-made material and those who apparently create their own. Let us stay with the latter and, for the purpose of our comparison, direct our attention not to those writers who enjoy the highest critical esteem, but to the more modest authors of novels, romances and short stories, who nevertheless have the most numerous and enthusiastic readership. We cannot help being struck, above all, by one special feature of their writings: they all have a hero who is the centre of interest, for whom the author seeks to win our sympathy by every possible means, and whom he seems to place under the protection of a special providence. If, at the end of one chapter of the novel, the hero is left unconscious and bleeding from severe wounds, he is sure to be found, at the beginning of the next, being carefully nursed back to health. And if the first volume has ended with the ship he is in going down in a storm, the reader is bound, at the beginning of the second, to read of his miraculous rescue, without which the novel could not continue. The sense of security with which I accompany the hero through all his tribulations is the same as the feeling with which a real-life hero plunges into the water to save a drowning man or exposes himself to enemy fire in order to storm a battery. It is that true heroic feeling that one of our best writers, Ludwig Anzengruber, has captured in the priceless phrase 'Nothing can happen to you!'[4] It seems to me, however, that, because of this tell-tale trait of invulnerability, we have no difficulty in recognizing His Majesty the Ego, the hero of every daydream and every novel.

Other typical features of these egocentric stories point to the same kinship. If all the women in a novel invariably fall in love with the hero, this can hardly be taken as a representation of reality, but it can be easily understood as a necessary feature of a daydream. The same is true if the other characters are sharply divided into good and bad, in spite of the rich variety of characters we encounter in real life; the 'good' ones are the helpers, the 'bad' ones the enemies and rivals of the ego that has become the hero of the story.

Now, we are by no means unaware that very many imaginative writings are far removed from the model of the naïve daydream, but I cannot suppress the suspicion that even the most extreme deviations from this model could be linked to it by an unbroken series of transitions. It has struck me that in many so-called psychological novels there is still only one person, again the hero, who is described from within; the author sits, as it were, inside the hero's mind and looks at the other characters from outside. On the whole the psychological novel no doubt owes its special character chiefly to the tendency of the modern writer to split up his ego, by self-observation, into partial egos and consequently to personify the conflicting currents in his mental life in several heroes. There seems to be a particularly marked contrast between the typical daydream and those novels that might be called 'eccentric', in which the person introduced as the hero plays an extremely small active part and is more of an onlooker, seeing the actions and sufferings of others pass before him. Several of Zola's later novels are of this kind. Yet I have to remark that the psychological analysis of individuals who are not writers and in some ways deviate from what is supposedly normal has acquainted us with analogous variations in daydreams, in which the ego contents itself with the role of an onlooker.

If our equation of the creative writer with the daydreamer and literary creation with daydreams is to have any value, it must above all prove fruitful in some way. Let us try, for instance, to apply to literary works the thesis we proposed a short while ago regarding the relation of the fantasy to the three time phases and the desire running through them, and let us, with its help, try to study the relations between the writer's life and work. As a rule, people

have not known with what expectations this problem should be approached, and the connection has often been thought of in far too simple terms. Given the insight we have gained from the study of fantasies we should expect the following state of affairs. A potent experience in the present awakens in the writer the memory of an earlier experience, usually belonging to his childhood; from there proceeds the desire that finds its fulfilment in the literary work; the work itself exhibits elements of both the recent occasion and the old memory.

Do not be alarmed by the complexity of this formula; I suspect that the scheme it represents will prove inadequate, but it might contain a first approximation to the true state of affairs, and, after carrying out a few experiments, I am inclined to think that such an approach to literary works may prove to be not altogether unfruitful. You will remember that the emphasis it places on childhood memories in the writer's life – an emphasis that may seem perplexing – derives ultimately from the supposition that the literary work, like the daydream, is a continuation of, and a substitute for, the earlier play of childhood.

Let us not neglect to go back to that class of writings that we have to regard not as original creations, but as adaptations of ready-made and familiar material. Even here the creative writer is left with some independence, which can manifest itself in the choice of the material and the often extensive modification to which he subjects it. However, insofar as the material is given, it has its origin in the popular treasury of myth, legend and fairy tale. The study of these products of folk-psychology is by no means complete; however, it is highly likely that myths, for instance, correspond to the distorted remains of the wishful fantasies of whole nations, the *secular dreams* of youthful humanity.

You will say that I have told you far more about fantasies than about the creative writer, whom I have nevertheless put first in the title of my paper. I am aware of this and will try to excuse it by reference to the present state of our knowledge. I have been able to offer you only suggestions and encouragements, which start out from the study of fantasies and lead on to the problem of the writer's

choice of material. The other question – about the means by which the writer achieves the emotional effects that his creations arouse in us – we have not yet touched upon at all. However, I should at least like to show you the path that leads from our discussions of fantasies to the problems of literary effects.

As you will recall, we said that the daydreamer carefully conceals his fantasies from others because he feels he has reason to be ashamed of them. I would now add that even if he were to tell us about them he could not give us any pleasure through such disclosures. On learning of such fantasies we are repelled by them or at best feel cool towards them. However, when the creative writer plays his games for us or tells us what we are inclined to explain as his personal daydreams, we feel a great deal of pleasure, deriving no doubt from many confluent sources. How the writer achieves this is his most intimate secret; the true *ars poetica* lies in the technique by which he overcomes our repulsion, which certainly has to do with the barriers that arise between each single ego and the others. We can make a guess at two of the means used by this technique: the writer tones down the character of the egoistic daydream by modifying and disguising it, and bribes us with the purely formal – that is aesthetic – bonus of pleasure that he offers us in the way he presents his fantasies. This bonus of pleasure, which is offered to us so that greater pleasure may be released from more profound psychical sources, is called an *incentive bonus* or *fore-pleasure*. In my opinion, all the aesthetic pleasure that the creative writer gives us is in the nature of a fore-pleasure, and the real enjoyment of a literary work derives from the relaxation of tensions in our minds. Maybe this effect is due in no small measure to the fact that the writer enables us, from now on, to enjoy our own fantasies without shame or self-reproach. Here we have reached the threshold of new, interesting and complicated investigations, but also, at least for the time being, the end of our discussions.

(1908 [1907])

Notes

1. [In the German text Freud cites the words *Lustspiel* ('comedy', literally 'pleasure play'), *Trauerspiel* ('tragedy', literally 'mourning play') and *Schauspieler* ('actor', literally 'show-player').]

2. [This is an allusion to lines spoken by the poet-hero of Goethe's play *Torquato Tasso*:

> *Und wenn der Mensch in seiner Qual verstummt,*
> *Gab mir ein Gott, zu sagen, wie ich leide.*

('And if the human being becomes silent in his torment, a god has granted me the gift to tell how I suffer').]

3. Cf. the author's study, *The Interpretation of Dreams*, 1900 [VI. I] (*Gesammelte Werke*, vols II and III).

4. [Translator's note: This is a literal rendering of the German sentence 'Es kann dir nix g'schehen.' Here the hero is addressing himself and places no special emphasis on the personal pronoun. I. F. Duff Grant, in his version of 1925, rendered it as 'Nothing can happen to *me*!', which suggests that the hero is distinguishing himself from others less fortunate.]

Family Romances

The separation of the individual, as he grows up, from the authority of his parents is one of the most necessary achievements of his development, yet at the same time one of the most painful. It is absolutely necessary for it to take place, and we may presume that it has been achieved in some measure by everyone who has developed into a normal person. Indeed, the progress of society in general rests upon the opposition between the generations. On the other hand, there is a class of neurotics whose condition is recognizably determined by their having failed in this task.

For a small child his parents are at first his only authority and the source of all he believes in. To become like them – that is to say, like the parent of one's own sex – to grow up and be like one's father or mother, is the most intense desire of these early years, and the one most fraught with consequences. However, as the child develops intellectually he cannot help gradually getting to know the category his parents belong to. He becomes acquainted with other parents, compares them with his own, and so becomes entitled to doubt the incomparable and unique status he once attributed to them. Small events in the child's life may induce in him a mood of dissatisfaction and so provide him with an occasion to start criticizing his parents and to support this critical attitude with the recently acquired knowledge that other parents are in some respects to be preferred to them. From the psychology of neurosis we know that, along with other factors, the most intense feelings of sexual rivalry play a part in this. The reason for such a reaction is obviously a feeling of being slighted. There are all too many occasions when a child is slighted, or at least feels that he has been slighted, that he does not have the

whole of his parents' love, and when above all he regrets having to share it with brothers and sisters. The feeling that his own affection is not fully reciprocated then finds expression in the idea, often consciously recollected from early childhood, that he is a stepchild or an adopted child. Many people who have not become victims of neurosis frequently remember such occasions when – usually as a result of something they had read – they interpreted and reacted in this way to hostile behaviour on the part of their parents. But here the influence of sex is already evident, in that a boy is far more inclined to feel hostile impulses towards his father than towards his mother, and has a far more intense desire to free himself from *him* than from *her*. In this respect the imaginative activity of girls may prove much weaker. In these childhood emotions, which are consciously recalled, we find the factor that enables us to understand the nature of myths.

Seldom recalled consciously, but nearly always demonstrable through psychoanalysis, is the next stage in the development of this incipient estrangement from the parents, which may be described as the *family romances of neurotics*. For an essential feature of neurosis, and also of any considerable talent, is a special imaginative activity, which reveals itself first in children's games and then, beginning roughly in the prepubertal period, seizes upon the theme of family relations. A characteristic example of this peculiar imaginative activity is the familiar phenomenon of *daydreaming*,[1] which continues long after puberty. Precise observation of daydreams shows that their purpose is wish-fulfilment and the correction of real life, and that they have two principal aims, one of them erotic and the other ambitious (though behind the latter the erotic aim is usually present too). At about this time, then, the child's imagination is occupied with the task of ridding himself of his parents, of whom he now has a low opinion, and replacing them by others, usually of superior social standing. In this connection he makes use of the chance concurrence of these aims with actual experiences, such as an acquaintanceship with the lord of the manor or some landowner in the country, or with some aristocrat in the city. Such fortuitous experiences arouse the child's envy, which then finds expression in

a fantasy that replaces both parents by others who are grander. The technique used in developing such fantasies, which at this period are of course conscious, depends on the child's ingenuity and the material he has at his disposal. It is also a question of how much or how little effort has gone into making the fantasies seem probable. This stage is reached at a time when the child still lacks any knowledge of the sexual determinants of procreation.

When the child subsequently learns about the different sexual roles of the father and the mother, when he understands that *pater semper incertus est*, whereas the mother is *certissima*,[2] the family romance is subject to a peculiar restriction: it contents itself with raising the status of the father, while no longer casting doubt on descent from the mother, which is something unalterable. This second (sexual) stage of the family romance rests on a second motive, which was not present at the first (asexual) stage. Knowledge of sexual processes gives rise to a tendency on the part of the child to picture to himself various erotic situations and relationships. The motive force behind this is a desire to involve his mother – who is the object of extreme sexual curiosity – in situations of secret infidelity and in secret love affairs. In this way the first (as it were asexual) fantasies are now brought up to the level of the current state of knowledge.

Moreover, the motive of revenge and retaliation, which was in the foreground at the earlier stage, is still present at the later one. And as a rule it is precisely those neurotic children whose parents once punished them for sexual misbehaviour who now take revenge on them by means of fantasies of this kind.

It is in particular the younger children of a marriage who seek above all to deprive their older siblings of their prerogatives by inventing such stories (as in historical intrigues) and often do not recoil from attributing as many fictitious love affairs to their mother as they themselves have competitors. An interesting variant of the family romance arises when the author-hero returns to legitimacy himself, while using this device to eliminate his siblings as illegitimate. Moreover, any other special interest can direct the course of the family romance, which, thanks to its versatility and wide

applicability, is adequate to all kinds of endeavour. In this way, for instance, the little fantasist can eliminate his blood-relationship to a sister who happens to attract him sexually.

We would remind anyone who turns away in horror from the depravity we have attributed to the mind of the child, or may even wish to deny that such things are possible, that none of these seemingly hostile fictions are really ill-intended, but preserve, under a slight disguise, the child's original affection for his parents. The infidelity and ingratitude are only apparent. For if one takes a close look at the commonest of these romances – the replacement of both parents or just the father by grander personages – one discovers that these new, distinguished parents are provided with features that derive from the child's actual memories of his real, more humble parents: the child does not really eliminate his father, but exalts him. Indeed, the whole effort to replace the real father by another who is more distinguished is merely an expression of the child's longing for the happy times gone by, when his father seemed to him the strongest and most distinguished of men, and his mother the dearest and loveliest of women. He turns away from the man he now knows as his father to the one he believed in as a child. The fantasy is actually only an expression of regret for the happy times that have vanished. In such fantasies, then, the overestimation of the earliest years of childhood once more comes into its own. An interesting contribution to this theme is supplied by the study of dreams. For the interpretation of dreams tells us that when we dream of the Emperor or the Empress, even late in life, these distinguished personalities represent our father and mother.[3] The child's over-estimation of his parents is thus retained in the dreams of the normal adult.

(1909)

Notes

1. On this cf. Freud, 'Hysterische Phantasien und ihre Beziehung zur Bisexualität' ['Hysterical Phantasies and their Relation to Bisexuality'] (*Gesammelte Werke*, vol. VI), where references to the relevant literature may be found.

2. [An old legal tag: 'The father is always uncertain, (the mother) most certain.]

3. *The Interpretation of Dreams*, 8th edn, p. 242 [VI. E] (*Gesammelte Werke*, vol. II/III).

Leonardo da Vinci and a
Memory of his Childhood

I

Psychiatric research usually makes do with frail human material, but when it approaches one of the great representatives of the human race its motives are not those that laymen so often impute to it. It does not seek 'to blacken the radiant and drag the sublime in the dust'.[1] It derives no satisfaction from reducing the gap between such perfection and the inadequacy of its usual objects. Yet it cannot help thinking that whatever can be discerned in the former deserves to be understood, and it believes no one to be so great that it would be a disgrace for him to be subject to the laws that govern both normal and pathological behaviour with equal rigour.

Even in his lifetime Leonardo da Vinci (1452–1519) was admired as one of the greatest men of the Italian Renaissance, but to his contemporaries he already seemed a puzzling figure, as he still does to us today. It was as a painter that this universal genius, 'whose outlines can only be guessed, never fathomed',[2] exercised the most decisive influence on his age; it was left to ours to recognize the greatness of the natural scientist (and engineer)[3] who combined in him with the artist.

Although he left us masterpieces of painting, while his scientific discoveries remained unpublished and unused, the scientist in him never wholly relinquished his hold over the artist, but often did him serious harm; indeed it may in the end have destroyed him. Vasari tells us that in the last hour of his life Leonardo reproached himself for having offended God and mankind by failing in his duty as an artist.[4] And even if this story of Vasari's has no external and little internal probability to recommend it, but belongs to the legend that was already growing up around the mysterious master during his

45

lifetime, it provides undeniably valuable evidence of how Leonardo was perceived in his own day.

What was it that made Leonardo's personality incomprehensible to his contemporaries? Certainly not his many-sided knowledge and accomplishments, which allowed him to present himself at the court of Lodovico Sforza, Duke of Milan, known as Il Moro, as a lutenist who performed on an instrument of his own invention, or address that remarkable letter to the Duke in which he boasted of his achievements as a civil and military engineer. After all, the age of the Renaissance was probably used to seeing many abilities united in one person, though admittedly Leonardo himself was one of the most splendid illustrations of the phenomenon. Nor was he one of those geniuses who, having been outwardly ill-endowed by nature, set no store by life's outward forms and, in a spirit of painful melancholy, shun the society of their fellow men. Indeed, he was tall and well-proportioned, endowed with fine facial features and uncommon physical strength; he was gifted with charming manners and a mastery of words, and was cheerful and amiable towards everyone. He loved beauty in the things that surrounded him, was fond of fine clothes, and appreciated every refinement of living. In his treatise on painting there is a passage that reveals his lively capacity for enjoyment;[5] in it he compares painting with its sister arts and describes the hardships attendant upon the work of the sculptor: 'His face is smeared all over and engrained with marble dust, so that he looks like a baker; he is totally covered with little marble splinters, as if snow had fallen on his back; and his house is full of stone splinters and dust. With the painter the very opposite is the case . . . he sits comfortably in front of his work, wearing fine clothes and wielding a light brush with delightful pigments. He dresses in whatever clothes he pleases. His house is full of cheerful paintings and, what is more, spotlessly clean. Often he has company, musicians or persons who read to him from various beautiful works; he listens to them with great pleasure, undisturbed by the din of hammering and other noises.'

It may be that the image of the gay, pleasure-loving Leonardo belongs only to the first, and longer, period of his life. Later, when

the collapse of Lodovico Moro's rule forced Leonardo to leave Milan, until then the centre of his activity, to abandon his secure position and embark upon a life of insecurity that afforded few outward successes until his final exile in France, his brilliant temperament may have lost some of its lustre, and some strange traits in his character may have come more to the fore. Moreover, the shift of his interests from art to science was bound to widen the gulf between him and his contemporaries. All the experiments with which he frittered away his time – as they saw it – instead of busily painting to order and enriching himself, like his former fellow-pupil Perugino, struck them as capricious frivolities or even exposed him to the suspicion of serving the 'black art'. In this respect we are better placed to understand him, since we know from his notes what arts he practised. In an age that was beginning to replace the authority of the Church with that of antiquity, but was not yet familiar with research that was free of presuppositions, Leonardo – the precursor and by no means unworthy rival of Bacon and Copernicus – was inevitably isolated. When he dissected the bodies of horses and human beings, constructed flying machines, or studied the nutrition of plants and their reactions to poisons, he was admittedly moving away from the commentators on Aristotle and towards the despised practitioners of alchemy, in whose laboratories experimental research had at least found refuge in those unfavourable times.

The effect of this on his painting was that he became reluctant to take up the brush; he painted less and less, left the works he began largely unfinished, and cared little about their subsequent fate. This earned him reproaches from his contemporaries, to whom his relation to his art remained a riddle.

Several of Leonardo's later admirers have tried to clear his character of the slur of instability, pointing out that what is criticized in Leonardo is a characteristic of great artists generally. Even the energetic Michelangelo, absorbed though he was in his art, left many of his works uncompleted, and for this he was as little to blame as Leonardo in the same situation. Moreover, where some pictures are concerned, it is not so much a question of their being unfinished as

of the artist's declaring them to be. What strikes the layman as a masterpiece may appear to its creator as an unsatisfactory embodiment of his intentions; he envisages an image of perfection, but repeatedly despairs of reproducing its likeness. And, above all, the artist should not be held responsible for what subsequently happens to his works.

Valid though some of these excuses may be, they do not cover the whole state of affairs that confronts us in the case of Leonardo. The same distressing struggle with the work, the eventual flight from it, and the artist's indifference to its subsequent fate may be matched in the cases of many other artists, but Leonardo's behaviour in this regard was undoubtedly extreme. Solmi quotes a remark by one of his pupils: 'Pareva, che ad ogni ora tremasse, quando si poneva a pipingere, e pero non diede mai fine ad alcuna cosa cominciata, considerando la grandezza dell' arte, tal che egli scorgeva errori in quelle cose, che ad altri parevano miracoli.'[6] ['He appeared to tremble the whole time when he set himself to paint, and yet he never completed any work he had begun, having so high a regard for the greatness of art that he discovered faults in things that to others seemed miracles.'] His last pictures, the *Leda*, the *Madonna di Sant' Onofrio*, the *Bacchus* and the *San Giovanni Battista*, remained unfinished 'come quasi intervenne di tutte le cose sue . . .' ['as happened more or less to all his works . . .']. Lomazzo, who made a copy of the *Last Supper*, referred in a sonnet to Leonardo's notorious inability to complete a picture:

> *Protogen che il pennel di sue pitture*
> *Non levava, agguaglio il Vinci Divo,*
> *Di cui opra non e finita pure.*[7]

[Protogenes, who never lifted his brush from his work, was the equal of the divine Vinci, who never finished anything at all.]

Leonardo's slow pace of working was proverbial. After the most thorough preliminary studies, he worked for three years on the *Last Supper* at the monastery of Santa Maria delle Grazie. A contemporary, the story-writer Matteo Bandelli, who had been a young monk

young men who shared his life, as was then customary for pupils, did not extend to sexual activity. Moreover, he must not be credited with a high degree of sexual activity.

In connection with Leonardo's dual nature as an artist and a scientist, there is only one way to understand the peculiar nature of his emotional and sexual life. Among his biographers, to whom psychological approaches are often quite alien, I know of only one, Edmondo Solmi, who has come close to solving this riddle. Yet Dmitry Sergeyevich Merezhkovsky, a creative writer who has made Leonardo the hero of a large historical novel, bases his portrait on such an understanding of this unusual man and expresses his view very clearly, admittedly not in plain language, but in vivid terms – as is the way of imaginative writers.[19] Solmi writes: 'But the unquenchable desire to get to know everything that surrounded him and, with cold superiority, to fathom the most profound secret of all that is perfect, had doomed Leonardo's works to remain for ever unfinished.'[20] In an essay in the *Conferenze Fiorentine*, a remark of Leonardo's is quoted which amounts to a confession of faith and supplies the key to his nature: 'Nessuna cosa si puo amare ni odiare, se prima non si ha cognition di quella.'[21] That is to say, one has no right to love or hate something unless one has gained a thorough knowledge of its nature. And Leonardo repeats this in the treatise on painting, in a passage where he appears to be defending himself against the charge of irreligion: 'But such critics should hold their peace. For that (line of conduct) is the way to get to know the Maker of so many wonderful things, and this the way to love so great an Inventor. For, in truth, great love springs from great knowledge of the thing you love, and if you have little knowledge of it you will be able to love it only a little or not at all . . .'[22]

The value of these remarks of Leonardo's does not lie in their conveying a significant psychological fact, for what they assert is patently wrong, and Leonardo must have known this as well as we do. It is not true that people put off loving or hating until they have studied the object of these emotions and become acquainted with its nature. Rather, they love impulsively, prompted by emotions that have nothing to do with knowledge and whose effect is at most

there at the time, told how Leonardo would often climb up the scaffolding early in the morning and not lay down his brush until dusk, never thinking of eating and drinking. Then days would go by without his touching the work. And there were times when he would spend hours in front of the painting, simply examining it in his mind. At other times he would come straight to the monastery from the courtyard of the castle of Milan, where he was working on the model for the equestrian statue of Francesco Sforza, add a few brush-strokes to one of the figures, and promptly leave.[8] According to Vasari he spent four years painting the portrait of Mona Lisa, the wife of the Florentine Francesco del Giocondo, but could not bring it to completion; this may explain why it was not delivered to the man who had commissioned it, but remained with the artist and went with him to France.[9] It was bought by Francis I and is now one of the greatest treasures of the Louvre.

Comparing these accounts of Leonardo's way of working with the evidence contained in the exceptionally large number of his surviving sketches and studies, in which every motif that figures in his pictures is found in a great variety of forms, we must wholly reject the view that hastiness and instability had any bearing upon his relation to his art. On the contrary, one notes a quite extraordinary absorption in the work, an abundance of possibilities, between which one can decide only after some hesitation, demands that can scarcely be satisfied, and an inhibition in the actual execution that cannot really be explained even by the artist's necessarily falling short of his ideal vision. The slow tempo that was a constant feature of Leonardo's work, turns out to be a symptom of this inhibition and a harbinger of his later withdrawal from painting.[10] It was this that determined the fate of the *Last Supper*. Leonardo was not good at painting *al fresco*, which requires rapid execution while the ground of the painting is still moist. This was why he chose oils, which were slow to dry and so enabled him to protract the completion of the picture to suit his mood and leisure. However, the pigments detached themselves from the ground to which they were applied and which isolated them from the wall; the defects of the wall and the subsequent fate of the building contributed further to the

apparently inevitable ruin of the picture.[11] The failure of a similar technical experiment seems to have been responsible for the destruction of the *Battle of Anghiari*, which he later started painting on a wall of the Sala del Consiglio in Florence, in competition with Michelangelo, but then abandoned before it was completed. Here it seems as if a quite different interest – that of the experimenter – initially reinforced the artistic interest, but later proved detrimental to the work.

The character of Leonardo the man displayed other unusual traits and apparent contradictions. There seems to have been an unmistakable indolence and indifference about him. At a time when all other artists sought to promote their work as widely as possible – which cannot be done without a degree of energy and aggression – Leonardo was noted for his quiet, peaceable nature and his avoidance of all contention and quarrelling. He was gentle and kindly towards everyone; he is said to have abstained from eating meat, thinking it unjustifiable to rob animals of their lives, and to have taken particular pleasure in buying birds in the market and then setting them free.[12] He condemned war and bloodshed and said that man was not so much the king of the animal world as the worst of its savage beasts.[13] Yet this womanly tenderness of feeling did not prevent him from accompanying condemned criminals on their way to execution, so that he could study their features, distorted with fear, and sketch them in his notebook, or from designing the cruellest weapons of war when working for Cesare Borgia as his chief military engineer. He often seemed indifferent to good and evil, or demanded that he should be measured by a special yardstick. Occupying a position of authority, he accompanied Cesare on the campaign by which that most ruthless and faithless of all adversaries won possession of the Romagna. Not a single line in Leonardo's notes reveals any criticism of the events of those days or any qualms they may have caused him. Here one cannot wholly dismiss a comparison with Goethe during the campaign in France.

If a biographical study really seeks to arrive at an understanding of the mental life of its hero, it must not – as most biographies do, out of discretion or prudery – keep silent about his sexual activity and sexual individuality. Of Leonardo's we know little, but that little is highly significant. In an age that saw unbridled sensuality in contention with gloomy asceticism, Leonardo was an example of the cool rejection of sexuality, which one would not expect in an artist who portrayed female beauty. Solmi quotes the following sentence of his, which is characteristic of Leonardo's frigidity: 'The act of procreation and everything connected with it is so disgusting that mankind would soon die out if it were not an old-established custom and there were not still pretty faces and sensual natures.'[14] His posthumous writings, which not only deal with the greatest scientific problems, but also contain trivialities that seem hardly worthy of such a great mind (an allegorical natural history, animal fables, jocular tales, prophecies),[15] are chaste – one might even say sexless – to a degree that would be surprising in a work of *belles lettres* even today. Anything sexual is so resolutely shunned that it seems as though Eros alone, the preserver of all that lives, is unworthy to be the object of the scientist's thirst for knowledge.[16] It is well known that great artists often enjoy giving free rein to their fancy in erotic even grossly obscene pictures. From Leonardo, however, we have only a few anatomical drawings of the internal female genitalia, the position of the embryo in the womb, etc.[17]

It is doubtful whether Leonardo ever held a woman in a passionate embrace. And he is not known to have had an intimate spiritual association with one, like that of Michelangelo with Vittoria Colonna. When he was living as an apprentice at the house of his master Verrocchio, a charge of unlawful homosexual practices was brought against him and other young people, but it ended in his acquittal. He appears to have come under suspicion through using a boy of ill-repute as a model.[18] When he became a master, he surrounded himself with handsome boys and youths, whom he took on as pupils. The last of them, Francesco Melzi, accompanied him to France, stayed with him until his death, and was appointed as his heir. While not sharing the certainty of Leonardo's modern biographers, who naturally reject the possibility of sexual relations between him and his pupils as a baseless defamation of the great man, one may think it far more likely that Leonardo's affectionate relations with

weakened by thought and reflection. So Leonardo can only have meant that the love practised by human beings was not of the true, irreproachable kind: one *ought* to love in such a way that emotion is held back, subjected to reflection, and not allowed to take its course until it has passed the test of thought. And we understand that he wishes us to know that this is true of him, and that it would be desirable if everyone else adopted his attitude to love and hate.

And it really does seem to have been true of Leonardo. His emotions were restrained and subjected to the investigative drive; he neither loved nor hated, but asked himself about the provenance and significance of what he was supposed to love or hate; and so he was at first bound to appear indifferent to good and evil, beauty and ugliness. During this process of investigation, love and hate ceased to be positive or negative, both being replaced by intellectual interest. Leonardo did not really lack passion, the divine spark that is, directly or indirectly, the driving force – *il primo motore* – behind all human activity. He had simply transformed his passion into a thirst for knowledge. He now devoted himself to scientific research with a perseverance, a constancy and an absorption that derive from passion; and at the climax of his intellectual work, having attained knowledge, he allowed the long-restrained emotion to break loose and flow away freely, like a stream of water that had been diverted from a river to drive a machine. At the height of a discovery, when he could suddenly survey all the interrelations, he was overcome by pathos and exalted in ecstatic language the grandeur of that part of creation that he had been studying, or – to couch it in religious terms – the greatness of the Creator. Solmi understands this process of transformation correctly. After quoting such a passage, in which Leonardo celebrates the sublime necessity of nature ('O mirabile necessità . . .'), he remarks, 'Tale trasfigurazione della scienza della natura in emozione, quasi direi, religiosa. è uno dei tratti caratteristici de' manoscritti vinciani, e si trova cento e cento volte espressa . . .'[23] ['Such a transfiguration of natural science into a sort of religious emotion is one of the characteristic features of Leonardo's manuscripts, and there are hundreds and hundreds of examples of it . . .']

Because of his insatiable, indefatigable pursuit of knowledge, Leonardo has been dubbed the Italian Faust. However, leaving aside any reservations we may have about the possible re-transformation of the investigative drive into enjoyment of life, which the Faust tragedy seems to presuppose, we might venture to observe that Leonardo's development has a close affinity to the thinking of Spinoza.

The conversion of the force of a psychical drive into different forms of activity can perhaps no more be effected without loss than the conversion of physical forces. The example of Leonardo teaches us how many other things connected with these processes must be followed up. Postponing loving until knowledge has been acquired means substituting knowledge for love. Having won through to knowledge, one no longer really loves and hates: one is now beyond love and hate. One has engaged in research instead of loving. And this may be why Leonardo's life was so much more lacking in love than those of other great men and other artists. The tempestuous passions that exalt and consume, passions to which others have owed their richest experiences, seem not to have touched him.

And there are other consequences besides. Investigation takes over from action and creativity. Whoever begins to sense the grandeur of the universe, its cohesion and its laws, easily loses sight of his own insignificant self. Lost in wonder and humility, he too easily forgets that he himself is part of these active forces and that, in accordance with his personal strength, he can make a minute alteration in the destined course of the world, in which, after all, the small is no less wonderful or significant than the great.

Leonardo had perhaps, as Solmi thinks, begun his scientific research in the service of his art;[24] he was concerned with the properties and laws of light, colours, shadows and perspective, in order to secure mastery for himself in the imitation of nature and point others in the same direction. Even at the time he probably overrated the value this knowledge had for the artist. Then, still following the lead set by the needs of the painter, he was impelled to study the objects of his art – animals, plants, the proportions of the human body – and to move on from observation of their outward appearance to knowledge of their inner structure and vital functions,

which are manifested in their appearance and demand artistic representation. And finally he was carried away by the investigative drive, which now became overwhelming, until the link with the demands of his art was severed, with the result that he discovered the general laws of mechanics, divined the history of the stratifications and fossilizations in the Arno valley, and was able to enter the following discovery in big letters in his book: '*Il sole non si move*.'[25] ['The sun does not move.'] His investigations extended to virtually every branch of natural science, and in each of them he was a discoverer, or at least a prophet and a pioneer.[26] Yet his urge for knowledge was always directed to the external world; something prevented him from studying the human mind. In the 'Academia Vinciana' (p. 78), for which he drew some ingeniously intertwined emblems, there was little room for psychology.

Then, when he tried to return from scientific research to the practice of art, from which he had started out, he found himself disturbed by the new focus of his interests and the change in his mental activity. What now interested him in a picture was above all a problem, and behind this one problem he saw countless others emerging – an experience that was familiar to him from the endless, inexhaustible study of nature. He could no longer bring himself to limit his demands, to isolate the work of art and tear it out of the wider context in which he knew it belonged. After the most exhausting efforts to express in it whatever was associated with it in his thoughts, he was forced to abandon it before it was completed or pronounce it unfinished.

The artist had at first taken on the scientist as his assistant; now the servant became the stronger of the two and suppressed the master.

When we find that in the picture of a person's character one drive has become excessively strong, like the thirst for knowledge in Leonardo's case, we seek to explain it as due to a particular disposition, of whose determinants – probably organic – we usually lack any precise knowledge. However, our psychoanalytic studies of those suffering from nervous disorders incline us to entertain two further expectations, which it would be pleasing to find confirmed in every

case. We think it likely that this excessively strong drive was already at work in the subject's earliest childhood and that its dominance was established by impressions received in infancy. We further assume that it gained strength by harnessing forces that originally belonged to the sex drive, so that at a later date it could replace part of the subject's sexual life. Such a person would therefore devote himself just as passionately to research as another would to love: he might even replace love by research. Not only in the case of the investigative drive, but in most other cases where one drive acquires a special intensity, we would venture to infer that there had been a sexual reinforcement.

Observation of people's daily lives shows us that most succeed in directing a quite substantial portion of their sex drive into their professional activity. The sex drive is particularly well suited to making such contributions, as it is endowed with a capacity for sublimation, an ability to replace its immediate aim with others that may be more highly valued and are not sexual. We take this procedure as proven when the history of a person's childhood – of his mental development, in other words – shows us that in childhood this over-powerful drive served sexual interests. We find additional confirmation of this if there is a marked atrophy of the subject's sexual life in his mature years, as if part of his sexual activity had been replaced by the activity of the over-powerful drive.

There seem to be special difficulties about applying these expectations to the case of an over-powerful investigative drive, as there is a reluctance to credit children either with this serious drive or with notable sexual interests. But these difficulties are easily overcome. The curiosity of small children is attested by their untiring fondness for asking questions, which the adult finds puzzling so long as he fails to understand that they are simply beating about the bush, that the questions cannot come to an end because the child wishes to use them as substitutes for just one question, which he nevertheless does not ask. When he is older and better informed, this show of curiosity often comes to an abrupt end. However, a full explanation is provided by psychoanalytic research, which tells us that, from the age of about two, many children, perhaps most – or

at any rate the most gifted – go through a period of what may be termed *infantile sexual research*. As far as we know, the curiosity of children of this age does not awaken spontaneously, but is due to the impression made by some important event – by the birth of a little brother or sister, which has either already taken place or is to be feared, on the basis of external experiences – in which the child sees a threat to its own selfish interests. Its research is directed to the question of where babies come from, just as if it were seeking ways and means to prevent such an undesirable event. We have thus been astonished to learn that the child refuses to believe the bits of information it is given, that it energetically rejects, for instance, the fable of the stork, with its rich mythological significance, that it dates its intellectual independence from this act of disbelief, often feels seriously at odds with adults and never really forgives them for cheating it of the truth in this matter. It follows its own lines of enquiry. It guesses that the unborn child is present in the mother's body and, guided by impulses from its own sexuality, develops theories about babies originating in food and being born through the bowels, and about the mysterious part played by the father. By then it already has an inkling of the sex act, which seems to be something hostile and violent. However, as its own sexual consti-tution is not yet equal to procreation, its researches into where babies come from inevitably lead nowhere and are abandoned as incapable of completion. The impression made by this failure to pass the first test of intellectual independence appears to be long-lasting and deeply depressing.[27]

When the period of infantile sexual research has been brought to an end by a phase of strenuous sexual repression, the investigative drive has three possibilities open to it, all stemming from its early connection with sexual interests. One is that research shares the fate of sexuality; curiosity remains inhibited from now on, perhaps for the rest of the subject's life, and the free play of the intelligence is restricted, especially as, shortly after this, his upbringing will ensure that thinking is seriously inhibited by religion. This type is charac-terized by neurotic inhibition. We understand very well that the intellectual debility acquired in this way is effective in promoting the

onset of neurotic illness. In a second type, the subject's intellectual development is strong enough to withstand the sexual repression that tugs at it. Some time after the period of infantile sexual research comes to an end, the intelligence – which has grown stronger and is mindful of the old sexual link – offers its help in evading sexual repression. The suppressed sexual researches re-emerge from the unconscious in the form of compulsive brooding, admittedly in a distorted and constrained form, but powerful enough to sexualize thinking itself and colour intellectual activity with the pleasure and anxiety that are associated with real sexual processes. Here research becomes a sexual activity, often the only one; the feeling that comes from settling and clarifying things in one's mind takes the place of sexual satisfaction; but the interminable nature of the infantile researches is repeated too: the brooding never ends, and the intellectual feeling, so much sought-after, of having found a solution, recedes further and further into the distance.

The third type, the rarest and most perfect, escapes both the inhibition of thought and the neurotic compulsion to think, by virtue of a special disposition. Here too, sexual repression occurs, but it does not succeed in relegating a component drive of sexual desire to the unconscious. Instead, the libido avoids repression by being sublimated into curiosity from the beginning and by joining and strengthening the powerful investigative drive. Here too, research becomes to some extent compulsive, a substitute for sexual activity, but because of the total disparity of the underlying psychical processes (sublimation instead of an irruption from the unconscious) the quality of neurosis is absent; there is no longer any link with the original complexes of infantile sexual research. The drive can operate freely in the service of intellectual curiosity. It still takes account of sexual repression, which made it so strong by its contribution of sublimated libido, in that it avoids any concern with sexual themes.

If we consider the concurrence of Leonardo's exceedingly powerful investigative drive and the atrophy of his sexual life, which was restricted to what is called ideal homosexuality, we shall be inclined to claim him as an exemplar of our third type. The core and secret of his nature would lie in the fact that, after his curiosity had

been activated in the service of infantile sexual interests, he then succeeded in sublimating the greater part of his libido into an urge for scientific research. It is admittedly not easy to substantiate this view. To do so we should need an insight into his mental development during the early years of childhood, and it seems foolish to hope for such data when the accounts of his life are so meagre and uncertain, and, moreover, when it is a question of information regarding conditions that still escape the attention of observers in relation to members of our own generation.

We know very little about Leonardo's youth. He was born in 1452 in the small town of Vinci, between Florence and Empoli. He was an illegitimate child, though at the time this was certainly not regarded as a grave social blemish. His father was Ser Piero da Vinci, a notary from a family of notaries and farmers that took its name from the town of Vinci. His mother, named Caterina, was probably a peasant girl who later married another inhabitant of Vinci. This mother plays no part in Leonardo's later life; only the novelist Merezhkovsky believes he can point to some trace of her. The only solid information about Leonardo's childhood is contained in an official document dating from the year 1457, a Florentine land register kept for fiscal purposes, in which Leonardo is mentioned among the members of the Vinci family as the five-year-old illegitimate son of Ser Piero.[28] Ser Piero's marriage to one Donna Albiera remained childless, and so the little Leonardo could be brought up in his father's house. He did not leave it until he entered the workshop of Andrea del Verrocchio as an apprentice – we do not know at what age. In 1472 Leonardo's name was already to be found in the list of members of the *Compagnia dei Pittori*. That is all.

II

As far as I know, Leonardo only once includes a piece of information about his childhood in his scientific writings. In a passage dealing with the flight of the vulture he suddenly interrupts himself to pursue a memory from his very early childhood that has sprung to mind.

'It seems that I was predestined to study the vulture so thoroughly, because I recall, as a very early memory, that when I was still in my cradle a vulture came down to me, opened my mouth with its tail and struck me many times with this tail against my lips.'[1] A childhood memory, then, and of an extremely strange kind. Strange on account of its content and of the time of life it is assigned to. Perhaps it is not impossible to remember something that happened when one was still a baby, but it can by no means be regarded as certain. However, what this memory of Leonardo's asserts – that a vulture opened the child's mouth with its tail – sounds so improbable, so fanciful, that a different view of it, one that removed both difficulties at once, would commend itself more to our judgement. According to this view the scene with the vulture is not a memory of Leonardo's, but a fantasy that he conceived at a later date and then transposed into his childhood.[2] People's memories of their childhood often have no other origin. Unlike the conscious memories of one's mature years, they are not fixed from the moment of the experience to which they relate and subsequently repeated, but are brought out only later, when childhood is past; in the course of this process they are altered, falsified, and made to serve later preoccupations, so that in general they cannot be strictly distinguished from fantasies. Perhaps one can get the clearest idea of their nature by thinking of how historiography arose among the peoples of the ancient world.

So long as a nation was small and weak it did not think of recording
its history. The people tilled the soil, defended themselves against
their neighbours, tried to win land from them and acquire wealth.
This was a heroic, unhistorical age. Then came the dawn of a new
age, in which the nation began to reflect and saw itself as rich and
powerful; it now felt a need to know where it had come from and
how it had evolved. The writing of history, which had begun as a
continuous record of current events, now looked back into the past,
collected traditions and legends, interpreted remnants of earlier
times that survived in customs and usages, and so created a history
of the primeval period. Inevitably this primeval history was more an
expression of present opinions and wishes than a depiction of the
past, for many things had been eliminated from popular memory and
others had been distorted. Some traces of the past were misleadingly
interpreted in accordance with current ideas. Moreover, the motive
behind the writing of history was not objective curiosity, but a desire
to influence contemporaries, to stimulate and uplift them, or to hold
a mirror up to them. Now, a person's conscious recollection of the
experiences of his mature years is altogether comparable with the
former kind of historiography [which was a record of current events],
while his memories of childhood really correspond, as regards their
origin and reliability, to the history of a nation's primeval epoch, put
together at a late stage and for tendentious reasons.

So, if Leonardo's story about the vulture visiting him in his cradle
is only a latter-day fantasy, one might think it hardly worth one's
while to spend much time over it. In order to explain it, one might
content oneself with Leonardo's openly acknowledged inclination
to dignify his study of bird flight by the notion that it was predestined.
Yet to belittle it in this way would be to commit an injustice not
unlike that of lightly dismissing the material contained in the legends,
traditions and interpretations of a nation's prehistory. Despite all
the distortions and misconceptions, they still represent the reality
of the past; they are what the nation has fashioned out of its primeval
experiences, swayed by motives that were once powerful and are
still effective today; and if it were only possible to know all the forces
at work and undo these distortions, one could uncover the historical

truth underlying the legends. The same applies to the childhood memories or fantasies of individuals. What a person thinks he remembers of his childhood is not a matter of indifference: hidden behind these residual memories, which he himself does not understand, there are as a rule priceless pieces of evidence about the most significant features of his mental development.[3]

Since we now posses, in the techniques of psychoanalysis, excellent methods that help to bring this hidden material to light, we may perhaps try to fill in the gap in the story of Leonardo's life by analysing his childhood fantasy. If we fail to reach a satisfactory degree of certainty, we must take comfort in the thought that so many other studies of this great and enigmatic figure have fared no better.

However, if we look at Leonardo's vulture fantasy with the eye of the psychoanalyst, it does not seem strange to us for long. We seem to recall often having encountered something similar, for instance in dreams, and so we can venture to translate this fantasy out of its own peculiar language into one that is generally comprehensible. The translation then points to an erotic meaning. A tail (*coda*) is one of the best known symbols and alternative designations for the male organ, in Italian and other languages. The situation in the fantasy – a vulture opening the child's mouth and beating around vigorously inside it with its tail – corresponds to the notion of fellatio, a sexual act in which the penis is placed in the mouth of the person who is being used. It is strange that this fantasy is so completely passive in character; it also resembles certain dreams and fantasies found in women or passive homosexuals (who play the female role in sexual intercourse).

I trust that the reader will restrain himself and not refuse, in an access of indignation, to go along with psychoanalysis on the ground that it leads, as soon as it is applied, to an unpardonable slur on the memory of a great and pure-minded man. It is after all patent that such indignation will never be able to tell us the meaning of Leonardo's childhood fantasy; on the other hand, Leonardo acknowledged this fantasy quite openly, and we will not abandon our expectation – or prejudice, if this term is preferred – that such a fantasy, like any other psychical construct – a dream, a vision, a

delirium – must have some meaning. So let us, for the time being, give a fair hearing to the analytical approach, which has not yet spoken its last word.

The inclination to take the man's organ in one's mouth and suck at it, which in middle-class society counts as a disgusting sexual perversion, is nevertheless very common among women today – and in former times too, as old sculptures testify – and for those who are in love it seems to lose its offensive character entirely. The doctor comes across fantasies based on this inclination, even among women who have not learned of the possibility of such sexual gratification from the pages of Krafft-Ebing's *Psychopathia sexualis* or other sources of information. It appears that women find it easy to create such wishful fantasies spontaneously.[4] Further investigation reveals that this situation, so strictly proscribed by morality, admits of the most innocent derivation. It is nothing but a variant of another situation in which we all felt comfortable once, when we were babies (*essendo io in culla*)[5] [(while I was in my cradle)] and took our mother's or the wet-nurse's nipple in our mouth in order to suck at it. The organic impression of this first experience of pleasure is probably indelibly imprinted on our minds. When the child later becomes acquainted with the cow's udder, which has the function of a nipple and the shape and abdominal position of the penis, he has reached the preliminary stage that leads on to the formation of the offensive fantasy in question.[6]

We now understand why Leonardo transposed the memory of his supposed experience with the vulture into the time when he was a babe in arms. Hidden behind this fantasy is nothing but a reminiscence of sucking, or being suckled, at his mother's breast – a beautiful human scene that he and so many other artists took it upon themselves to depict in relation to the Madonna and Child. There is of course another matter, which we do not wish to lose sight of but do not yet understand, namely that this reminiscence, which is equally significant for both sexes, was transformed by Leonardo, a man, into a passive homosexual fantasy. For the time being we will leave aside the question of a possible connection between homosexuality and the child's sucking at his mother's

breast, and simply recall that according to tradition Leonardo was a man with homosexual leanings. In this connection it is irrelevant whether the charge laid against him as a youth was justified or not: it is not a person's actual behaviour, but his emotional attitude, that determines whether we describe him as subject to inversion.[7]

First, however, another unexplained feature of Leonardo's childhood fantasy claims our attention. We interpret it as relating to his being suckled by his mother, and find the mother replaced by – a vulture. Where does the vulture come from, and how does it enter the story?

An idea suggests itself, but from a source so remote that one might be tempted to dismiss it out of hand. In ancient Egyptian hieroglyphics the mother is represented by the figure of a vulture.[8] Moreover, the Egyptians worshipped a mother goddess who was represented with a vulture's head, or with several heads, at least one of them being a vulture's.[9] The name of this goddess was *Mut*. Can the phonetic similarity to *Mutter*, the German word for 'mother', simply be fortuitous? So there really is a connection between the vulture and the mother, but how can this help us? Can we credit Leonardo with knowing this, given that François Champollion (1790–1832) was the first European to succeed in reading the hieroglyphs?[10]

It would be interesting to know how the ancient Egyptians could have chosen the vulture as the symbol for motherhood. Now, Egyptian religion and culture aroused the curiosity of Greek and Roman scholars, so that, long before we ourselves could read the ancient Egyptian texts, isolated items of information about them were available to us in the extant writings of classical antiquity. Some of these are by well-known authors such as Strabo, Plutarch and Aminiamus Marcellus.[11] Others, which bear unknown names, are of doubtful provenance and cannot be dated with certainty; among these are the *Hieroglyphica* of Horapollo Nilus and the book of oriental priestly wisdom that has come down to us under the name of the god Hermes Trismegistos. From these sources we learn that the vulture was seen as a symbol of motherhood because it was believed that there were only female vultures and no males.[12] Ancient natural history also knew of a male counterpart – the scarab, a species of

beetle that the Egyptians worshipped as divine and of which only males were thought to exist.[13]

Now, how could vultures be impregnated if they were all female? In this connection a passage in Horapollo's work[14] is highly informative. At a certain time these birds stop in mid-flight, open their vaginas, and are impregnated by the wind.

We have now unexpectedly reached a point at which something we lately felt obliged to reject as absurd appears quite probable. Leonardo may well have known the scholarly fable that caused the ancient Egyptians to use the image of the vulture to represent the concept 'mother'. He was widely read, and his interests embraced all branches of literature and science. The *Codex Atlanticus* contains a catalogue of all the books he owned at a certain date[15] and numerous notes about others that he had borrowed from friends, and, to judge by the excerpts assembled from his notes by Fr [J. P.] Richter,[16] we can scarcely overestimate the extent of his reading. Among these books there is no lack of either earlier or contemporary works on natural science. All were in print at the time, and Milan was the main Italian centre for the new art of printing.

If we now go further, we come upon a piece of information that can turn the probability of Leonardo's having known the vulture fable into a certainty. The learned editor of Horapollo,[17] commenting on the passage already cited, writes: 'Caeterum hanc fabulam de vulturibus cupide amplexi sunt Patres Ecclesiastici, ut ita argumento ex rerum natura petito refutarent eos, qui Virginis partum negabant; itaque apud omnes fere hujus rei mentio occurrit' ['But this fable about the vultures was eagerly embraced by the Church Fathers, so that they might confute, with a proof drawn from nature, those who denied the Virgin Birth. The matter is therefore mentioned by nearly all of them'].

The fable of the single-sex vultures and their mode of conception had thus by no means remained a neutral anecdote, like that of the single-sex scarabs. The Church Fathers seized upon it in order to have to hand an argument from natural history that could be used against those who doubted the biblical record. If the best accounts from antiquity stated that vultures had to rely on impregnation by

the wind, why should not the same thing have once happened to a human female? Because it could be exploited in this way, the fable of the vulture was recounted by 'nearly all' the Fathers. Hence, in view of such powerful patronage, there can be hardly any doubt that Leonardo knew it too.

We can now reconstruct the origin of Leonardo's vulture fantasy as follows. He once read, in the writings of a Church Father or a work of natural science, that vultures were all female and could procreate without male assistance. This called to mind a memory that was then transformed into the fantasy in question, the sense of which, however, was that he too had been a 'vulture's child', having a mother but no father, and this was associated, in the only way in which such early impressions can gain expression, with an echo of the pleasure he had known at his mother's breast. The allusion that the writers had established to the idea of the Blessed Virgin and her Child, so dear to every artist, was bound to play a part in making this fantasy seem valuable and meaningful to him. For in this way he came to identify himself with the Christ Child, the Comforter and Saviour – and not just of this one woman.

In dissecting a childhood fantasy, we try to separate the real memory it embodies from the later motives that modify and distort the initial content. In Leonardo's case we now think we know the real content of the fantasy. The replacement of the mother by the vulture indicates that the child was conscious of his father's absence and found himself alone with his mother. The fact that Leonardo was an illegitimate child is in keeping with his vulture fantasy; this alone could have caused him to liken himself to a vulture's child. However, the next attested fact about his childhood is that by the age of five he had been taken into his father's household; as to when this happened – within a few months of his birth or a few weeks before the land register was drawn up – we are totally ignorant. It is here that the interpretation of the vulture fantasy comes into its own; it tells us that Leonardo spent the first, decisive, years of his life not with his father and stepmother, but with his poor, deserted natural mother; he thus had time to feel the absence of his father. This seems a meagre, but at the same time daring, result of psycho-

analytic study, but it will gain in importance as we go into the matter more deeply. Our certainty is strengthened when we consider the actual circumstances of Leonardo's childhood. It is reported that in the very year of Leonardo's birth his father, Ser Piero da Vinci, married the well-born Donna Albiera, and that, because the marriage was childless, Leonardo was taken into his father's house (or rather his grandfather's), as the documentary evidence confirms. Now, it is not usual to place an illegitimate child immediately in the care of a young wife who still hopes to be blessed with offspring. The couple must have suffered years of disappointment before they decided to adopt this illegitimate child, who was probably by now a charming little boy, to compensate for the legitimate children they had hoped for in vain. It accords best with our interpretation of the vulture fantasy if at least three years of Leonardo's life, perhaps even five, had elapsed before he could exchange his single mother for a married couple. But by then it was too late. In the first three or four years of our lives our impressions become fixed, and we develop ways of reacting to the outside world that no later experiences can rob of their significance.

If it is true that the unintelligible memories of a person's childhood and the fantasies that are built on them always bring out what is most important in his psychical development, then the fact that Leonardo spent the first few years of his life with his single mother – a fact confirmed by the vulture fantasy – must have had the most decisive influence on the shaping of his inner life. An inevitable effect of this situation was that the child, who in his early years found he had one problem more to deal with than other children, began to brood on these riddles with particular intensity and so, at a very early age, became a researcher, tormented by the big questions of where babies come from and what part the father plays in the process. An inkling of this connection between his research and the history of his childhood later drew from him the declaration that he had probably always been destined to immerse himself in the study of bird flight, as he had been visited by a vulture while still in his cradle. It will not be difficult, later on, to derive the curiosity that was directed to the flight of birds from his infantile sexual researches.

III

In Leonardo's childhood fantasy we took the vulture to represent the real content of the memory, and the context in which Leonardo himself set the fantasy threw a strong light on the significance that this content had for his later life. Now, pursuing our work of interpretation, we come up against the strange problem of why this recollected content was adapted to a homosexual situation. The mother who suckles the child – or rather, at whose breast the child sucks – is transformed into a vulture, which sticks its tail in the child's mouth. It is our contention that, in accordance with the common practice of lexical substitution, the *coda* of the vulture cannot signify anything other than a male genital organ, a penis. But we do not understand how the play of fancy can go so far as to provide the very bird that represents motherhood with this distinguishing mark of masculinity. Faced with this absurdity, we begin to doubt whether it is possible to distil any reasonable sense from this imaginative construct.

Yet we must not lose heart. How many seemingly absurd dreams have we not forced to yield up their meanings! Why should a childhood fantasy pose more difficulties than a dream?

Remembering that it is unsatisfactory for one peculiarity to be found in isolation, let us quickly add another that is even more striking.

The Egyptian goddess Mut, depicted with a vulture's head and judged by Drexler (in Roscher's lexicon) to be a wholly impersonal figure, was often merged with other mother-goddesses of more striking individuality, such as Isis and Hathor, while retaining her separate existence and cult. It was a peculiar feature of the Egyptian

pantheon that the individual divinities did not disappear in the process of syncretism: the simple figure of the deity continued to exist independently beside the composite entity that resulted from such fusions. Now, in most Egyptian depictions this vulture-headed mother-goddess was endowed with a phallus;[1] her body, though characterized as female by the breasts, was also provided with a male organ in the erect state.

In the goddess Mut, then, we find the same combination of maternal and masculine characteristics as in Leonardo's vulture fantasy! Are we to explain this coincidence by supposing that Leonardo had learned about the androgynous nature of the maternal vulture from his reading? This is highly unlikely; it appears that the sources available to him contained no information about this curious phenomenon. It seems more plausible to trace the coincidence back to a motive that was at work in both cases, but is still unknown.

Mythology teaches us that an androgynous representation, which combines male and female sex characteristics, was not confined to Mut, but shared with other divinities such as Isis and Hathor, though perhaps only insofar as they too had a maternal nature and had merged with Mut.[2] It tells us also that other Egyptian deities, such as Neith of Sais, who later developed into the Greek Athene, were originally conceived of as androgynous, that is hermaphrodite, and that the same was true of many of the *Greek* gods too, especially those associated with Dionysus, but also of Aphrodite, whose role was later restricted to that of a goddess of love. Mythology may then offer the explanation that the phallus, added to the female body, was meant to signify the primal creative force of nature, and that all these hermaphrodite deities convey the idea that only the union of male and female can properly represent divine perfection. Yet none of this can explain the psychologically puzzling fact that the human imagination is not offended when a figure that supposedly embodies the essence of motherhood is endowed with the mark of male potency, the very opposite of the maternal.

The explanation is supplied by infantile sexual theories. There was a time in our lives when the male genital was compatible with the image of the mother. When the male child first directs his

curiosity to the riddles of sexual life, he is dominated by interest in his own genital. He finds this part of his body so valuable, so important, that he cannot believe it might be missing in others who seem so much like himself. Unable to envisage another genital structure of equal worth, he is bound to presume that everyone else – man or woman – has a penis. This preconception takes such firm root in the mind of the young investigator that it is proof against his first observations of little girls' genitals. True, he perceives that in this area they differ somewhat from him, but he cannot admit to himself what this perception implies – that he cannot find a penis in a girl. The idea that the penis might be missing strikes him as weird and intolerable, and so he tries to reach a compromise solution: a girl has a penis too, but it is very small; later it will grow bigger.[3] When this expectation apparently fails to be borne out by subsequent observations, he hits upon another solution: the penis was once present in little girls, but it was cut off, and a wound was left in its place. This theoretical advance draws on personal experiences of a distressing kind: he has meanwhile heard the threat that his precious organ will be taken away from him if he shows too obvious an interest in it. Under the influence of this threat of castration, he now rethinks his view of the female genitals. From now on he will tremble for his masculinity, yet at the same time despise those hapless creatures on whom he thinks this atrocious punishment has already been visited.[4]

Before the child came to be dominated by the castration complex, at a time when he still accorded women their full value, he evolved an intense scopophilia, a voyeuristic propensity prompted by the erotic drive. He wanted to see other people's genitals – at first, no doubt, in order to compare them with his own. The erotic attraction that emanated from his mother soon culminated in a longing for her genital organ, which he took to be a penis. Later, when a child learns that a woman has no penis, this longing often turns into its opposite and gives way to disgust, which in puberty may cause psychical impotence, misogyny and permanent homosexuality. But the fixation on the object he once desired so fervently, the woman's penis, leaves indelible traces in the mental life of the child who has been especially

thorough in carrying out this part of his infantile sexual research. The fetishistic reverence for the female foot and women's shoes seems to take the foot simply as a substitutive symbol for the female organ, once revered and later found to be missing. So-called *coupeurs de nattes* (people who take pleasure in cutting off women's plaits) are unwittingly performing the act of castration on the female genital.

So long as people adhere to an attitude of civilized contempt for the genitals, and sexual functions generally, they will be unable to relate properly to the sexual activities of children and will probably resort to declaring that what is said here is unworthy of belief. If we are to reach an understanding of the child's mental life we need primeval analogies. For generations we have regarded the genitals as *pudenda*, as objects of shame and even, when sexual repression is taken to extremes, of disgust. Taking an overall view of sexual life in our own day – and especially in those classes that sustain human civilization, we are tempted to say that only with reluctance do the majority of those alive today obey the injunction to procreate, and in doing so they feel that their human dignity is offended and degraded.[5] Any other view of sexual life that survives in our society has withdrawn into the unrefined lower orders; in the cultivated ranks of society it hides itself as culturally inferior and ventures into practice only amid embittering strictures from a bad conscience. It was different in the early days of mankind. Students of civilization have laboriously collected material that shows convincingly how the genitals were once the pride and hope of the living; how they were worshipped as divine and conferred the godlike nature of their functions on every new activity learnt by man. The sublimation of their nature gave rise to countless divinities, and after the link between official religion and sexual activity was concealed from the general consciousness, secret cults sought to keep it alive among initiates. Finally, as civilization progressed, so much of the divine and the sacred had been drained from sexuality that the exhausted remains were subject to contempt. However, since all mental traces are by their nature indelible, one should not be surprised to learn that even the most primitive forms of genital worship can be shown

to have survived into quite recent times, and that today's linguistic usage, customs and superstitions contain remnants from every phase of this process of development.[6]

Weighty biological analogies have prepared us for the idea that the individual's psychical development replicates the course of human history in abbreviated form. We shall therefore find nothing improbable in what psychoanalytic research into the child's mind has revealed about the high value it places on the genitals. His assumption that his mother has a penis is the common source to which the androgynous representation of mother-goddesses such as the Egyptian Mut and the vulture's *coda* in Leonardo's infantile fantasy can be traced back. It is of course wrong to call these depictions of the gods 'hermaphrodite' in the medical sense. In none of them are the real genitals of the two sexes combined, as they are in some malformations, to the horror of all who see them: the male member is simply added to the breasts, the mark of motherhood, as it is in the child's first image of his mother's body. Mythology has preserved this time-honoured fantasy for the faithful. We can now translate the emphasis on the vulture's tail in Leonardo's fantasy as follows: 'This was when my tender curiosity was directed to my mother and I still believed that she had a genital organ like my own.' Here is further evidence of Leonardo's early sexual research, which in our view was crucial for the rest of his life.

At this point, a little reflection will warn us not to rest content with our explanation of the vulture's tail in Leonardo's fantasy. There appears to be something more to it, something we still do not understand. After all, the most striking feature of the fantasy is that it transforms the child's sucking at the mother's breast into being suckled, into a passive experience, and so into a situation of an unambiguously homosexual nature. Bearing in mind that in real life Leonardo probably behaved like a man who had homosexual feelings, we are bound to ask whether this fantasy does not indicate a causal link between Leonardo's childhood relationship with his mother and the manifest, if idealized, homosexuality that he displayed later on. We should not venture to infer such a connection from Leonardo's distorted reminiscence if we did not know, from

psychoanalytic studies of homosexuals, that it actually exists and is indeed an intimate and necessary connection.

In our own day, homosexuals campaign vigorously against the restrictions that the law places on their sexual activity and like to present themselves, through their theoretical spokesmen, as a separate sexual subspecies, midway between male and female, as a 'third sex', as men who are innately compelled by organic conditioning to find pleasure in other men and are denied such pleasure in women. Glad though one is, on grounds of humanity, to subscribe to their demands, one cannot help having reservations about their theories, which are advanced with no regard for the psychical genesis of homosexuality. Psychoanalysis supplies the means to fill this gap and put their claims to the test. In this task it has succeeded only with a small number of persons, but all the investigations undertaken so far have yielded the same surprising result.[7] All our male homosexual subjects had had an intense erotic attachment to a woman, usually the mother, in their earliest childhood (which the individual later forgets), an attachment that was evoked or intensified by excessive affection on the mother's part and further reinforced by the withdrawal of the father during childhood. Sadger stresses that the mothers of his homosexual patients were often mannish women of strong character, who were able to oust the father from his proper place. I have occasionally observed the same phenomenon, but I have been more impressed by those cases in which the father was absent from the outset or disappeared from the scene early on, leaving the boy exposed wholly to female influence. Indeed, it seems almost as if the presence of a strong father ensures that when the son comes to choose a sexual object, he will opt correctly for a member of the opposite sex.[8]

After this preliminary stage a transformation takes place, the mechanism of which is familiar to us, though we do not yet understand the motive forces behind it. The child's love for his mother cannot go on developing consciously, and so it yields to repression. The boy represses his love for his mother by putting himself in her place, identifying himself with her, and taking his own person as the model whose likeness will determine his subsequent choice of

love-objects. In this way he becomes a homosexual; he actually slips back into auto-eroticism, since the boys he now loves as he grows up are merely substitutive figures, new versions of the child he once was, and he loves them just as his mother loved him when he was a child. We say that he finds love-objects along the path of *narcissism*, for Greek legend tells of a youth named Narcissus, who loved his own reflection more than anything else and was transformed into the beautiful flower that bears his name.

More profound psychological considerations justify the contention that anyone who becomes a homosexual in this way remains unconsciously fixated on the memory-image of his mother. By repressing his love for his mother, he preserves it in his unconscious and henceforth remains faithful to her. He may appear to be running after boys and acting as a lover, but he is in fact running away from other women, who might cause him to be unfaithful. Through direct observation of individuals we have been able to show that a man who seems susceptible only to male charm is in fact affected like a normal man by the attraction that emanates from women, but whenever this happens he hastens to transfer the excitation he has received from a woman to a male object and thus reactivates, again and again, the mechanism by which he first acquired his homosexuality.

We have no wish to exaggerate the importance of these arguments for the psychical genesis of homosexuality. They are clearly in sharp contradiction to the official theories of those who speak for homosexuals, but we know that they are not comprehensive enough to allow of a definitive clarification of the problem. What is for practical reasons called homosexuality may arise through various psychosexual inhibitory processes; the process we have identified may be one of many and relate to only one type of 'homosexuality'. Moreover, we must concede that, where this type is concerned, the cases in which the required determinants can be shown to exist far outnumber those in which the effect we deduce from them actually occurs; hence, even we cannot discount the involvement of unknown constitutional factors, which are commonly held responsible for all homosexuality. We should have no occasion whatever to go into the psychical origin of the form of homosexuality we have studied, were

it not for a strong presumption that Leonardo himself, whose vulture fantasy was the starting point of our investigation, belonged to this very type.

Few details are known about the sexual conduct of this great artist and scientist, but we may confidently suppose that the statements of contemporaries are unlikely to be greatly mistaken. In the light of tradition, then, he seems to have been a man whose sexual needs and activities were extraordinarily reduced, as if a superior aspiration had raised him above the common creaturely appetites of humanity. Whether he ever sought direct sexual satisfaction – and if so, in what way – or was able to dispense with it entirely, must remain an open question. Yet even in his case we are justified in looking for the emotional currents that impel others to sexual activity, for we cannot believe that anyone's mental life has ever been devoid of an element of sexual desire, in the widest sense of the term – a libidinal element – even if this has diverged far from its original aim or escaped realization.

In Leonardo we cannot expect to find much more than vestiges of untransformed sexual desire. Yet the vestiges we find point in one direction and enable us to classify him as a homosexual. It was always stressed that he took on only strikingly good-looking boys and youths as pupils. He was kind and indulgent to them, looked after them and cared for them when they were sick, as a mother cares for her children – as his own mother doubtless cared for him. Having been chosen for looks rather than talent, none of them – Cesare da Sesto, Boltraffio, Andrea Salaino, Francesco Melzi and others – became a painter of any note. Most failed to make themselves independent of the master, and after his death they disappeared from the scene and left no significant trace in the history of art. There were others whose works might justify their claim to be his pupils – artists such as Luini and Bazzi, called Sodoma – but he probably did not know them personally.

While fully aware of the objection that Leonardo's behaviour towards his pupils was not sexually motivated and warrants no inference regarding his sexual leanings, we would nevertheless submit, with the utmost diffidence, that our approach may account for

75

certain curious aspects of the master's conduct that would otherwise remain rather puzzling. Leonardo kept a diary, in his small, neat hand, with the text running from right to left; it contained notes intended solely for his own use. It is noteworthy that in it he addresses himself in the second person: 'Learn the multiplication of roots from Master Luca.'[9] 'Get Master d'Abaco to show you the squaring of the circle.'[10] Or, when he was planning a journey:[11] 'I am going to Milan on business to do with my garden. Have two baggage trunks made. Get Boltraffio to show you the lathe and get him to polish a stone on it. Leave the book for Master Andrea il Todesco.'[12] Or, in relation to a project of far greater import: 'In your treatise you must show that the earth is a star, like the moon or roughly so, and thus demonstrate the nobility of our world.'[13]

In this diary – which incidentally, like the diaries of other mortals, often touches on the most important events of the day with just a few words or ignores them altogether – some entries are so strange as to be quoted by all Leonardo's biographers. These are notes relating to small sums of money spent by the master and recorded with meticulous care, as if by a pedantically strict and thrifty *paterfamilias*; at the same time there are no records of major expenditure or anything to suggest that Leonardo was at home in keeping household accounts. One of these entries relates to a new cloak bought for his pupil Andrea Salaino:[14]

Silver brocade	15 lire	4	soldi
Red velvet for trimming	9 "	–	"
Braid	– "	9	"
Buttons	– "	12	"

Another very detailed note brings together all the expenses caused by another pupil[15] through his bad character and propensity to theft: 'On the 21st of April 1490 I began this book and started work again on the horse.[16] Jacomo came to me on St Mary Magdalen's Day one thousand 490, aged 10 years. (Marginal note: "thievish, lying, selfish, greedy.") On the second day I had two shirts, a pair of trousers and a jacket made for him. When I put aside the money to pay for

the said items, he stole it from my purse and could not be made to own up, though I was quite sure he had done it (marginal note: "4 lire . . ."). ' The report of the child's misdeeds goes on and ends with an account of the expenses incurred: 'In the first year, one cloak, 2 lire; 6 shirts, 4 lire; 3 jackets, 6 lire; 4 pairs of stockings, 7 lire, etc.'[17]

Nothing is further from the minds of Leonardo's biographers than a desire to solve all the puzzles of their hero's mental life by examining his foibles and idiosyncrasies. In their comments on these curious accounts they usually stress his kindness and indulgence to his pupils, forgetting that what has to be explained is not Leonardo's behaviour, but the fact that he left us this evidence of it. We cannot possibly credit him with wanting to see that proofs of his good nature fell into our hands. So we have to assume that another motive, of an affective kind, caused him to record these notes. It is hard to guess what this motive may have been, and we should be at a loss to suggest one, were it not for another account among Leonardo's papers, which throws a vivid light on these curiously petty notes about his pupils' clothing, etc.:

Expenses after Caterina's death for her funeral	27	florins
2 pounds of wax	18	"
For transporting and setting up the cross	12	"
Catafalque	4	"
Pall-bearers	8	"
For 4 priests and 4 clerks	20	"
Bell-ringing	2	"
For the grave-diggers	16	"
For the licence – to the officials	1	"
Total	108	florins
Previous expenses:		
For the physician	4	florins
For sugar and candles	12	"
	16	"
Grand total	124	florins[18]

The novelist Merezhkovsky is the only writer who can tell us who this Caterina was. From two other short notes he concludes that in 1493 Leonardo's mother, the poor peasant woman from Vinci, came to Milan to see her son, now aged 41, that she fell ill there, that Leonardo placed her in the hospital, and that when she died he honoured her by giving her a costly funeral.[19]

This interpretation by a psychological novelist is not susceptible of proof, but it can lay claim to such inner probability, and is so much in keeping with whatever else we know about Leonardo's emotional life, that I cannot forbear to accept it as correct. Leonardo had managed to subordinate his emotional life to scientific research and inhibit its free expression; but there were occasions when what had been suppressed forced its way to the surface, and the death of his once dearly loved mother was one of these. In the account of her funeral expenses we have an expression of her son's grief, distorted almost beyond recognition. We wonder how such a distortion can arise; we cannot understand it as a product of normal mental processes. Yet under the abnormal conditions of neurosis, and especially of so-called *obsessional neurosis*, we know of similar phenomena. We see the expression of intense feelings, which have been repressed and become unconscious, converted into trivial, even senseless, forms of activity. The opposing forces have succeeded in so degrading the expression of these repressed feelings that one would have to rate their intensity extremely low, were it not that the compulsive nature of this trivial activity revealed the true force of the impulses involved, which is rooted in the unconscious and would be disavowed by the conscious mind. Only such an echo of what occurs in cases of obsessional neurosis can explain Leonardo's account of the funeral expenses he incurred on the death of his mother. In his unconscious he was still tied to her, as he had been in his childhood, by feelings that were erotically tinged; the opposition caused by the later repression of this childhood love did not allow a different, worthier memorial to her to appear in the diary, but the compromise that emerged from this neurotic conflict had to find expression, and so the account of the funeral expenses was entered in the diary, to the bafflement of posterity.

It does not seem unduly bold to apply what we have learnt from the account of the funeral expenses to the accounts relating to pupils. This would then be another instance of the compulsive manner in which the scant remains of Leonardo's libidinal impulses found distorted expression. His mother and his pupils, the likenesses of his own boyish beauty, would thus have been his sexual objects – insofar as the term is appropriate, given the degree of sexual repression that dominated his nature – and the compulsion to record precisely what he had spent on them would in a strange way reveal his rudimentary conflicts. It would thus seem that Leonardo's erotic life really did belong to that type of homosexuality whose psychical development we have been able to discover, and the emergence of the homosexual situation in his vulture fantasy would become intelligible, for it would mean nothing other than what we have already asserted about this type. It would have to be translated as follows: 'It was through this erotic relation to my mother that I became a homosexual.'[20]

IV

Leonardo's vulture fantasy still holds our attention. In words that remind one only too plainly of a description of a sexual act ('and struck me many times with its tail against[1] my lips') Leonardo stresses the intensity of the erotic relations between mother and child. Starting from this connection between the activity of the mother (the vulture) and the emphasis on the region of the mouth, it is not hard to guess that the fantasy involves yet another memory. This we may translate as follows: 'My mother pressed countless passionate kisses on my lips.' The fantasy is made up of the memory of being suckled by his mother and of being kissed by her.

Kindly nature has granted the artist the ability to express his most secret psychical impulses, hidden even from himself, by creating works that have a powerful emotive effect on others – people who are strangers to him and themselves unaware of the source of their emotion. Can it be that there is nothing in Leonardo's life's work that bears witness to what his memory retained as the strongest impression of his childhood? One would certainly expect there was something. Yet if one considers what profound transformations an impression from the artist's life must undergo before it is allowed to contribute to a work of art, one will be bound to reduce any claim to certainty in one's proof, especially in Leonardo's case, to quite a modest level.

Whoever thinks of Leonardo's pictures will be reminded of the strange, fascinating, enigmatic smile that he conjured up on the lips of his female figures – an unchanging smile, on long curved lips, that became a characteristic feature of his style and is often called 'Leonardesque'.[2] It is in the strangely beautiful face of the Florentine Mona Lisa del Giocondo that it has produced the most powerful

and confusing effect on viewers.[3] This smile called for an interpretation, and a great variety of interpretations were forthcoming, but none was satisfactory. 'Voilà quatre siècles bientôt que Monna Lisa fait perdre la tête à tous ceux qui parlent d'elle, après l'avoir longtemps regardée.'[4] ['For almost four centuries now, Mona Lisa has caused all who talk of her, having long contemplated her, to lose their heads.'] Muther writes:[5] 'What particularly captivates the viewer is the demonic magic of this smile. Hundreds of poets and writers have written about this woman, who seems now to smile seductively, now to stare coldly and soullessly into the void. No one has solved the riddle of her smile, no one has interpreted her thoughts. Everything, even the landscape, is mysteriously dream-like, as if trembling in a kind of sultry sensuality.'

The idea that two different elements combine in the Gioconda's smile has suggested itself to several critics. They therefore find, in the facial expression of this Florentine beauty, the most perfect reflection of the contrasts that dominate the erotic life of women: reserve and seduction, devoted tenderness and ruthlessly demanding sensuality, which consumes men as if they were alien beings. This is how Müntz puts it:[6] 'On sait quelle énigme indéchiffrable et passionnante Monna Lisa Gioconde ne cesse, depuis bientôt quatre siècles, de proposer aux admirateurs pressés devant elle. Jamais artiste (j'emprunte la plume du délicat écrivain qui se cache sous le pseudonyme de Pierre de Corlay) "a-t-il traduit ainsi l'essence même de la féminité: tendresse et coquetterie, pudeur et sourde volupté, tout le mystère d'un coeur qui se réserve; d'un cerveau qui réfléchit, d'une personnalité qui se garde et ne livre d'elle-même que son rayonnement . . ."' ['We know what an insoluble and enthralling enigma Mona Lisa Gioconda has for almost four centuries unceasingly presented to the admirers who crowd in front of her. No artist (here I borrow the words of the sensitive writer who hides behind the pseudonym Pierre de Corlay) "has ever so well expressed the very essence of femininity – tenderness and coquetry, modesty and secret sensuality, all the mystery of a heart that holds itself aloof, of a brain that reflects, of a personality that holds back and yields nothing of itself but its radiance . . ."'] The Italian Angelo Conti[7]

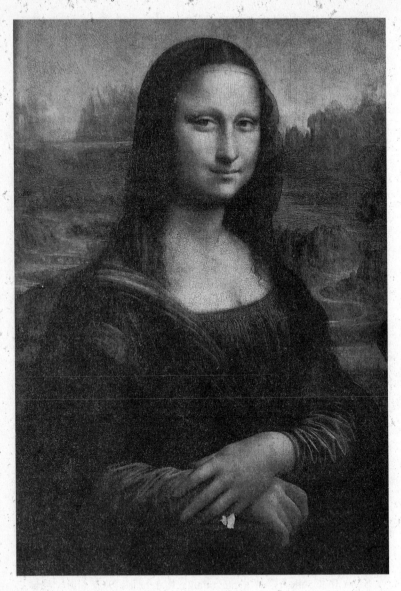

Plate 1. Leonardo's *Mona Lisa*. (*Louvre, Paris*)

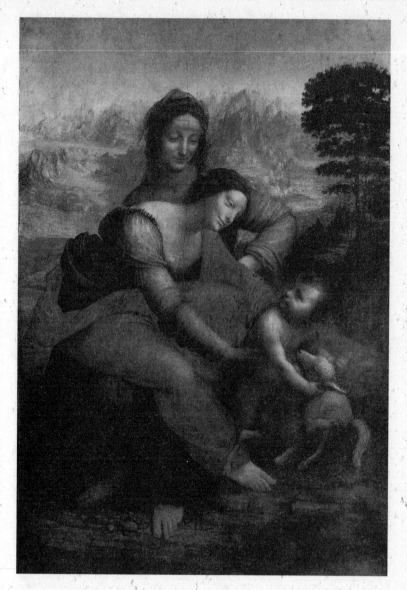

Plate 2. Leonardo's *Madonna and Child with St Anne.* (*Louvre, Paris*)

sees the picture in the Louvre illuminated by a ray of sunshine: 'La donna sorrideva in una calma regale: i suoi istinti di conquista, di ferocia, tutta l'eredità della specie, la volontà della seduzione e dell' agguato, la grazia del inganno, la bontà che cela un proposito crudele, tutto ciò appariva alternativamente e scompariva dietro il velo rid-ente e si fondeva nel poema del suo sorriso . . . Buona e malvagia, crudele e compassionevole, graziosa e felina, ella rideva . . .' ['The lady smiled in regal calm: her instincts of conquest, of ferocity, all the heredity of the species, the will to seduce and ensnare, the charm of deceit, the kindness that conceals a cruel purpose – all this appeared and disappeared by turns behind the veil of laughter and buried itself in the poem of her smile . . . Good and wicked, cruel and compassionate, graceful and feline, she laughed . . .']

Leonardo worked on this picture for four years, perhaps from 1503 to 1507, during his second period in Florence, when he was over fifty. According to Vasari's account he used the most elaborate devices in order to divert the lady during sittings and keep this famous smile playing on her features. Of all the subtleties his brush reproduced on the canvas, little is preserved by the picture in its present state. While it was being painted it was judged the acme of all that art could achieve. Yet it certainly did not satisfy Leonardo, who declared it unfinished and did not deliver it to the person who had commissioned it, but took it with him to France, where his patron, Francis I, acquired it from him for the Louvre.

Let us leave the riddle of Mona Lisa's expression unsolved and note the undoubted fact that her smile fascinated the artist himself no less than all who have contemplated it in the past four centuries. From now on this entrancing smile recurred in all his paintings and those of his pupils. Since the *Mona Lisa* is a portrait, one cannot suppose that he took it upon himself to lend such an expressive feature to the face of the sitter unless she already possessed it. We seem to have hardly any choice but to believe that he found this smile in his model and fell so much under its spell that from now on he bestowed it on the independent creations of his imagination. This fairly obvious view is expressed, for instance, by A. Konstantinowa, who writes:[8] 'During the long period when the master was working

on the portrait of Mona Lisa del Giocondo, he immersed himself with such sympathy in the subtleties of this woman's expression that he transferred these features – especially the mysterious smile and the strange gaze – to all the faces he painted or drew from now on. The Gioconda's strange facial expression can be perceived even in the picture of John the Baptist, which also hangs in the Louvre, but above all it can be clearly recognized in the expression on the face of Mary in the *Madonna and Child with St Anne*.[9]

Yet it may have happened differently. More than one of Leonardo's biographers have felt that there must be a deeper reason for the attraction of the Gioconda's smile, which took hold of the artist and never released its hold. Walter Pater, who sees the picture of Mona Lisa as the 'embodiment of all civilized humanity's experience of love' and writes very sensitively of 'that unfathomable smile, always with a touch of something sinister in it, which plays all over Leonardo's work', gives us another clue when he says:[10] 'Besides, the picture is a portrait. From childhood we see this image defining itself on the fabric of his dreams; and were it not for express historical testimony, we might fancy that this was but his ideal lady, embodied and beheld at last . . .'

M. Herzfeld has probably something similar in mind when she declares that in Mona Lisa Leonardo encountered himself and was therefore able to put so much of his own nature into the picture, 'whose features had lain all along in mysterious sympathy within Leonardo's mind'.[11]

Let us attempt to develop and clarify these suggestions. Maybe Leonardo was captivated by Mona Lisa's smile because it awoke in him something that had long lain dormant in his mind, probably an old memory, but one so significant that, once aroused, it did not release its hold on him, so that he was repeatedly impelled to give it fresh expression. Pater's statement that we can see how, from childhood on, a face like Mona Lisa's mixed into the fabric of his dreams seems credible and deserves to be understood literally.

Vasari mentions, as the subjects of Leonardo's first artistic efforts, 'teste di femmine, che ridono' ['heads of laughing women'].[12] The passage in question, which is beyond any suspicion of falsification, as it does not seek to prove anything, is rendered more fully in

Schorn's German translation:[13] 'In his youth he formed some heads of laughing women out of clay, which were reproduced in plaster, and some heads of children, which were as beautiful as if they had been fashioned by the hand of a master . . .'

We learn, then, that Leonardo's artistic career began with the representation of two kinds of object, and these are bound to recall the two kinds of sexual object that we have inferred from our analysis of his vulture fantasy. If the beautiful children's heads were reproductions of himself as a child, then the smiling women were nothing other than replicas of Caterina, his mother, and we begin to glimpse the possibility that his mother may have possessed that mysterious smile, whose image he had lost, and that so captivated him when he found it again in the Florentine lady.[14]

The work of Leonardo's that is closest in time to the *Mona Lisa* is the painting of *St Anne with the Madonna and Child* ('St Anne with two others'). In both women's faces we see the 'Leonardesque' smile at its most beautiful. We cannot know how long before or after the *Mona Lisa* the artist began to paint this picture. Work on both went on for years, and so it may be assumed that Leonardo was occupied with both at the same time. It would fit in best with our expectations if his intense preoccupation with the features of Mona Lisa had prompted him to create the St Anne composition out of his imagination. For if the Gioconda's smile conjured up the memory of his mother, we can understand that it at first impelled him to create a work that glorified motherhood and to restore to his own mother the smile that he had found in the face of the grand Florentine lady. So we may allow our interest to pass from the portrait of Mona Lisa to the other, hardly less beautiful picture by Leonardo, which also hangs in the Louvre.

St Anne with her daughter and grandson is a subject rarely treated in Italian art, and in any case Leonardo's depiction differs substantially from all other known versions. Muther writes:[15] 'Some masters, such as Hans Fries, the elder Holbein and Girolamo dai Libri, had Anna sitting beside Mary, with the child between them. Others, such as Jakob Cornelisz, in his Berlin picture, showed 'St Anne and two others' in the true sense of the phrase – St Anne

holding in her arms the small figure of Mary, with the still smaller figure of the infant Christ sitting on Mary's lap. In Leonardo's painting Mary sits on her mother's lap, leaning forward and stretching out her arms to the child, who is playing with a lamb, probably rather roughly. The grandmother rests her unconcealed arm on her hip and looks down at the pair with a blissful smile. The grouping is certainly not altogether unforced. Yet although the smile that plays on the lips of the two women is undoubtedly the same as the one we see in the *Mona Lisa*, it has lost its uncanny, enigmatic character and now expresses inwardness of feeling and silent happiness.[16]

After contemplating this picture for some time, the viewer suddenly realizes that only Leonardo could have painted it, just as he alone could have invented the vulture fantasy. The picture contains a synthesis of the story of his childhood; its details can be explained by reference to the most personal impressions of his life. In his father's house he found not only his kindly stepmother, Donna Albiera, but his paternal grandmother, Monna Lucia, whom we will assume to have been no less affectionate towards him than grandmothers usually are. These circumstances may well have suggested to him a representation of childhood, watched over by a mother and a grandmother. St Anne, the mother of Mary and the grandmother of the Christ Child, should have been a matronly figure. Yet here she is depicted as perhaps slightly more mature and serious than Mary, but still as a young woman of unfaded beauty. Leonardo has actually given the child two mothers, one who stretches out her arms to him and another in the background; and both are endowed with the blissful smile that expresses the joy of motherhood. This peculiarity of the picture has not failed to amaze the commentators. Muther, for instance, thinks that Leonardo could not bear to paint old age, with its lines and wrinkles, and so made St Anne too into a woman of radiant beauty. Can one rest content with this explanation? Others have resorted to denying the 'equality of age of mother and daughter'.[17] However, Muther's attempt at an explanation probably suffices to show that the impression that St Anne has been made to look young derives from the picture itself and is not invented for a tendentious purpose.

Leonardo's childhood had been just as curious as his picture. He had had two mothers: his natural mother, Caterina, from whom he was separated at some point between the ages of three and five, and a young, affectionate stepmother, Donna Albiera, his father's wife. It was through the linking of this fact about his childhood with the artistic one mentioned above – the simultaneous presence of both mother and grandmother[18] – and their combination in a complex unity that the composition of *St Anne and Two Others* took shape. The maternal figure furthest from the child – the grandmother – would seem, on the basis of her appearance and the distance between her and the child, to correspond to Caterina, Leonardo's real mother. With St Anne's blissful smile the artist probably sought to deny and conceal the envy that this unhappy woman felt when she had to give up her son, as she had already given up his father, to her socially superior rival.[19]

We thus seem to have found some confirmation, in another work by Leonardo, of our surmise that the smile of Mona Lisa del Giocondo awakened in the grown man the memory of the mother he had known in infancy. From now on, Italian painters would depict madonnas and grand ladies humbly bowing their heads and smiling the strange, blissful smile of the poor peasant girl Caterina, who brought her wonderful son into the world to paint, to engage in scientific research and to suffer.

If Leonardo succeeded in conveying, in the face of Mona Lisa, the double meaning of this smile – its promise of boundless tenderness and its hint of what Pater called 'sinister menace' – then in this too he remained true to the content of his earliest memory. For his mother's tenderness was fateful for him: it determined his destiny and the privations that lay in store for him. The violence of her caresses, as indicated by his vulture fantasy, was only too natural, for in her love for her child this poor, deserted mother had to merge all her memories of past tenderness and her longing for its renewal. She was forced to compensate not only herself – for having no man to caress her – but also her child, for having no father to fondle him. And so, like all unsatisfied mothers, she substituted her little son for her lover and, through his erotic precocity, robbed him of part of his

masculinity. A mother's love for the infant she suckles and cares for is far deeper than her later affection for the growing child. It has the character of a completely satisfying love relationship, fulfilling not only every mental wish, but every physical need; and if it represents one of the forms of happiness attainable to mankind, this is due in no small measure to the possibility that it affords of satisfying, without reproach, wishful impulses that have long been repressed and must be called perverted.[20] In the early stages of even the happiest marriage the father realizes that his child, and especially a little son, has become his rival, and this is the starting point for an antagonism towards the favourite that has deep roots in the unconscious.

When Leonardo, at the high point of his life, once more encountered that blissful, ecstatic smile that had played on his mother's lips as she fondled him, he had long been dominated by an inhibition that forbade him ever to desire such tenderness from a woman's lips again. But he had become a painter, and so he strove to recreate this smile with his brush; and he gave it to all his pictures, whether executed by himself or by his pupils under his direction – to the *Leda*, the *John the Baptist* and the *Bacchus*. The last two are variants of the same type. Muther says:[21] 'Out of the locust-eater of the Bible Leonardo made a Bacchus, a young Apollo, who, with an enigmatic smile on his lips and his smooth legs crossed, gazes at us with eyes that bewitch the senses.' These pictures exhale a mysticism into whose secret one dare not penetrate; one can at most try to establish their connection with Leonardo's earlier creations. The figures are again androgynous, but no longer in the manner of the vulture fantasy. They are handsome youths, endowed with feminine delicacy and effeminate forms; they do not lower their eyes, but gaze at us in mysterious triumph, as if they knew of some great joyous achievement that must not be spoken of; the familiar, entrancing smile suggests that it is a secret to do with love. It may be that in these figures Leonardo denies the unhappiness of his erotic life and has triumphed over it in his art, by showing how the desires of the boy who was once infatuated by his mother are fulfilled in this blissful union of the male and and the female nature.

V

Among the entries in Leonardo's diaries is one that holds the reader's attention on account of its significant content and a slight formal error: In July 1504 he wrote: 'Adì 9 di Luglio 1504 mercoledì a ore 7 morì Ser Piero da Vinci, notalio al palazzo del Potestà, mio padre, a ore 7. Era d'età d'anni 80, lasciò 10 figlioli maschi e 2 femmine.'[1] ['On 9 July 1504, Wednesday, at 7 o'clock died Ser Piero da Vinci, notary at the palace of the Podestà, my father, at 7 o'clock. He was 80 years old, and left 10 sons and 2 daughters.'] The note relates, then, to the death of Leonardo's father. The small formal error consists in the repetition of the time of day: the phrase 'a ore 7' occurs twice, as if by the end of the sentence Leonardo had forgotten that he had written it down at the beginning. This is a trifle, and anyone other than a psychoanalyst would attach no importance to it. He might not even notice it, and if his attention were drawn to it he would say, 'That can happen to anybody in a moment of distraction, or under the stress of emotion, and is of no further consequence.'

The psychoanalyst thinks differently; for him nothing is too small to be an expression of hidden mental processes. He learned long ago that such instances of forgetting or repetition are significant, and that it is to 'distraction' that we owe the revelation of impulses that are otherwise hidden.

We shall say that this note too, like the account of the expenses for Caterina's funeral and the accounts of pupils' expenses, is yet another instance of Leonardo's failing to suppress his emotions and being forced to give distorted expression to what had long been concealed. The form too is similar – the same pedantic exactitude, the same obtrusion of numbers.[2]

Such a repetition is called a perseveration. It is an excellent indicator of affective emphasis. Consider, for example, St Peter's tirade against his unworthy earthly representative in Dante's *Paradiso*:

> *Quegli ch'usurpa in terra il luogo mio,*
> *Il luogo mio, il luogo mio, che vaca*
> *Nella presenza del Figliuol di Dio,*

> *Fatto ha del cimiterio mio cloaca.*[3]

['He who on earth usurps my place, my place, my place, which in the presence of the Son of God is vacant, has made a sewer of the ground where I am buried.']

Had it not been for Leonardo's affective inhibition, the entry in the diary might have read: 'Today at 7 o'clock my father died, Ser Piero da Vinci, my poor father!' But the shifting of the perseveration to the least important detail in the account, the hour of death, robs the entry of any emotion and gives us just the merest hint that something here was to be concealed and suppressed.

Ser Piero da Vinci, a notary born into a family of notaries, was a man of great energy who won himself esteem and affluence. He married four times. His first two wives died childless; the third bore him his first legitimate son in 1476, when Leonardo, then aged twenty-four, had long since exchanged the paternal home for the studio of his master, Verrocchio. His fourth and last wife, whom he married in his fifties, bore him nine sons and two daughters.[4]

There is no doubt that this father too came to play a significant part in Leonardo's psychosexual development – and not just negatively, by being absent during the first years of the boy's childhood, but directly too, through his presence during his later childhood. Nobody who, as a child, desires his mother can avoid wanting to put himself in his father's place, identifying himself with him in his imagination, and later making it his life's task to get the better of him. When Leonardo, not yet five years old, was received into his grandfather's house, his young stepmother, Albiera, must have replaced his natural mother where his feelings were concerned, so

that he entered into what may be called the normal relationship of rivalry with his father. As we know, the decision in favour of homosexuality does not take place until about the time of puberty. Once this decision was made in Leonardo's case, his identification with his father lost all significance for his sexual life, but it continued in other, non-erotic spheres of activity. We hear that he was fond of splendour and fine clothes, and that he kept servants and horses, though Vasari tells us that he 'possessed almost nothing and did little work'. Such tastes are not to be attributed solely to his sense of beauty: we can also recognize in them a compulsion to copy and outdo his father. To the poor peasant girl his father had been the grand gentleman; hence, the son felt a continuing urge to play the grand gentleman, to 'out-herod Herod',[5] to show his father what real grandeur was.

There is no doubt that the creative artist feels like a father towards his works. But for Leonardo's creativity as a painter the identification with his father had a fateful consequence. Having created his works, he ceased to care about them, just as his father had ceased to care about him. The concern that his father showed later could not alter this compulsion, for the compulsion derived from the impressions of the first years of childhood; what has been repressed and remains unconscious cannot be corrected by later experience.

In the age of the Renaissance – as in much later times too – every artist needed a gentleman of rank, a benefactor, a *padrone*, who gave him commissions and held his destiny in his hands. Leonardo found a patron in the ambitious Ludovico Sforza, Duke of Milan, known as Il Moro, a lover of splendour and a shrewd diplomat, but also an erratic and unreliable character. It was at Ludovico's court that Leonardo spent the most brilliant years of his life; in his service he gave the most uninhibited scope to his creative powers, to which the *Last Supper* and the equestrian statue of Francesco Sforza bore witness. He left Milan before Ludovico was overtaken by catastrophe and died in a French dungeon. Hearing of his patron's fate, Leonardo wrote in his diary: 'The duke lost his state, his property and his liberty, and none of the works he undertook was completed.'[6] It is curious, and certainly not without significance, that here he levels at his patron the very reproach that posterity would direct against

him; it is as though he wished to make one of his father-figures responsible for the fact that his own works were left unfinished. In fact he was not wrong in what he said about the Duke.

But if Leonardo's imitation of his father was detrimental to his art, his rebellion against him was the infantile determinant of his perhaps equally magnificent achievement in the field of scientific research. In an admirable simile Merezhkovsky likens him to a man who had woken up too early, when it was still dark and everyone else was still asleep.[7] He dared to utter the bold proposition, which after all contains the justification of all independent research: 'Whoever appeals to authority when opinions differ is working with his memory, not with his reason.'[8] He thus became the first natural scientist of modern times, and an abundance of discoveries and conjectures rewarded the courage he showed in being the first person since Greek times to rely solely on observation and his own judgement when approaching the secrets of nature. But in teaching that authority is to be looked down on and the imitation of the 'ancients' rejected, in constantly pointing to the study of nature as the source of all truth, he was merely repeating, in the highest sublimation attainable to man, the point of view that had already forced itself on him when, as a little boy, he gazed in wonder at the world. Translated back from scientific abstraction into concrete individual experience, the ancients and authority simply corresponded to his father, and nature became once more the tender, kindly mother who had nursed him. Whereas for most other human beings – today no less than in primitive times – the need for some kind of authority to rely on is so imperative that their world begins to totter if this authority is threatened, Leonardo could dispense with this support. He could not have done so had he not learnt to do without his father in his earliest years. The boldness and independence of his later scientific research presupposed previous infantile sexual researches, uninhibited by his father, and ensured their continuation – with the sexual element excluded.

If someone has escaped being intimidated by his father in his earliest[9] childhood, as Leonardo did, and has thrown off the shackles of authority in his research, it would be sharply at odds with our

expectations if we were to find that he had remained a believer and been unable to escape from dogmatic religion. Psychoanalysis has made us aware of the intimate connection between the father-complex and belief in God; it has shown that, psychologically, the personal God is nothing other than an exalted father, and it furnishes daily proof of how young people lose their religious faith as soon as paternal authority breaks down. We thus recognize that the need for religion has its roots in the parental complex: the almighty, just God and kindly Nature appear to us as grandiose sublimations of father and mother, or rather as renewals and restorations of the young child's images of them. In biological terms, religiosity can be traced back to the small child's prolonged helplessness and need of help; later, having realized how forlorn and powerless he really is in the face of the great forces of life, he feels that his situation is much the same as it was in his infancy, and he seeks to deny its wretchedness by a regressive revival of the forces that protected him then. The protection against neurotic illness that religion offers the faithful is easily explained by the fact that it removes their parental complex, on which the sense of guilt depends, in individuals and in mankind as a whole, and disposes of it for them, while the unbeliever has to grapple with the problem on his own.[10]

It does not seem as if Leonardo's example could show this view of religious belief to be incorrect. Accusations of unbelief or – what at the time amounted to the same thing – of apostasy from the Christian faith were already in the air during his lifetime and found expression in the first version of Vasari's life of Leonardo.[11] In the second edition of the *Vite*, published in 1568, Vasari expunged these remarks. We find it perfectly understandable, in view of the extraordinary sensitivity of the age in matters of religion, that Leonardo should have refrained, even in his notebooks, from any direct statements about his attitude to Christianity. In his scientific research he did not allow himself to be at all misled by the scriptural accounts of the Creation: he disputed, for instance, the possibility of a universal Flood, and in geology he reckoned in terms of hundreds of thousands of years as unreservedly as modern scientists.

Among his 'prophecies' there are a number that could not have

V *Leonardo da Vinci*

failed to offend the sensitivities of a Christian believer, for example:[12]

Of praying to images of the saints:

'Men will speak to men who hear nothing, who have their eyes open and do not see; they will speak to them and receive no answer; they will ask for grace from him who has ears and does not hear; they will light candles for him who is blind.'

Or this:[13]

Of mourning on Good Friday:

'In all parts of Europe great numbers of people will weep for the death of a single man who died in the East.'

It has been said of Leonardo's art that he took from the sacred figures the last remnant of their ties with the Church and drew them into the human world, so that he could use them to represent great and beautiful human emotions. Muther praises him for overcoming the mood of decadence and restoring to human beings the right to sensuality and the enjoyment of life. In his notes, which show him engrossed in fathoming the great riddles of nature, there is no dearth of passages that express his admiration for the Creator, the ultimate cause of all these glorious mysteries, but there is nothing to suggest that he sought a personal relationship with this divine being. The propositions in which he couched the profound wisdom of his final years convey the resignation of the human being who subjects himself to Ἀνάγκη ('Necessity'), the laws of nature, and expects no mitigation from God's goodness or grace. There is hardly any doubt that Leonardo had put both dogmatic and personal religion behind him and that through his research he had moved far away from the world view of the Christian believer.

Our insights into the development of the mental life of children, which were mentioned earlier, suggest that in Leonardo's case too the first infantile researches were concerned with problems of sexuality. Yet he reveals this to us himself, in a fairly transparent disguise, by linking his urge to pursue scientific research with the fantasy of the vulture and by singling out the flight of birds as a problem to which he was destined to apply himself, owing to a particular combination of circumstances. In his notes on the flight of birds there is a quite obscure passage that sounds almost like a

prophecy and affords the clearest evidence of the affection with which Leonardo clung to his desire to be able to imitate the art of flying himself: 'The great bird will set off on its first flight from the back of its great swan; it will fill the universe with astonishment and all the books with its fame, and it will be the everlasting glory of the nest in which it was born.'[14] He probably hoped he would one day be able to fly, and we know from the wishful dreams of our subjects what joy they expect from the fulfilment of this hope.

Yet why do so many people dream of being able to fly? The answer of psychoanalysis is that to fly – to be a bird – is only a disguise for another wish, to which we have more than one linguistic and factual pointer. If curious youngsters are told that babies are brought by a big bird such as the stork, if the ancients depicted the phallus with wings, if the commonest German verb for male sexual activity is *vögeln*, derived from the noun *Vogel* ('bird'), and if the Italians call the male organ simply *l'uccello* ('the bird'), then these are just fragments from a larger complex, which teaches us that in our dreams the desire to be able to fly signifies nothing other than a longing to be capable of sexual achievements.[15] This is an early infantile wish. When adults remember their childhood, it is as a happy time in which they enjoyed the passing moment and approached the future with no particular desires, and this is why they envy children. But the children themselves, were they able to inform us earlier,[16] would probably tell a different story. It seems that childhood is not the blissful idyll into which we subsequently distort it, but that we are whipped through the years of childhood by one desire – to become grown-up and do what grown-ups do. This desire motivates all children's games. If children sense, in pursuing their sexual researches, that in this one puzzling, but important sphere a grown-up can do something wonderful that they are not permitted to know about, let alone do, they are seized by a violent wish to be able to do the same, and they dream about it in the form of flying or disguise it in this way in preparation for dreams of flying that they will have later. Thus even aviation, which is finally reaching its goal in our own day, has its roots in infantile eroticism.

By telling us that ever since his childhood he has felt a special

personal link with the problem of flight, Leonardo confirms that his childish researches were directed to sexual matters, as in fact we were bound to surmise on the basis of our studies of modern children. This one problem at least had escaped the repression that later alienated him from sexuality; from childhood until the years of full intellectual maturity, it was a problem that continued to interest him, with slight modifications in its meaning, and it may be that he had no more success in acquiring the desired skill in its primary (sexual) sense than in its mechanical sense – that both wishes were denied him.

Indeed, in some ways the great Leonardo remained a child throughout his life; it is said that all great men necessarily retain something of the child about them. Even as an adult he went on playing, and this sometimes made him seem strange and perplexing to his contemporaries. If he constructed the most ingenious mechanical toys for court festivities and ceremonial receptions, it is only we who are dissatisfied, for we do not like to see the master applying his great gifts to such trifles; he himself does not seem to have minded spending his time in this way, for Vasari tells us that he made such things even when he was not commissioned to do so: 'There (in Rome) he got a soft lump of wax and made very delicate animals out of it, filled with air; when he blew into them they flew around, and when the air ran out they fell to the ground. For a peculiar lizard that was found by the vintner of Belvedere he made wings from skins torn from other lizards, then filled them with quicksilver, so that they moved and quivered when it walked. Then he made eyes, a beard and horns for it, tamed it, put it in a box, and scared all his friends with it.'[17] Such frivolities often served to express serious ideas: 'He often had a sheep's intestines cleaned so carefully that they could be held in the hollow of the hand; he would carry them into a large room, take a pair of smith's bellows into an adjoining room, fasten the intestines to them and inflate these until they took up the whole room and people had to move into a corner. In this way he showed how they gradually became transparent and filled with air; and because they at first took up very little space, but then expanded to fill the whole of the room, he compared them with genius.'[18] The same playful delight in harmlessly concealing things

and giving them ingenious disguises is illustrated by his fables and riddles. The latter are cast in the form of 'prophecies'; nearly all are rich in ideas and remarkably lacking in wit.

In some cases the games and pranks that Leonardo allowed his fancy to play have seriously misled his biographers, who have misunderstood this side of his character. Among Leonardo's Milanese manuscripts there are for instance drafts of letters to the 'Diodario of Sorio (Syria), Viceroy of the Holy Sultan of Babylonia', in which he presents himself as an engineer who was sent to these regions of the Orient to carry out certain works, defends himself against the charge of idleness, provides geographical descriptions of towns and mountains, and concludes with a description of a great natural event that took place while he was there.[19]

In 1883 J. P. Richter tried to prove from these documents that Leonardo had really made these observations while travelling in the service of the Sultan of Egypt and had even adopted the Mohammedan religion while in the East. These travels supposedly took place before 1483, that is to say, before he moved to the court of the Duke of Milan. However, other authors have had no difficulty in recognizing the evidence of Leonardo's supposed oriental travels for what it was – a fantastical invention by a young artist, meant for his own amusement and expressing, perhaps, a desire to see the world and meet with adventure.

Another product of Leonardo's imagination is probably the 'Academia Vinciana', whose existence has been presumed on the basis of five or six emblems, highly intricate patterns containing the name of the academy. Vasari mentions these drawings, but not the academy.[20] Müntz, who places such an ornament on the cover of his big work on Leonardo, was among the few who believed that it really existed.

It is likely that Leonardo's play drive disappeared in his maturer years and was absorbed into his research activity, which represented the last, supreme unfolding of his personality. But the fact that it survived for so long shows how long it takes a person to tear himself away from his childhood if, in this early period of his life, he enjoyed the highest erotic bliss and has never recaptured it.

VI

It would be pointless to blind oneself to the fact that there is a general distaste among readers today for any study of an individual that emphasizes the influence of disease on his life and character. Their aversion is dressed up in the reproach that such an account of a great man can never lead to an understanding of his importance and achievement, and that it is therefore useless and mischievous to study in him things that can be found just as easily in the first person one happens upon. Yet this criticism is so patently unjust that it can be understood only as a pretext and a disguise. It is in no way the purpose of such a study to make a great man's achievements understandable, and surely no one should be blamed for failing to keep a promise he never made. The true motives behind this aversion are different. We can discover them if we bear in mind that biographers are fixated on their heroes in a quite peculiar way. A biographer will often choose a certain person as his subject because, for reasons to do with his own emotional life, he has always felt a special affection for him. He will then engage in an exercise in idealization and try to place the great man within a series of childhood models, and perhaps to renew in him the infantile image of his own father. In accordance with this wish, he obliterates any individual features in the subject's physiognomy; he smooths out any traces of the internal and external conflicts in his life, refuses to tolerate any vestiges of human weakness or imperfection in him, and then presents us with what turns out to be a cold, alien, idealized figure, rather than a real human being to whom we might feel some remote affinity. It is to be regretted that biographers act in this way, for in doing so they sacrifice truth to illusion and, by indulging their

infantile fantasies, forfeit the opportunity to penetrate the most fascinating secrets of human nature.[1]

Leonardo himself, with his love of truth and his thirst for knowledge, would not have objected to an attempt to use the minor oddities and riddles in his nature as clues to what determined his psychical and intellectual development. We do him homage by learning from him. It does not detract from his greatness if we study the sacrifices that his development, from childhood on, was bound to cost him and bring together those factors that impressed the tragic mark of failure on his personality.

Let us stress that we have never numbered Leonardo among the neurotics – or 'nerve cases', to borrow an inelegant phrase. Whoever complains about our daring to apply to him what has been learnt from pathology is still clinging to prejudices that are now rightly abandoned. We no longer believe that a sharp distinction can be made between health and sickness, between the normal and the neurotic, and that neurotic traits must be taken as evidence of general inferiority. Today we know that neurotic symptoms are substitutive structures that compensate for certain repressions that are inevitable in our passage from infancy to civilized adulthood, that we all produce such substitutive structures, and that only their frequency, intensity and distribution can justify the practical concept of sickness and the inference of constitutional inferiority. On the basis of the minor indications that we find in Leonardo's personality, we are justified in associating him with the neurotic type that we describe as 'obsessional', in comparing his research with the 'obsessive brooding' of neurotics and his inhibitions with their so-called 'abulias'.

The aim of this study has been to explain the inhibitions in Leonardo's sexual life and artistic activity. With this end in view we may perhaps be permitted to sum up what we have been able to conjecture about the course of his psychical development.

All knowledge of his heredity is denied us. On the other hand, we recognize that the accidental circumstances of his childhood had a profound and disturbing effect on him. His illegitimate birth removed him from his father's influence until perhaps his fifth year

and left him to the tender seductive attentions of a mother whose only solace he was. Kissed by her into sexual precocity, he may well have entered upon a phase of infantile sexual activity, of which only one manifestation is attested with any certainty – the intensity of his infantile sexual researches. It was the scopophilic and the investigative drive that were most powerfully stimulated by the impressions he received in his earliest childhood, and the erogenous zone of the mouth acquired a prominence that it never lost. From his later behaviour, which tended in the opposite direction – from his excessive compassion for animals, for instance – we may conclude that at this period of his childhood there was no lack of pronounced sadistic traits.

A phase of strenuous repression put an end to this infantile excess and established the dispositions that would become evident in puberty. Probably the most striking result of this transformation was an aversion to any crudely sensual activity: Leonardo would be able to lead a life of abstinence and give the impression of being asexual. When the excitations of puberty flooded in upon him, they would not make him sick or force him to develop substitutive structures of a costly and damaging kind. Owing to his early propensity to sexual curiosity, most of the needs of his sex drive could be sublimated into a general thirst for knowledge and so escape repression. From now on a far smaller portion of his libido would be directed to sexual aims and represent the stunted sexual life of the grown man. Following the repression of his love for his mother, this portion of his libido would be forced into homosexual channels and express itself as an idealized love of boys. The fixation on his mother, and the rapturous memories of his relationship with her, lived on in the unconscious, but remained for the time being inactive. And so repression, fixation and sublimation all played a part in determining the contribution of the sex drive to Leonardo's mental life.

From his obscure boyhood Leonardo emerges before us as an artist – a painter and a sculptor – thanks to a specific gift that may have been enhanced by the precocious awakening of the scopophilic drive in early childhood. We should like to show how artistic activity

derives from the primal psychical drives, but it is precisely here that the means at our disposal prove inadequate. So we will content ourselves with stressing the fact – which can scarcely be doubted any longer – that an artist's creative work also provides an outlet for his sexual desires, and with pointing, in Leonardo's case, to Vasari's report that heads of smiling women and beautiful boys – representations of his sexual objects, in other words – were notable among his earliest artistic endeavours. In the first bloom of youth Leonardo seems to have worked without inhibitions. Just as he took his father as a model in his outward conduct, so he went through a period of masculine creative power and artistic productivity in Milan, where a propitious destiny enabled him to find a father-substitute in Duke Lodovico Moro. But we soon find confirmation in him of what we know from experience: that the almost total suppression of real sexual life does not provide the most favourable conditions for the exercise of sublimated sexual strivings. The pattern imposed by sexual life made itself felt: his activity and the ability to make quick decisions began to flag; the tendency to deliberation and delay became disturbingly noticeable in the case of the *Last Supper* and, by affecting his technique, determined the fate of this magnificent work. A process was in train in him that is matched only by the regressions we find in neurotics. The development that made him an artist at the time of puberty was overtaken by another, which had its determinants in early infancy and now turned him into a scientist. The second sublimation of his erotic drives yielded to the original one, for which the way had been prepared at the time of the first repression. He became a researcher, at first still in the service of his art, but later independently of it and at an ever greater remove from it. When he lost the patron who had replaced his father and his life took on an increasingly sombre aspect, this regressive shift gained more and more ground. He became *'impacientissimo al pennello'*[2] ['most impatient with painting'], as a correspondent reports to the margravine Isabella d'Este, who was eager to own a picture painted by Leonardo. His infantile past gained control over him. But the research that now replaced his artistic creativity seems to have had some features that characterize the activity of unconscious drives

– insatiability, ruthless rigidity and an inability to adapt to real conditions.

At the high point of his life, when he was in his early fifties – at an age when in women the sexual characteristics have regressed and in men the libido often makes another surge forward – a new transformation came over him. The content of even deeper layers of his mind was re-activated. Yet this further regression benefited his art, which was becoming atrophied. He encountered a woman who awakened in him the memory of his mother's happy and sensually ecstatic smile, and under the influence of this encounter he recovered the impetus that had guided him at the outset of his artistic career, when he modelled the smiling women in clay. He painted the *Mona Lisa, St Anne and Two Others*, and the series of mysterious pictures that are distinguished by that enigmatic smile. With the help of his very earliest erotic impulses he triumphed once more over the inhibition that had impeded his art. This final phase of his development is obscured for us by approaching age. Before this his intellect had soared to the highest achievements of a world view that far outstripped his own age.

In the previous chapters I have adduced evidence to justify such a presentation of Leonardo's development, such a subdivision of his life and such an explanation of its oscillation between art and science. Should my exposition prompt the judgement, even among friends of psychoanalysis and experts in the field, that I have done no more than write a psychoanalytic novel, I would reply that I certainly do not overrate the reliability of my findings. I have yielded, like others, to the fascination of this great and enigmatic figure, in whose nature one senses powerful instinctual passions, which can nevertheless express themselves only in a strangely subdued fashion.

Yet whatever the truth about Leonardo's life, we cannot abandon our attempt to explore it by psychoanalytic means until we have completed another task. We must stake out, in quite general terms, the limits of what psychoanalysis can achieve in the field of biography; lest any explanation that is not forthcoming should be marked up against us as a failure. As material for research, psychoanalysis has at its disposal the data of a person's life history – on the one

hand the contingencies of events and background influences, on the other hand his reported reactions. Relying on its knowledge of psychical mechanisms, psychoanalysis tries to explore the nature of the individual in dynamic terms, by observing his reactions, and to disclose the original motive forces of his psyche and their subsequent transformations and developments. If this is successful, a person's behaviour during the course of his life can be explained by the interplay of constitution and fate, of internal forces and external powers. If such an undertaking fails to produce any certain results – as in Leonardo's case perhaps – the blame lies not with the faulty or inadequate methods of psychoanalysis, but with the uncertain and fragmentary material supplied by tradition about the person in question. The responsibility for failure thus lies solely with the author, who forced psychoanalysis to deliver an opinion based on insufficient material.

Yet even if we had an abundance of historical material at our command and could handle the psychical mechanisms with absolute assurance, there would still be two significant points at which no psychoanalytic investigation could say whether an individual was bound to develop in the way he did and not otherwise. In the case of Leonardo we were obliged to advance the view that the accident of his illegitimate birth and his mother's excessive tenderness had the most decisive influence on the formation of his character and subsequent destiny, in that the sexual repression that occurred after this infantile phase caused him to sublimate his libido into a thirst for knowledge and ensured that he would be sexually inactive for the rest of his life. Yet this repression, following upon the first erotic satisfactions of childhood, was not inevitable; it might not have occurred in another individual, or it might have assumed lesser proportions. Here we must recognize a degree of freedom that can no longer be resolved by psychoanalysis. Nor have we any right to claim that the outcome of this phase of repression was the only one possible. Another person would probably not have succeeded in saving the greater part of his libido from repression by sublimating it into a thirst for knowledge; subject to the same influences as Leonardo, he might have suffered permanent damage to his capacity

for thought or acquired an uncontrollable disposition to obsessional neurosis. And so we are left with these two characteristics of Leonardo that cannot be explained by psychoanalytic study: his particular tendency to repression and his extraordinary ability to sublimate the primitive drives.

The drives and their transformations represent the limit of what is discernible to psychoanalysis. From this point on, psychoanalysis gives way to biological research. We are obliged to derive the tendency to repression and the capacity for sublimation from the organic foundations of character, on which the mental structure is then built. Since artistic talent and achievement are closely bound up with sublimation, we have to admit that the nature of artistic achievement too is not accessible to us by way of psychoanalysis. Biological research today tends to explain the main features of a person's organic constitution as the result of a mixture of male and female dispositions, in a material [chemical] sense. Leonardo's physical beauty and his left-handedness might lend support to such an approach. But we will not abandon the ground of purely psychological research. It remains our aim to show how a person's external experiences and his reactions to them are connected by way of the activity of the drives. Psychoanalysis may not explain Leonardo's artistry, but it helps us to understand its manifestations and its limitations. For it seems as though only a man who had had Leonardo's childhood experiences would have been capable of painting the *Mona Lisa* and *St Anne and Two Others*; of ensuring such a dismal fate for his works, and of embarking on such an unprecedented career as a natural scientist – as though the key to all his achievements and misfortunes lay hidden in the childhood fantasy of the vulture.

Yet may one not take exception to the results of an investigation that attributes such a decisive influence on a person's fate to the accidents of his parental circumstances and makes Leonardo's fate, for example, dependent on his illegitimate birth and the infertility of his stepmother, Donna Albiera? I believe one has no right to do so. To think that chance is unworthy of deciding our fate is simply to relapse into the pious view of the world whose overthrow Leonardo

himself anticipated when he wrote that the sun did not move. We are naturally hurt when a just God and a kindly providence do not shield us better from such influences during the most defenceless period of our lives. At the same time we readily forget that in fact everything in our lives is subject to chance, from the moment when we come into being through the meeting of spermatozoon and ovum – chance, which thus has its share in the laws and necessities of nature, but lacks any connection with our desires and our illusions. Dividing up what determines our lives between the 'necessities' of our constitution and the 'accidents' of our childhood may still be uncertain in detail; but on the whole there can no longer be any doubt about the importance of our first years of childhood. All of us still show too little respect for nature, which – according to Leonardo's obscure words, reminiscent of Hamlet's – 'is full of countless causes that never enter experience'.[3] Each of us human beings corresponds to one of the countless experiments in which these *ragioni* of nature force their way into experience.

(1910)

Notes

I

1. [*Es liebet die Welt, das Strahlende zu schwärzen*
 Und das Erhabene in den Staub zu ziehn.

('The world loves to blacken the radiant and drag the sublime in the dust.') From a poem by Schiller, 'Das Mädchen von Orléans', inserted as an extra prologue to the 1801 edition of his play *Die Jungfrau von Orléans*.]
2. The words are Jacob Burckhardt's, quoted by Alexandra Konstantinowa, *Die Entwick[e]lung des Madonnentypus bei Leonardo da Vinci*, Strasbourg 1907 (Zur Kunstgeschichte des Auslandes, fasc. 54) [p. 51].
3. [The words in parentheses were added in 1923.]
4. 'Egli per reverenza, rizzatosi a sedere sul letto, contando il mal suo e gli accidenti di quello, mostrava tuttavia, quanto aveva offeso Dio e gli uomini del mondo, non avendo operato nell' arte come si conveniva.' Vasari, *Le vite de' si piu eccelenti Architetti, Pittori et Scultori Italiana*, 2nd edn

Florence 1568 (ed. Poggi, Florence 1919) [p. 43]. ['He having raised himself out of reverence so as to sit on the bed, and giving an account of his illness and its circumstances, yet showed how much he had offended God and mankind in not having worked at his art as he should have done.']

5. *Trattato della Pittura* [Ludwig (1909, p. 36); also I. A. Richter (1952, pp. 330f.)].

6. Solmi, 'La resurrezione dell' opera di Leonardo', in *Leonardo da Vinci. Conferenze Fiorentine* (Milan 1910), p. 12.

7. Quoted by [N. Smiraglia] Scognamiglio, *Ricerche e Documenti sulla Giovinezza di Leonardo da Vinci* [1452–82] (Naples 1900) [p. 112].

8. W. von Seidlitz, *Leonardo da Vinci, der Wendepunkt der Renaissance* [2 vols, Berlin] 1909, I, p. 203.

9. Seidlitz, op. cit., II, p. 48.

10. W. Pater, *Studies in the History of the Renaissance* (London 1873), p. 100: 'But it is certain that at one period of his life he had almost ceased to be an artist.'

11. Cf. the history of the attempts at restoration and preservation given by Seidlitz, op. cit., I [pp. 205ff.].

12. E. Müntz, *Léonard de Vinci* (Paris 1899), p. 18. (A letter of a contemporary, writing from India to one of the Medici, alludes to this characteristic of Leonardo. See [J. P.] Richter, *The Literary Works of Leonardo da Vinci* [London 1883; 1939, II, pp. 103–4 *n*.].)

13. F. Bottazzi, 'Leonardo biologico e anatomico' in: *Conferenze Fiorentine* ([Milan] 1910), p. 186.

14. E. Solmi, *Leonardo da Vinci*, German translation by Emmi Hirschberg (Berlin 1908) [p. 24].

15. Marie Herzfeld, *Leonardo da Vinci, der Denker, Forscher und Poet* (2nd edn, Jena 1906), based on the published manuscripts.

16. An exception to this, though not an important one, is perhaps to be found in his collected farces – *belle facezie* – which have not been translated. Cf. Herzfeld, op. cit., p. CLI.

17. [*Footnote a added in 1919:*] A drawing by Leonardo [see Fig. 1], which shows the sex act in anatomical sagittal section and can certainly not be called obscene, contains some curious errors that were discovered by Dr R. Reitler, *Internationale Zeitschrift für Psychoanalyse* IV (1916/17) [p. 205] and discussed by him in the light of the account I have given here of Leonardo's character:

'And it was precisely when it came to a portrayal of the act of procreation that this extreme investigative drive failed completely, naturally because it had been even more strongly repressed. The man's body is drawn in full,

the woman's only in part. If the drawing, reproduced here, is shown to an unprejudiced onlooker with only the head visible and everything below it covered up, he can safely be expected to take it to be a woman's head. The wavy locks over the forehead, and those flowing down the back roughly to the fourth or fifth vertebra, definitely mark the head as more female than male.

Fig. 1

'The woman's breast has two defects. One is artistic, for the contour of the breast makes it appear displeasingly flabby and pendulous; the other is anatomical, for Leonardo the researcher had clearly been prevented, by his

aversion to sexuality, from looking closely, even once, at the nipple of a nursing woman. Had he done so, he would surely have noticed that the milk flows from a number of separate excretory ducts. Leonardo, however, drew only one duct, which extends far down into the abdominal cavity; he may have thought that it drew the milk out of the *cisterna chyli* and was perhaps connected in some way with the sex organs. Of course we must remember that in those days it was extremely difficult to study the internal organs of the human body, because the dissection of bodies was regarded as a desecration of the dead and very severely punished. It is therefore highly questionable whether Leonardo, with access to very little material for dissection, knew anything at all about the existence of a lymph reservoir in the abdominal cavity, though his drawing undoubtedly depicts a cavity that can be interpreted in this way. Yet the fact that it shows the lactiferous duct extending down to the internal sex organs suggests that Leonardo was trying to represent the temporal coincidence of the beginning of the secretion of milk and the end of pregnancy by means of visible anatomical connections too. Although we may wish to excuse the artist's faulty anatomical knowledge by reference to contemporary conditions, it is nonetheless striking that he was so careless in his representation of the female genitals. Of course one can recognize the vagina and an indication of the *portio uteri*, but the lines representing the uterus itself are quite confused.

'On the other hand, Leonardo represents the male genitals much more correctly. For instance, he is not content to draw the testicle, but quite accurately includes the epididymis in the sketch.

'What is extremely curious is the position in which Leonardo shows coitus being performed. There are pictures and drawings by outstanding artists that show *coitus a tergo, a latere* etc., but to draw a picture of the sexual act performed in a standing position inevitably leads one to suspect that a particularly strong sexual repression lies behind this solitary and almost grotesque representation. If one wishes to enjoy sexual congress, one usually makes oneself as comfortable as possible. This is of course true of both the primal drives, hunger and love. Most peoples in the ancient world took their meals in a recumbent position, and for coition we normally lie as comfortably as our ancestors did. The recumbent position expresses, to some extent, the wish to remain in the desired situation for some time.

'Moreover, the facial features of the man with the feminine head show a positively indignant resistance. He is frowning; his gaze is directed sideways with an expression of nervousness; his lips are pressed together and drawn down at the corners. This face shows neither the pleasure of loving nor the joy of giving; it expresses only displeasure and revulsion.

'Leonardo's clumsiest blunder, however, is in his drawing of the lower extremities. The man's foot should be his right one; for, since Leonardo represented the act of procreation in the form of an anatomical sagittal section, it follows that the man's left foot would have to be imagined above the plane of the picture; conversely, for the same reason, the woman's foot should belong to her left side. The male figure has a left foot and the female figure a right foot. This swapping of the feet is most easily understood if one remembers that the big toes are on the inner sides of the feet.

'From this anatomical drawing alone one could have inferred a libidinal repression that almost confused the great artist and scientist.'

[*Added 1923:*] This account by Reitler has admittedly been criticized on the ground that it is improper to draw such serious conclusions from a hasty sketch, and that it is not even certain that the various parts of the drawing belong together.

[*Note by the editors of the 'Students' Edition', vol. 10 (1969), p. 99:*] 'The anatomical drawing reproduced here, which was analysed by Reitler and regarded by him (and consequently by Freud too) as Leonardo's original, is in fact, as has since been shown, a reproduction of a lithograph by Wehrt, which was published in 1830 as a copy of an engraving by Bartolozzi, itself published in 1812. It was Bartolozzi who added the feet, which Leonardo had omitted, and it was Wehrt who added the sour expression on the man's face. In Leonardo's original drawing, now in Windsor Castle (*Quaderni d'Anatomia*, III folio, 3 v.), the face has a calm, neutral expression.']

18. According to Scognamiglio (op. cit., p. 49) this incident is referred to in an obscure passage of the *Codex Atlanticus* that has been variously interpreted: 'Quando io feci Domeneddio putto voi mi metteste in prigione, or s'io lo fo grande, voimi farete peggio.' [When I represented the Lord God as a baby, you put me in prison; now if I represent him as an adult you will do worse to me.']

19. Merezhkovsky, *Leonardo da Vinci*, a biographical novel set at the turn of the fifteenth century (German translation by C. von Gütschow, Leipzig 1903), the second part of a large historical trilogy entitled *Christ and Antichrist*. The other volumes are *Julian the Apostate* and *Peter and Alexis*.

20. Solmi, *Leonardo da Vinci*, transl. Emmi Hirschberg, Berlin 1908, p. 46.

21. Filippo Bottazzi, *Leonardo biologico e anatomico* (1910, p. 193) [J.P. Richter (1939), II, p. 244].

22. Leonardo da Vinci, *Trattato della Pittura*, transl. H. Ludwig, ed. with introduction by M. Herzfeld (Jena 1909), p. 54.

23. Solmi, 'La resurrezione . . .' [1910], p. 11.

24. 'La resurrezione . . .', p. 8: 'Leonardo aveva posto, come regola al pittore,

lo studio della natura . . . poì la passione dello studio era divenuta dominante, egli aveva voluto acquistare non più la scienza per l'arte, ma la scienza per la scienza' ['Leonardo had prescribed the study of nature as a rule for the painter . . . then the passion for study had become dominant, he had no longer wished to acquire learning for the sake of art, but learning for the sake of learning'].

25. *Quaderni d'Anatomia*, 1–6, Royal Library, Windsor, V, 25.

26. See the list of his scientific achievements in the admirable biographical introduction by Maria Herzfeld (Jena 1906), in individual essays of the *Conferenze Fiorentine* (1910) and elsewhere.

27. For corroboration of these seemingly improbable statements see my 'Analysis of a Phobia in a Five-year-old Boy', 1909 (*Gesammelte Werke*, vol. VII) and similar observations. [Before 1924 these last words ran: 'and of the similar observation in Volume II of the *Jahrbuch für psychoanalytische und psychopathologische Forschungen*' – a reference to Jung (1910).] In an article on 'The Sexual Theories of Children', 1908 (*Gesammelte Werke*, vol. VII), I wrote: 'This brooding and doubting, however, sets the pattern for all subsequent thinking about intellectual problems, and the effect of the first failure turns out to be permanently paralysing.'

28. Scognamiglio, p. 15.

II

1. 'Questo scriver si distintamente del nibio par che sia mio destino, perchè nella mia prima ricordatione della mia infantia e' mi parea che, essendo io in culla, che un nibio venissi a me e mi aprissi la bocca colla sua coda e molte volte mi percuotesse con tal coda dentro alle labbra' (*Cod. Atlant.* F. 65 V., quoted by Scognamiglio [p. 22]. [In the German text Freud quotes Herzfeld's translation, and the version given above is a rendering of the German. There are in fact two inaccuracies in the German: *nibio* means 'kite', not 'vulture', and *dentro* 'within' is omitted. This omission is in fact rectified by Freud himself below (p. 42).]

2. [*Footnote added 1919:*] In a friendly notice of this book in the *Journal of Mental Science* (July 1910 [vol. 56, p. 522]) Havelock Ellis questioned the interpretation given above on the ground that this memory of Leonardo's could have had a real foundation, as childhood memories often go back much further than is commonly believed. And the big bird need not have been a vulture. I gladly concede this point and, to lessen the difficulty, I offer the surmise that his mother observed the big bird's visit to her child, which she may easily have taken as an omen, and repeatedly told him about it later, so that he retained the memory of the story and then, as so

often happens, confused it with a memory of something he had himself experienced. Yet this modification does not detract from the force of my account. As a rule, in fact, people's later fantasies about their childhood rest on small, but real events that took place in this remote and otherwise forgotten period of their lives. So there must have been a reason for giving prominence to a real event of no great importance and elaborating it as Leonardo did in this story of the vulture and its curious behaviour.

3. [*Addition 1919:*] I have since attempted to make similar use of a childhood memory, also not understood, of another great figure. On the first pages of Goethe's autobiography, *Dichtung und Wahrheit*, written when he was about sixty, he tells us how, encouraged by neighbours, he hurled pieces of crockery, some large and some small, out of the window into the street, with the result that they were smashed to pieces. This is the only scene that Goethe reports from his earliest years. I was prompted by the sheer inconsequentiality of the content and the way it agreed with the childhood memories of others – who did not become especially great – and by the fact that in this passage Goethe does not mention his little brother, at the time of whose birth he was aged three and three-quarters and at whose death he was almost ten. (True, Goethe does mention the child later, while dwelling on the many illnesses of childhood.) I hoped to replace this inconsequentiality by something else, which would fit better into Goethe's account and whose content would make it worthy of being retained in the place he assigned to it in the story of his life. This short analysis ('A Childhood Recollection from *Dichtung und Wahrheit*', 1917, *Gesammelte Werke*, vol. XII) made it possible to recognize the throwing out of the crockery as a magical act, directed against a troublesome intruder, and in the passage where the incident is described, it is meant to signify Goethe's triumphant knowledge that no second son was to be allowed, in the long run, to disturb Goethe's intimate relationship with his mother. If the earliest memory of childhood, preserved in such disguises by both Goethe and Leonardo, relates to the mother, what would be surprising about that?

4. On this point compare my 'Bruchstück einer Hysterie-Analyse' ['Fragment of an Analysis of a Case of Hysteria', I], 1905 (*Gesammelte Werke*, vol. V [pp. 210f.]).

5. [See note 1, this section.]

6. [Cf. the analysis of 'Little Hans' (1909), I.]

7. [Here the first edition had 'homosexuality' (*Homosexualität*), not 'inversion' (*Inversion*).]

8. Horapollo, *Hieroglyphica* 1, p. 11. 'Μητέρα δὲ γράφοντες . . . γῦπα ξωγραφοῦσιν' ['To represent a mother . . . they draw a vulture'].

9. Roscher, *Ausführliches Lexikon der griechischen und römischen Mythologie*, entry on 'Mut', II, [Leipzig] 1894–7; Lanzone, *Dizionario di mitologia egizia*, Turin 1882.

10. H. Hartleben, *Champollion. Sein Leben und sein Werk*, [Berlin] 1906.

11. [Incorrect: the name should be 'Ammianus Marcellinus'.]

12. 'γῦπα δὲ ἄρρενα οὔ φαοι γινέσδαι ποτε, ἀλλὰ δηλείας ἁπάσας' ['They say that no male vulture has ever existed, but that all are females'], Aelian, *De Natura Animalium*, II, 46, quoted by von Römer, 'Über die androgynische Idee des Lebens', *Jahrbuch für sexuelle Zwischenstufen*, V, 1903, p. 732.

13. Plutarch: 'Veluti scarabaeos mares tantum esse putarunt Aegyptii sic inter vultures mares non inveniri statuerunt.' ['Just as they believed that only male scarabs existed, so the Egyptians concluded that no male vultures were to be found.' This sentence in fact comes not from Plutarch, but from a commentary by C. Leemans in his edition of Horapollo's work (Amsterdam 1835); cf. the following note.]

14. *Horapollinis Niloï Hieroglyphica*, edidit Conradus Leemans Amstelodami, 1835. The words relating to the sex of vultures appear on p. 14: 'μητέρα μέν ἐπειδὴ ἄρρεν ἐν τούτῳ τῷ γένει τῶν ζώων οὐχ ὑπάρχει' [('They use the picture of the vulture to denote) a mother, because in this race of creatures there is no male.' Presumably Freud intended to quote here a passage on the impregnation of vultures by the wind, but this is missing.]

15. E. Müntz, *Léonard de Vinci* (Paris 1899), p. 282.

16. [*The Literary Works of Leonardo da Vinci*, London 1883; quoted from] Müntz, ibid.

17. [C. Leemans (1835), p. 172. See note 14, this section.]

III

1. Cf. the illustrations in Lanzone, op. cit., CXXXVI–CXXXVII.

2. Von Römer, loc. cit.

3. Cf. the observations in *Jahrbuch für psychoanalytische und psychopathologische Forschungen* [1909 and 1910], [*Added 1919:*] in *Internationale Zeitschrift für ärztliche Psychoanalyse* and [in the contributions on child analysis] in *Imago*.

4. [*Added 1919:*] It seems to me an irrefutable assumption that we have here one source of the hatred of the Jews, which appears with such elemental force in western nations and finds such irrational expression. Circumcision is unconsciously equated with castration. Venturing to project our surmises back into the primeval days of the human race, we may suspect that

circumcision was originally intended as a mitigated form of castration, a substitute for it.

5. [The first part of this sentence, up to 'to say that', was added in 1919.]

6. Cf. Richard Payne Knight, *A Discussion of the Worship of Priapus*, etc., London 1786.

7. These investigations were undertaken mainly by I. Sadger, but I can confirm his findings in the main from my own experience. I am aware also that W. Stekel in Vienna and S. Ferenczi in Budapest have arrived at the same results.

8. [*Added 1919:*] Psychoanalytic research has contributed two indisputable facts to our understanding of homosexuality, though it does not pretend to have solved the problem of how this sexual aberration is caused. One is the above-mentioned fixation of the subject's erotic needs on his mother; the other is expressed in the claim that every person, even the most normal, is capable of making a homosexual choice of object and has done so at some time in his life, and that he either adheres to this choice in his unconscious or guards against it by adopting vigorous opposing attitudes. These two discoveries put paid both to the homosexuals' claim to be recognized as a 'third sex' and to the supposedly important distinction between innate and acquired homosexuality. The presence of somatic features of the opposite sex (a degree of physical hermaphroditism) is highly conducive to the manifestation of a homosexual choice of object, but it is not decisive. It must regretfully be said that the scholars who speak for the homosexuals have learnt nothing from the assured findings of psychoanalysis.

9. E. Solmi, *Leonardo da Vinci*, German transl., 1908, p. 152.

10. Ibid.

11. Id., p. 201.

12. Leonardo behaves here like someone who is used to making a daily confession to another person and now replaces this person by his diary. For a surmise as to who this person may have been, see Merezhkovsky, p. 367.

13. M. Herzfeld, *Leonardo da Vinci*, 1906, p. CXLI.

14. The text is taken from Merezhkovsky, p. 282.

15. Or model.

16. For the equestrian statue of Francesco Sforza.

17. For the full text see M. Herzfeld, p. XLV.

18. Merezhkovsky, p. 372. As a depressing instance of the uncertainty of the information about Leonardo's private life, which is in any case meagre enough, I should mention that the same account of expenses is reproduced by Solmi, 104, but with substantial variations, the most serious of these being that the florins are replaced by soldi. One may assume that the florins

in this account are not the old 'gold florins', but the units of currency that were in use later, each equivalent to $1\frac{2}{3}$ lire or $33\frac{1}{3}$ soldi. Solmi assumes that Caterina was a maid who had run Leonardo's household for some time. The source upon which the two versions of the account drew was not available to me. [Some of the figures also vary in the different editions of Freud's works.]

19. 'Caterina arrived on 16 July 1493.' 'Giovannina – a fabulous face – call on Caterina in the hospital and make inquiries.' In fact, Merezhkovsky has mistranslated the second remark. It should read: 'Giovannina – a fabulous face – is at the hospital of Santa Caterina.'

20. The forms in which Leonardo's repressed libido is allowed to express itself – in circumstantial detail and concern over money – are among the character traits that result from anal eroticism. Cf. 'Character and Anal Eroticism', 1908 (*Gesammelte Werke*, vol. VII).

IV

1. See note 1 in Section II.

2. [*Added 1919*:] Here the connoisseur of art will think of the peculiar fixed smile found in archaic Greek sculptures, for instance in those from Aegina. He may also discover something similar in the figures of Leonardo's teacher Verrocchio, and therefore not wish to accept the following arguments unreservedly.

3. [See Plate 1.]

4. The words are Gruyer's, quoted by von Seidlitz, *Leonardo da Vinci*, II, p. 280.

5. *Geschichte der Malerei* [3 vols, Leipzig 1909], I, p. 314.

6. Op. cit., p. 417.

7. A. Conti, 'Leonardo pittore', in *Conferenze Fiorentine*, 93.

8. Op. cit., p. 44.

9. [See Plate 2. In German this painting is called *Die heilige Anna selbdritt*, i.e., 'St Anne with two others' (literally 'St Anne self-third').]

10. W. Pater, *Die Renaissance*, German translation, 2nd edn, 1906, p. 157.

11. M. Herzfeld, *Leonardo da Vinci*, p. LXXXVIII.

12. Quoted by Scognamiglio, p. 32.

13. III (1843), p. 6. [In the translation of J. C. and P. Bondanella, this passage reads: 'In his youth, he made in clay the heads of some women laughing, created through the craft of plaster-casting, as well as the heads of some children, which seemed to have issued forth from the hand of a master . . .', G. Vasari, *The Lives of the Artists* (Oxford 1991), p. 285.]

14. Merezhkovsky makes the same assumption, though his vision of Leonardo's childhood differs in important respects from the conclusions we have drawn from the vulture fantasy. Yet if this smile had been Leonardo's own [as Merezhkovsky also assumes] the sources are hardly likely to have failed to inform us of this.

15. Op. cit., p. 309.

16. A. Konstantinowa, op. cit. [p. 44], writes: 'Mary gazes down at her darling, full of inward feeling and with a smile that is reminiscent of the enigmatic expression of the Gioconda.' Elsewhere [p. 52] she says of Mary, 'Around her features hovers the smile of the Gioconda.'

17. Seidlitz, II, p. 274, footnotes.

18. [The phrase enclosed here by dashes was added in 1923.]

19. [*Added 1919:*] Trying to separate out the figures of Anne and Mary in the picture proves far from easy. One is inclined to say that they are fused with each other like badly condensed dream-figures, so that in places it is hard to say where Anne ends and Mary begins. Hence, what strikes the critic as a fault, as a compositional defect, is justified from the analyst's point of view by reference to its hidden meaning. The two mothers of the artist's childhood were allowed to merge in a single form.

Fig. 2

[*Added 1923:*] It is particularly intriguing to compare the *St Anne and Two Others* of the Louvre with the famous London cartoon, which represents another composition based on the same material. [See Fig. 2.] Here the forms of the two mothers are even more closely fused and their separate outlines even less clear, so that critics who had no intention whatever of proposing an interpretation have been compelled to say that 'two heads seem to be growing out of one body'.

Most writers agree that the London cartoon is the earlier of the two works and date it to Leonardo's first Milan period (before 1500). On the other hand, Adolf Rosenberg, in his monograph of 1898, sees the composition of the cartoon as a later, more successful treatment of the same theme and follows Anton Springer in dating it even later than the *Mona Lisa*. It is quite in keeping with our arguments that the cartoon should be by far the earlier work. Nor is it hard to imagine how the picture in the Louvre developed out of the cartoon, whereas the reverse process would make no sense. Starting from the composition of the cartoon, we see how Leonardo may have felt the need to undo the dreamlike fusion of the two women, which matched his childhood memory, and separate the two heads spatially. He did this by separating Mary's head and the upper part of her body from the figure of her mother and bending them downwards. To motivate this displacement, he had to move the infant Christ from her lap to the ground; there was then no room for the infant John, who was replaced by the lamb.

[*Added 1919:*] In the Louvre picture Oskar Pfister has made a curious discovery, which is of undeniable interest, even if one is disinclined to accept it without reservation. He has discovered the *outline of a vulture* in Mary's garments, which are arranged in a curious way that is not easy to understand; this he takes to be an *unconscious puzzle-picture*.

'On the picture representing the artist's mother *the vulture, the symbol of motherhood*, is to be seen quite clearly.

'In the blue cloth that is visible near the hip of the woman in front and extends towards her lap and right knee, we see the highly characteristic head of the vulture, its neck, and the sharp curve where its body begins. Hardly any observer to whom I have revealed my little discovery has been able to resist the evidence of this puzzle-picture.' ('Kryptolalie, Kryptographie und unbewusstes Vexierbild bei Normalen', *Jahrbuch für psychoanalytische und psychopathologische Forschungen*, V (1913) [p. 147].)

At this point the reader will surely not shun the effort of looking at the accompanying illustration and trying to discover the outlines of the vulture seen by Pfister. The blue cloth, whose edges form the contours of the

Fig. 3

puzzle-picture, is set off in the reproduction as a light-grey field against the darker ground of the other garments. [See Fig. 3 and Plate 2.]

Pfister continues (op. cit., p. 147): 'Now, the important question is: how far does the picture-puzzle extend? If we trace the cloth, which is so sharply set off against its surroundings, starting from the middle of the wing, we note that one part of it runs down to the woman's foot, while another part runs upwards towards her shoulder and the child. The first of these two parts would represent roughly the vulture's wing and natural tail, the second a pointed belly and – especially when we pay attention to the radiating lines that resemble the outlines of feathers – a bird's outspread tail, whose right-hand tip, *exactly as in Leonardo's portentous childhood dream, reaches to the child's, i.e. Leonardo's, mouth.*'

The author then goes on to elaborate this interpretation and discuss the difficulties arising from it.

20. Cf. *Three Essays on the Theory of Sexuality*, 5th edn, 1922 [III. 5].
21. Op. cit., p. 314.

V

1. Quoted by E. Müntz, p. 13 *n*.

2. I will ignore a more serious mistake: Leonardo states that his father was 80 years old when he was in fact 77.

3. Canto XXVII, vv. 22–5.

4. It seems that at this point in his diary Leonardo got the number of his siblings wrong; this is strangely at odds with the apparent exactitude of the passage.

5. [The Shakespearian phrase in quotation marks is in English in the original.]

6. 'Il duca perse lo stato e la roba e libertà e nessuna sua opera si finì per lui.' Quoted by Seidlitz, op. cit., II, p. 270.

7. Op. cit., p. 348.

8. 'Chi disputa allegando l'autorità non adopra l'ingegno ma piuttosto la memoria.' Quoted by Solmi, ['La resurrezione . . .', in] *Conferenze Fiorentine* [Milan 1910], p. 13.

9. [This word was added in 1925.]

10. [This last sentence was added in 1919.]

11. Müntz, *La Religion de Léonard*, pp. 299ff.

12. Quoted by Herzfeld, p. 292.

13. Ibid., p. 297.

14. Quoted by M. Herzfeld, p. 32. 'The great swan' is thought to refer to Monte Cecero, a hill near Florence [now called Monte Ceceri, *cecero* being the Italian word for 'swan'].

15. [*Added 1919:*] According to Paul Federn's investigations and those of Mourly Vold (1912), a Norwegian investigator who had no connection with psychoanalysis.

16. [Instead of *früher* ('earlier') the pre-1923 editions had *darüber* ('about it').]

17. Vasari, translated by Schorn, 1843 [p. 39].

18. Ibid., p. 39.

19. On these letters and the questions connected with them see Müntz, pp. 82ff.; for the texts of these and other related notes see M. Herzfeld, pp. 223ff.

20. 'Besides this, he wasted time in designing a series of knots in a cord which can be followed from one end to the other, with the entire cord forming a circular field containing a very difficult and beautiful engraving with these words in the middle: *Leonardus Vinci Academia.*' (Giorgio Vasari, *The Lives of the Artists*, transl. J. C. and P. Bondanella [Oxford/New York 1991], p. 286.

VI

1. This criticism is intended to apply quite generally and is not directed at Leonardo's biographers in particular.

2. Von Seidlitz, II, p. 271.

3. *'La natura è piena d'infinite ragioni che non furono mai in isperienza'* (M. Herzfeld, 1906, p. 11). [The Shakespearian allusion seems to be to *Hamlet*, 1.5:

> There are more things in heaven and earth, Horatio,
> Than are dreamt of in your philosophy.]

The Uncanny

I

Only rarely does the psychoanalyst feel impelled to engage in aesthetic investigations, even when aesthetics is not restricted to the theory of beauty, but described as relating to the qualities of our feeling. He works in other strata of the psyche and has little to do with the emotional impulses that provide the usual subject matter of aesthetics, impulses that are restrained, inhibited in their aims and dependent on numerous attendant circumstances. Yet now and then it happens that he has to take an interest in a particular area of aesthetics, and then it is usually a marginal one that has been neglected in the specialist literature.

One such is the 'uncanny'. There is no doubt that this belongs to the realm of the frightening, of what evokes fear and dread. It is equally beyond doubt that the word is not always used in a clearly definable sense, and so it commonly merges with what arouses fear in general. Yet one may presume that there exists a specific affective nucleus, which justifies the use of a special conceptual term. One would like to know the nature of this common nucleus, which allows us to distinguish the 'uncanny' within the field of the frightening.

On this topic we find virtually nothing in the detailed accounts of aesthetics, which on the whole prefer to concern themselves with our feelings for the beautiful, the grandiose and the attractive – that is to say, with feelings of a positive kind, their determinants and the objects that arouse them – rather than with their opposites, feelings of repulsion and distress. In the medico-psychological literature I know only one study on the subject, that of E. Jentsch;[1] and this, while rich in content, is not exhaustive. True, I have to own that, for

reasons that are not hard to divine, and inherent in the times we live in, I have not undertaken a thorough survey of the literature, especially the foreign literature, that would be relevant to the present modest contribution, which is therefore presented to the reader with no claim to priority.

Jentsch stresses, as one of the difficulties attendant upon the study of the uncanny, the fact that people differ greatly in their sensitivity to this kind of feeling. Indeed, the present writer must plead guilty to exceptional obtuseness in this regard, when great delicacy of feeling would be more appropriate. It is a long time since he experienced or became acquainted with anything that conveyed the impression of the uncanny. He must first put himself in the proper state of feeling and so put himself in the way of experiencing a sense of the uncanny. Yet such difficulties play an important part in other areas of aesthetics too; hence one need not, for that reason, give up hope of finding cases in which the feeling in question will be unequivocally acknowledged by most people.

There are thus two courses open to us: either we can investigate the semantic content that has accrued to the German word *unheimlich* [of which the nearest semantic equivalents in English are 'uncanny' and 'eerie', but which etymologically corresponds to 'unhomely'] as the language has developed, or we can assemble whatever it is about persons and things, sense impressions, experiences and situations, that evokes in us a sense of the uncanny, and then go on to infer its hidden nature from what all these have in common. I can say in advance that both these courses lead to the same conclusion – that the uncanny is that species of the frightening that goes back to what was once well known and had long been familiar. How this can be – under what conditions the familiar can become uncanny and frightening – will emerge in what follows. I must add that the present study actually began with a collection of individual cases and that the findings were only later corroborated by what we are told by [German] linguistic usage, but here I shall work in reverse order.

Unheimlich is clearly the opposite of *heimlich, heimisch, vertraut*,[2] and it seems obvious that something should be frightening

precisely because it is unknown and unfamiliar. But of course the converse is not true: not everything new and unfamiliar is frightening. All one can say is that what is novel may well prove frightening and uncanny; some things that are novel are indeed frightening, but by no means all. Something must be added to the novel and the unfamiliar if it is to become uncanny.

On the whole Jentsch does not go beyond relating the uncanny to the novel and the unfamiliar. For him the essential condition for the emergence of a sense of the uncanny is intellectual uncertainty. One would suppose, then, that the uncanny would always be an area in which a person was unsure of his way around: the better oriented he was in the world around him, the less likely he would be to find the objects and occurrences in it uncanny.

This definition is clearly not exhaustive. We will therefore try to go beyond a mere equation of the uncanny with the unfamiliar and turn first to other languages. But the dictionaries we consult tell us nothing new, if only perhaps because we ourselves speak a foreign language. Indeed, we gain the impression that many languages lack a word for this particular species of the frightening.[3]

LATIN (K. E. Georges, *Kleines Deutsch-Lateinisches Wörterbuch* 1898): 'ein unheimlicher Ort' ['an eerie place'] – *locus suspectus*; 'in unheimlicher Nachtzeit' ['in the eerie night hours'] – *intempesta nocte*.

GREEK (from the dictionaries of Rost and Schenkl): *xénos*, 'foreign, alien'.

ENGLISH (from the dictionaries of Lucas, Bellows, Flügel and Muret-Sanders): *uncomfortable, uneasy, gloomy, dismal, uncanny, ghastly*, (of a house): *haunted*, (of a person): *a repulsive fellow*.

FRENCH (Sachs-Villatte): *inquiétant, sinistre, lugubre, mal à son aise*.

SPANISH (Tollhausen 1889): *sospechoso, de mal aguero, lúgubre, siniestro*.

Italian and Portuguese seem to make do with words that we would call periphrases. In Arabic and Hebrew the 'uncanny' merges with the 'demonic' and the 'gruesome'.

So let us return to German. In Daniel Sanders' *Wörterbuch der*

Deutschen Sprache of 1860 we find the following information on the word *heimlich*, which I reproduce here in full, drawing attention to certain passages (vol. I, p. 729):[4]

Heimlich. *adj.* (*sb.* **-keit**, *pl.* **-en**):

1. also *Heimelich, heimelig,* 'zum Hause gehörig, nicht fremd, vertraut, zahm, traut und traulich, anheimelnd etc.' ['belonging to the house, not strange, familiar, tame, dear and intimate, homely, etc.']

a) (*obsolete*) 'zum Haus, zur Familie gehörig, oder: wie dazu gehörig betrachtet. vgl. lat. *familiaris*, "vertraut"' ['belonging to the house, to the family, or: regarded as belonging to it, cf. Lat. *familiaris*, "familiar"'], *die Heimlichen*, 'the members of the household'; *der heimliche Rath*, 'the privy councillor', Genesis 41, 45 [Luther: *Und nannte ihn den heimlichen Rat*, 'And called him the privy councillor'; AV: 'And Pharaoh called Joseph's name Zaphnath-paaneah', to which the following gloss is supplied: 'Which in the Coptic signifies *A revealer of secrets* or *The man to whom secrets are revealed*'; 2 Samuel 23, 23 [Luther: *Und David machte ihn zum heimlichen Rat*, 'And David made him privy councillor'; AV: 'And David set him over his guard (gloss: "or *council*")'.] [Here follow references to I Chronicles 12, 25 and Wisdom 8, 4, where the word *heimlich* does not appear.] The usual title for this office is now *Geheimer Rath* (see **Geheim 1**). See also *Heimlicher*.

b) 'von Thieren zahm, sich den Menschen traulich anschliessend. Ggstz wild' ['of animals: tame, associating familiarly with humans; antonym: wild'], e.g. *Thier, die weder wild noch heimlich sind* etc., 'Animals that are neither wild nor tame'. Eppendorf, 88; *Wilde Thier ... so man sie heimlich und gewohnsam um die Leute aufzeucht*, 'Wild animals ... that are brought up tame and accustomed to humans', 92. *So diese Thierle von Jugend bei den Menschen erzogen, werden sie ganz heimlich, freundlich* etc., 'When these little animals are reared among humans they become quite domesticated, friendly, etc.' Stumpf 608a etc. – Hence still [in the 18th century]: *So heimlich ist's (das Lamm) und frisst aus meiner Hand*, 'It is so tame (the lamb) and eats out of my hand', Hölty; *Ein schöner, heimelicher* (see

c) *Vogel bleibt der Storch immerhin*, 'The stork remains a beautiful tame bird all the same', Linck. Schl. 146. See **Häuslich** ('domestic') **1** etc.

c) 'traut, traulich anheimelnd, das Wohlgefühl stiller Befriedigung etc., behaglicher Ruhe u. sichern Schutzes, wie das umschlossne wohnliche Haus erregend' ['intimate, cosily homely; arousing a pleasant feeling of quiet contentment, etc., of comfortable repose and secure protection, like the enclosed, comfortable house'] (cf. **Geheuer**): *Ist dir's heimlich noch im Lande, wo die Fremden deine Wälder roden?*, 'Are you still at ease in the country, where strangers are uprooting your woods?', Alexis H. 1, 1, 289; *Es war ihr nicht allzu heimlich bei ihm*, 'She was not altogether at ease with him', Brentano Wehm. 92; *Auf einem hohen heimlichen Schattenpfade . . . längs dem rieselnden rauschenden und plätschernden Waldbach*, 'On a high, peaceful, shady path . . . beside the purling, murmuring, babbling woodland brook', Forster B. 1. 417. *Die Heimlichkeit der Heimath zerstören*, 'To destroy the tranquillity of the homeland', Gervinus Lit. 5, 375. *So vertraulich und heimlich habe ich nicht leicht ein Plätzchen gefunden*, 'It was not easy for me to find such a quiet and restful spot', Goethe 14, 14; *Wir dachten es uns so bequem, so artig, so gemütlich und heimlich*, 'We imagined it so comfortable, so pretty, so cosy and homely', 15, 9; *In stiller Heimlichkeit, umzielt von engen Schranken*, 'In quiet homeliness, enclosed within narrow bounds', Haller; *Einer sorglichen Hausfrau, die mit dem Wenigsten eine vergnügliche Heimlichkeit (Häuslichkeit) zu schaffen versteht*, 'A careful housewife, who knows how to create a pleasant homeliness (domesticity) with the meagrest of means'; Hartmann Unst. 1, 188: *Desto heimlicher kam ihm jetzt der ihm erst kurz noch so fremde Mann vor*. 'All the more familiar did the man now appear to him, who but a short while before had seemed such a stranger', Kerner 540; *Die protestantischen Besitzer fühlen sich . . . nicht heimlich unter ihren katholischen Unterthanen*, 'The Protestant owners do not feel at home among their Catholic subjects', Kohl, Irl. 1, 172; *Wenns heimlich wird und leise/die Abendstille nur an deiner Zelle lauscht*, 'When it becomes tranquil, and the evening's hush quietly harkens only at your cell', Tiedge 2, 39.

Still und lieb und heimlich, als sie sich / zum Ruhen einen Platz nur wünschen möchten, 'As quiet and dear and homely a place as they could wish to rest at', Wieland 11, 144; *Es war ihm garnicht heimlich dabei*, 'He did not feel at all at ease in all this', 27, 170, etc. – Also: *Der Platz war so still, so einsam, so schatten-heimlich*, 'The spot was so quiet, so lonely, so shadily restful', Scherr Pilg. 1, 170; *Die ab- und zuströmenden Fluthwellen, träumend und wiegenliedheimlich*, 'The ebb and flow of the waves, dreamy and restful as a lullaby', Körner, Sch. 3, 320, etc. – Cf. esp. **Unheimlich.** – Often trisyllabic, esp. in Swabian and Swiss authors: *Wie 'heimelich' war es dann Ivo Abends wieder, als er zu Hause lag*, 'How "cosy" it again seemed to Ivo in the evening as he lay at home', Auerbach D. 1, 249; *In dem Haus ist mir's so heimelig gewesen*, 'I have been so much at ease in the house', 4, 307; *Die warme Stube, der heimelige Nachmittag*, 'The warm living room, the cosy afternoon', Gotthelf, Sch. 127, 148; *Das ist das wahre Heimelig, wenn der Mensch so von Herzen fühlt, wie wenig er ist, wie gross der Herr ist*, 'That is true ease, when a man feels in his heart how little he is and how great the Lord is', 147; *Wurde man nach und nach recht gemüthlich und heimelig mit einander*, 'Little by little they became very comfortable and familiar with one another', U. 1, 297; *Die trauliche Heimeligkeit*, 'Cosy intimacy', 380, 2, 86; *Heimelicher wird es mir wohl nirgends werden als hier*, 'I shall probably feel nowhere more at home than here', 327; Pestalozzi 4, 240; *Was von ferne herkommt . . . lebt gewiss nicht ganz heimelig (heimatlich, freundnachbarlich) mit den Leuten*, 'Whoever comes here from afar . . . certainly does not live wholly at ease (on homely, friendly, neighbourly terms) with the [local] people', 325; *Die Hütte, wo er sonst so heimelig, so froh / . . . im Kreis der Seinen oft gesessen*, 'The cottage where once he had often sat so comfortably, so happily, in the circle of his family', Reithard 20; *Da klingt das Horn des Wächters so heimelig vom Thurm/da ladet seine Stimme so gastlich*, 'Now sounds the watchman's horn so familiarly from the tower; his voice now invites us so hospitably', 49; *Es schläft sich da so lind und warm/so wunderheim'lig ein*, 'There you can fall asleep so soft and warm, in such a wonderfully restful fashion', 23 etc. **This spelling deserves to**

become universal, in order to protect this excellent word from obsolescence through easy confusion with sense 2. Cf.: *'Die Zecks sind alle heimlich'* (sense 2). *'Heimlich?. . . Was verstehen Sie unter heimlich?' . . . 'Nun . . . es kommt mir mit ihnen vor, wie mit einem zugegrabenen Brunnen oder einem ausgetrockneten Teich. Man kann nicht darüber gehen, ohne dass es Einem immer ist, als könnte da wider einmal Wasser zum Vorschein kommen.' 'Wir nennen das unheimlich; Sie nennen's heimlich. Worin finden Sie denn, dass diese Familie etwas Verstecktes und Unzuverlässiges hat?'* etc., ('The Zecks are all mysterious.' 'Mysterious?. . . What do you mean by "mysterious"?' 'Well, I have the same impression with them as I have with a buried spring or a dried-up pond. You can't walk over them without constantly feeling that water might reappear.' 'We call that uncanny ["unhomely"]; you call it mysterious ["homely"]. So, what makes you think there's something hidden and unreliable about the family?') etc., Gutzkow R. 2, 61. (1)

d) (see **c**) especially Silesian: 'cheerful, serene', also of weather, see Adelung and Weinhold.

2. 'versteckt, verborgen gehalten, so dass man Andre nicht davon oder darum wissen lassen, es ihnen verbergen will' ['concealed, kept hidden, so that others do not get to know of it or about it and it is hidden from them'. Cf. **Geheim 2**, from which it is not always clearly distinguished, especially in the older language, as in the Bible, e.g. Job 11, 6, *die heimliche Weisheit*, 'the secret wisdom'; [AV: 'the secrets of wisdom']; 15, 8 *Gottes heimlichen Rat*, 'God's secret counsel'; [AV: 'the secret of God']; 1 Cor 2, 7, *der heimlichen, verborgenen Weisheit Gottes*, 'the secret, hidden wisdom of God'; [AV: 'the wisdom of God in a mystery, *even* the hidden wisdom'], etc., similarly *Heimlichkeit* instead of *Geheimnis*, Matth. 13, 35 etc., [Luther: *was verborgen war*, 'what was hidden'; AV: 'things which have been kept secret', etc.]: *Heimlich (hinter Jemandes Rücken) Etwas thun, treiben*, 'to do or engage in something secretly (behind someone's back)'; *Sich heimlich davon schleichen*, 'to steal secretly

away'; *Heimliche Zusammenkünfte, Verabredungen,* 'secret meet-
ings, assignations'; *Mit heimlicher Schadenfreude zusehen,* 'to watch
with hidden glee'; *Heimlich seufzen, weinen,* 'to sigh, to weep,
secretly'; *Heimlich thun, als ob man etwas zu verbergen hätte,* 'to act
secretively, as if one had something to hide'; *Heimliche Liebschaft,
Liebe, Sünde,* 'secret liaison, love, sin'; *Heimliche Orte (die der
Wohlstand zu verhüllen gebietet),* 'secret places (which propriety
requires to be hidden)', 1 Sam. 5, 6 [Luther (1545): *und schlug
Asdod und alle ihre Grenze an heimlichen Orten,* 'and smote Ashdod
and all their boundaries in secret places'; [AV: 'and smote them with
emerods, even Ashdod and the coasts thereof']; Vulgate: *et percussit
in secretiori parte natium,* 'and smote them in the more secret part
of the buttocks'];[5] 2 Kings 10, 27: *Das heimliche Gemach (Abtritt),*
'the private room (privy)' [AV: 'draught house']; Wieland 5, 256,
etc., also: *Der heimliche Stuhl,* 'the secret stool', Zinkgräf 1, 249; *In
Graben, in Heimlichkeiten werfen,* 'to cast into pits, into hidden
places', 3, 75; Rollenhagen Fr. 83 etc. – *Führte, heimlich vor Laome-
don/die Stuten vor,* 'Secretly led the mares out before Laomedon',
Bürger 161 b etc. – *Ebenso versteckt, heimlich, hinterlistig und
boshaft gegen grausame Herren . . . wie offen, frei, theilnehmend und
dienstwillig gegen den leidenden Freund,* 'Just as hidden, secretive,
treacherous and malicious towards cruel masters . . . as open, free,
sympathetic and obliging towards a suffering friend', Burmeister g
B2, 157; *Du sollst mein heimlich Heiligstes noch wissen,* 'You shall
yet know what I secretly hold most sacred', Chamisso 4, 56; *Die
heimliche Kunst (der Zauberei),* 'The secret art (of sorcery)', 3, 224;
*Wo die öffentliche Ventilation aufhören muss, fängt die heimliche
Machination an,* 'Where public ventilation has to cease, secret
machination begins', Forster, Br. 2, 135; *Freiheit ist die leise Parole
heimlich Verschworener, das laute Feldgeschrei der öffentlich
Umwälzenden,* 'Freedom is the quiet watchword of secret conspira-
tors, the loud war-cry of open revolutionaries', Goethe 4, 222; *Ein
heilig, heimlich Wirken,* 'A sacred, secret force at work', 15; *Ich habe
Wurzeln/die sind gar heimlich,/im tiefen Boden/bin ich gegründet,*
'I have roots that are very secret; I am grounded in the deep soil', 2,
109; *Meine heimliche Tücke* (vgl. *Heimtücke*), 'My secret craft' (cf.

Heimtücke [a compound noun combining the adjective and the noun of the previous phrase]), 30, 344; *Empfängt er es nicht offenbar und gewissenhaft, so mag er es heimlich und gewissenlos ergreifen*, 'If he does not receive it openly and conscientiously, he may seize it secretly and without conscience', 39, 22; *Liess heimlich und geheimnisvoll achromatische Fernröhre zusammensetzen*, 'Had achromatic telescopes constructed covertly and secretly', 375; *Von nun an, will ich, sei nichts Heimliches / mehr unter uns*, 'From now on I desire that there shall be nothing secret between us', Schiller 369b. *Jemandes Heimlichkeiten entdecken, offenbaren, verrathen*, 'To discover, reveal, betray someone's secrets'; *Heimlichkeiten hinter meinem Rücken zu brauen*, 'To concoct secrets behind my back', Alexis, H. 2, 3, 168; *Zu meiner Zeit / befliss man sich der Heimlichkeit*, 'In my day one studied secrecy', Hagedorn 3, 92; *Die Heimlichkeit und das Gepuschele unter der Hand*, 'Secrecy and underhand dealings', Immermann, M. 3. 289; *Der Heimlichkeit (des verborgenen Golds) unmächtigen Bann kann nur die Hand der Einsicht lösen*, 'The powerless spell of the mystery (of hidden gold) can be undone only by the hand of understanding', Novalis 1, 69; *Sag' an, wo du sie . . . verbirgst, in welches Ortes verschwiegener Heimlichkeit*, 'Say, where do you hide them, in the unspoken secrecy of what place?' Schiller 495; *Ihr Bienen, die thi knetet der Heimlichkeiten Schloss (Wachs zum Siegeln)*, 'You bees, who knead the lock of secrets (wax for sealing)', Tieck, Cymb. 3, 2; *Erfahren in seltnen Heimlichkeiten (Zauberkünsten)*, 'Experienced in rare mysteries (magic arts)', Schlegel Sh. 6, 102 etc. cf. **Geheimnis**, Lessing 10: 291 ff.

For compounds see **1 (c)**, especially the antonym formed with **Un-**: 'unbehagliches, banges Grauen erregend' ['arousing uneasy, fearful horror']: *Der schier ihm unheimlich, gespenstisch erschien*, 'Which seemed to him utterly uncanny, ghostly', Chamisso 3, 328; *Der Nacht unheimliche, bange Stunden*, 'The eerie, fearful hours of the night', 4, 148; *Mir war schon lang' unheimlich, ja graulich zu Muthe*, 'For a long time I had an uncanny feeling, indeed a feeling of horror', 242; *Nun fängts mir an, unheimlich zu werden*, 'Now I am beginning to feel uneasy', Goethe 6, 330; *Empfindet ein unheimliches Grauen*.

'Feels an uncanny horror', Heine, Verm. 1, 51; *Unheimlich und starr wie ein Steinbild*, 'Uncanny and motionless like a stone statue', Reis, 1, 10; *Den unheimlichen Nebel, Haarrauch geheissen*, 'The eery mist, called haze (or blight)', Immermann, M., 3, 299; *Diese blassen Jungen sind unheimlich und brauen Gott weiss was Schlimmes*. 'These pale youths are uncanny, concocting God knows what mischief', Laube, I, 119; **Unheimlich nennt man Alles, was im Geheimnis, im Verborgenen ... bleiben sollte und hervorgetreten ist, 'Uncanny is what one calls everything that was meant to remain secret and hidden and has come into the open'**, Schelling 2.2, 649, etc. – *Das Göttliche zu verhüllen, mit einer gewissen Unheimlichkeit zu umgeben*, 'To veil the divine and surround it with an aura of the uncanny', 658, etc. – *Unheimlich* is rare as the antonym of sense **2**); Campe lists it, but with no illustrative quotation.

For us the most interesting fact to emerge from this long excerpt is that among the various shades of meaning that are recorded for the word *heimlich* there is one in which it merges with its formal antonym, *unheimlich*, so that what is called *heimlich* becomes *unheimlich*. As witness the passage from Gutzkow: 'We call that *unheimlich*; you call it *heimlich*.' This reminds us that this word *heimlich* is not unambiguous, but belongs to two sets of ideas, which are not mutually contradictory, but very different from each other – the one relating to what is familiar and comfortable, the other to what is concealed and kept hidden. *Unheimlich* is the antonym of *heimlich* only in the latter's first sense, not in its second. Sanders suggests no genetic connection between the two senses. On the other hand, our attention is seized by Schelling's remark, which says something quite new – something we certainly did not expect – about the meaning of *unheimlich*, namely, that the term 'uncanny' (*unheimlich*) applies to everything that was intended to remain secret, hidden away, and has come into the open.

Some of the doubts that arise here are cleared up by the data in the German Dictionary of Jacob and Wilhelm Grimm (*Deutsches Wörterbuch*, Leipzig 1877, IV/2, 873ff.):

Heimlich: adj. and adv. *vernaculus, occultus*: Middle High German *heimelîch, heimlîch*.

p. 874: In a somewhat different sense: *es ist mir heimlich*, 'I feel well, free from fear', [3] *b) heimlich* is also used of a place that is free of ghostly influences . . .

p. 875: ß) familiar; friendly, confiding.

4. **Starting from the homely and the domestic, there is a further development towards the notion of something removed from the eyes of strangers, hidden, secret. This notion is extended in a number of ways . . .**

p. 876: *links am see*
 liegt eine matte heimlich im gehölz
 Schiller, *Wilhelm Tell* I, 4

(To the left by the lake
lies a meadow hidden among the trees.)

. . . Uncommon in modern usage is the combination of *heimlich* with a verb denoting concealment: *Er verbirgt mich heimlich in seinem gezelt* (Psalm 27, 5), [AV: 'In the secret of his tabernacle shall he hide me']. Secret places on the human body, the pudenda: *welche Leute nicht sturben, die wurden geschlagen an heimlichen örten*, I Samuel 5, 12: 'Those who did not die were smitten in secret places', [AV: 'And the men that died not were smitten with the emerods'].[6]

c) Officials who dispense important advice on affairs of state that is to be kept secret are called *heimliche räthe* ('privy councillors'); in modern usage the adjective is replaced by *geheim* (q.v.): *Pharao nennet ihn (Joseph) den heimlichen rath*, 'Pharaoh named him the privy councillor', Gen. 41, 45;

p. 878: 6. *heimlich* as used of knowledge, mystical, allegorical: *heimliche bedeutung* ('secret meaning'), *mysticus, divinus, occultus, figuratus*.

p. 878: in the following *heimlich* is used differently for what is withdrawn from knowledge, unconscious . . .

but then *heimlich* also means 'locked away, inscrutable': . . .

> *merkst du wohl? sie trauen uns[7] nicht,*
> *fürchten des Friedländers heimlich gesicht.*
>
> Schiller, *Wallensteins Lager*, scene 2
> (Do you see? They do not trust us,
> they fear the inscrutable face of the
> Friedländer [i.e. Wallenstein].)

9. **The notion of the hidden and the dangerous, which appears in the last section, undergoes a further development, so that *heimlich* acquires the sense that otherwise belongs to *unheimlich*** (formed from *heimlich*, 3 *b*, col. 874: *mir ist zu zeiten wie dem menschen der in nacht wandelt und an gespenster glaubt, jeder winkel ist ihm heimlich und schauerhaft*, 'I sometimes feel like a sleepwalker who believes in ghosts: every corner seems to him eerie and frightening'), Klinger, *Theater*, 3, 298.

Heimlich thus becomes increasingly ambivalent, until it finally merges with its antonym *unheimlich*. The uncanny (*das Unheimliche*, 'the unhomely') is in some way a species of the familiar (*das Heimliche*, 'the homely'). Let us relate this finding, which still has to be explained, to Schelling's definition of the uncanny. Separate investigations of cases of the uncanny will enable us to make sense of these hints.

II

If we now go on to review the persons and things, the impressions, processes and situations that can arouse an especially strong and distinct sense of the uncanny in us, we must clearly choose an appropriate example to start with. E. Jentsch singles out, as an excellent case, 'doubt as to whether an apparently animate object really is alive and, conversely, whether a lifeless object might not perhaps be animate'. In this connection he refers to the impressions made on us by waxwork figures, ingeniously constructed dolls and automata. To these he adds the uncanny effect produced by epileptic fits and the manifestations of insanity, because these arouse in the onlooker vague notions of automatic – mechanical – processes that may lie hidden behind the familiar image of a living person. Now, while not wholly convinced by the author's arguments, we will take them as a starting point for our own investigation, because he goes on to remind us of one writer who was more successful than any other at creating uncanny effects.

'One of the surest devices for producing slightly uncanny effects through story-telling,' writes Jentsch, 'is to leave the reader wondering whether a particular figure is a real person or an automaton, and to do so in such a way that his attention is not focused directly on the uncertainty, lest he should be prompted to examine and settle the matter at once, for in this way, as we have said, the special emotional effect can easily be dissipated. E. T. A. Hoffmann often employed this psychological manoeuvre with success in his imaginative writings.'

This observation, which is undoubtedly correct, refers in particular to Hoffmann's story 'The Sand-Man', one of the 'Night Pieces'

(vol. 3 of Hoffmann's *Gesammelte Werke* in Grisebach's edition), from which the doll Olimpia found her way into the first act of Offenbach's opera *The Tales of Hoffmann*. I must say, however – and I hope that most readers of the story will agree with me – that the motif of the seemingly animate doll Olimpia is by no means the only one responsible for the incomparably uncanny effect of the story, or even the one to which it is principally due. Nor is this effect enhanced by the fact that the author himself gives the Olimpia episode a slightly satirical twist using it to make fun of the young man's overvaluation of love. Rather, it is another motif that is central to the tale, the one that gives it its name and is repeatedly emphasized at crucial points – the motif of the Sand-Man, who tears out children's eyes.

A student named Nathaniel, with whose childhood memories this fantastic tale opens, is unable, for all his present happiness, to banish certain memories connected with the mysterious and terrifying death of his much-loved father. On certain evenings his mother would send the children to bed early with the warning 'The Sand-Man is coming.' And sure enough, on each such occasion the boy would hear the heavy tread of a visitor, with whom his father would then spend the whole evening. It is true that, when asked about the Sand-Man, the boy's mother would deny that any such person existed, except as a figure of speech, but a nursemaid was able to give him more tangible information: 'He is a bad man who comes to children when they won't go to bed and throws a handful of sand in their eyes, so that their eyes jump out of their heads, all bleeding. He then throws their eyes in his bag and takes them off to the half-moon as food for his children. These children sit up there in their nest; they have hooked beaks like owls, and use them to peck up the eyes of the naughty little boys and girls.'

Although little Nathaniel was old and sensible enough to dismiss such grisly details about the Sand-Man, fear of this figure took root even in him. He resolved to find out what the Sand-Man looked like, and one evening, when another visitation was due, he hid in his father's study. He recognized the visitor as a lawyer named Coppelius, a repulsive person of whom the children were afraid when

he occasionally came to lunch. He now identified Coppelius with the dreaded Sand-Man. In the remainder of this scene the author leaves us in doubt as to whether we are dealing with the initial delirium of the panic-stricken boy or an account of events that must be taken as real within the world represented in the tale. The boy's father and the visitor busy themselves at a brazier that emits glowing flames. Hearing Coppelius shout 'Eyes here! eyes here!' the little eavesdropper lets out a scream and reveals his presence. Coppelius seizes him and is about to drop red-hot grains of coal in his eyes and then throw these into the brazier. The father begs him to spare his son's eyes. This experience ends with the boy falling into a deep swoon, followed by a long illness. Whoever favours a rationalistic interpretation of the Sand-Man is bound to ascribe the child's fantasy to the continuing influence of the nursemaid's account. Instead of grains of sand, red-hot grains of coal are to be thrown into the child's eyes, but in either case the purpose is to make them jump out of his head. A year later, during another visit by the Sand-Man, the father is killed by an explosion in his study, and the lawyer Coppelius disappears from the town without trace.

Later, as a student, Nathaniel thinks he recognizes this fearful figure from his childhood in the person of Giuseppe Coppola, an itinerant Italian optician who hawks weather-glasses in the university town. When Nathaniel declines to buy one, Coppola says, 'So, no weather-glass, no weather-glass! I've got lovely eyes too, lovely eyes.' Nathaniel is at first terrified, but his terror is allayed when the eyes he is offered turn out to be harmless spectacles. He buys a pocket spyglass from Coppola and uses it to look into the house of Professor Spalanzani, on the other side of the street, where he catches sight of Olimpia, the professor's beautiful, but strangely silent and motionless daughter. He soon falls so madly in love with her that he forgets his wise and level-headed fiancée, Clara. But Olimpia is an automaton, for which Spalanzini has made the clockwork and in which Coppola – the Sand-Man – has set the eyes. The student comes upon the two quarrelling over their handiwork. The optician has carried off the eyeless wooden doll; the mechanic, Spalanzani, picks up Olimpia's bleeding eyes from the floor and throws them at

Nathaniel, from whom he says Coppola has stolen them. Nathaniel is seized by a fresh access of madness. In his delirium the memory of his father's death is compounded with this new impression: 'Hurry – hurry – hurry! – ring of fire – ring of fire! Spin round, ring of fire – quick – quick! Wooden doll, hurry, lovely wooden doll, spin round –'. Whereupon he hurls himself at the professor, Olimpia's supposed father, and tries to strangle him.

Having recovered from a long, serious illness, Nathaniel at last seems to be cured. He finds his fiancée again and plans to marry her. One day they are out walking in the town with her brother. The tall tower of the town hall casts a huge shadow over the market-place. Clara suggests that they go up the tower together while her brother remains below. At the top, her attention is drawn to the curious sight of something moving along the street. Nathaniel examines this through Coppola's spyglass, which he finds in his pocket. Again he is seized by madness and, uttering the words 'Wooden doll, spin round', he tries to cast the girl down from the tower. Her brother, hearing her screams, comes to her rescue and quickly escorts her to the ground. Up above, the madman runs around shouting out 'Ring of fire, spin round' – words whose origin is already familiar to us. Conspicuous among the people gathering below is the lawyer Coppelius, who has suddenly reappeared. We may assume that it was the sight of his approach that brought on Nathaniel's fit of madness. Some of the crowd want to go up the tower and overpower the madman, but Coppelius says laughingly: 'Just wait. He'll come down by himself.' Nathaniel suddenly stands still, catches sight of Coppelius and, with a cry of 'Yes! Lovely eyes – lovely eyes', throws himself over the parapet. Moments later he is lying on the pavement, his head shattered, and the Sand-Man has vanished in the milling crowd.

This brief summary will probably make it clear beyond doubt that in Hoffmann's tale the sense of the uncanny attaches directly to the figure of the Sand-Man, and therefore to the idea of being robbed of one's eyes – and that intellectual uncertainty, as Jentsch understands it, has nothing to do with this effect. Uncertainty as to whether an object is animate or inanimate, which we were bound to

acknowledge in the case of the doll Olimpia, is quite irrelevant in the case of this more potent example of the uncanny. It is true that the author initially creates a kind of uncertainty by preventing us – certainly not unintentionally – from guessing whether he is going to take us into the real world or into some fantastic world of his own choosing. He is of course entitled to do either, and if he chooses, for instance, to set the action in a world in which spirits, demons and ghosts play a part, as Shakespeare does in *Hamlet, Macbeth* and *Julius Caesar* and, rather differently, in *The Tempest* and *A Midsummer Night's Dream*, we must yield to his choice and treat his posited world as if it were real for as long as we submit to his spell. But in the course of Hoffmann's tale this uncertainty disappears; it becomes clear that the author wants us too to look through the spectacles or the spyglass of the demon optician, and even, perhaps, that he has looked through such an instrument himself. For, after all, the conclusion of the tale makes it clear that the optician Coppola really is the lawyer Coppelius[1] and so also the Sand-Man.

There is no longer any question of 'intellectual uncertainty': we know now that what we are presented with are not figments of a madman's imagination, behind which we, with our superior rationality, can recognize the sober truth – yet this clear knowledge in no way diminishes the impression of the uncanny. The notion of intellectual uncertainty in no way helps us to understand this uncanny effect.

On the other hand, psychoanalytic experience reminds us that some children have a terrible fear of damaging or losing their eyes. Many retain this anxiety into adult life and fear no physical injury so much as one to the eye. And there is a common saying that one will 'guard something like the apple of one's eye'. The study of dreams, fantasies and myths has taught us also that anxiety about one's eyes, the fear of going blind, is quite often a substitute for the fear of castration. When the mythical criminal Oedipus blinds himself, this is merely a mitigated form of the penalty of castration, the only one that befits him according to the *lex talionis*. Taking up a rationalistic stance, one may seek to reject the idea that the fear of damaging the

eyes can be traced back to the fear of castration; one finds it understandable that so precious an organ as the eye should be guarded by a commensurate anxiety. Indeed, one can go further and claim that no deeper mystery and no other significance lie behind the fear of castration. Yet this does not account for the substitutive relation between the eye and the male member that is manifested in dreams, fantasies and myths; nor can it counter the impression that a particularly strong and obscure emotion is aroused by the threat of losing the sexual organ, and that it is this emotion that first gives such resonance to the idea of losing other organs. Any remaining doubt vanishes once one has learnt the details of the 'castration complex' from analyses of neurotic patients and realized what an immense part it plays in their mental life.

Moreover, I would not advise any opponent of the psychoanalytic view to appeal to Hoffmann's story of the Sand-Man in support of the contention that fear for the eyes is something independent of the castration complex. For why is this fear for the eyes so closely linked here with the death of the father? Why does the Sand-Man always appear as a disruptor of love? He estranges the unfortunate student from his fiancée, and from her brother, his best friend; he destroys the second object of his love, the beautiful doll Olimpia, and even drives him to suicide just when he has won back his fiancée and the two are about to be happily united. These and many other features of the tale appear arbitrary and meaningless if one rejects the relation between fear for the eyes and fear of castration, but they become meaningful as soon as the Sand-Man is replaced by the dreaded father, at whose hands castration is expected.[2]

We would therefore venture to trace back the uncanny element in the Sand-Man to the anxiety caused by the infantile castration complex. Yet as soon as we conceive the idea of ascribing the emergence of the sense of the uncanny to an infantile factor such as this, we cannot help trying to derive other examples of the uncanny from the same source. 'The Sand-Man' also contains the motif of the apparently animate doll, which was singled out by Jentsch. According to him we have particularly favourable conditions for generating feelings of the uncanny if intellectual uncertainty is

aroused as to whether something is animate or inanimate, and whether the lifeless bears an excessive likeness to the living. With dolls, of course, we are not far from the world of childhood. We recall that children, in their early games, make no sharp distinction between the animate and the inanimate, and that they are especially fond of treating their dolls as if they were alive. Indeed, one occasionally hears a woman patient tell how, at the age of eight, she was still convinced that her dolls were bound to come to life if she looked at them in a certain way, as intently as possible. Here too, then, the infantile factor is easily demonstrated. But, oddly enough, 'The Sand-Man' involved the evocation of an old childhood fear, whereas there is no question of fear in the case of a living doll: children are not afraid of their dolls coming to life – they may even want them to. Here, then, the sense of the uncanny would derive not from an infantile fear, but from an infantile wish, or simply from an infantile belief. This sounds like a contradiction, but possibly it is just a complication, which may further our understanding later on.

E. T. A. Hoffmann is the unrivalled master of the uncanny in literature. His novel *Die Elexiere des Teufels* [*The Elixirs of the Devil*] presents a whole complex of motifs to which one is tempted to ascribe the uncanny effect of the story. The content is too rich and intricate for us to venture upon a summary. At the end of the book, when the reader finally learns of the presuppositions, hitherto withheld, which underlie the plot, this leads not to his enlightenment, but to his utter bewilderment. The author has piled up too much homogeneous material, and this is detrimental, not to the impression made by the whole, but to its intelligibility. One must content oneself with selecting the most prominent of those motifs that produce an uncanny effect, and see whether they too can reasonably be traced back to infantile sources. They involve the idea of the 'double' (the *Doppelgänger*), in all its nuances and manifestations – that is to say, the appearance of persons who have to be regarded as identical because they look alike. This relationship is intensified by the spontaneous transmission of mental processes from one of these persons to the other – what we would call telepathy – so that the one becomes co-owner of the other's knowledge,

emotions and experience. Moreover, a person may identify himself with another and so become unsure of his true self; or he may substitute the other's self for his own. The self may thus be duplicated, divided and interchanged. Finally there is the constant recurrence of the same thing, the repetition of the same facial features, the same characters, the same destinies, the same misdeeds, even the same names, through successive generations.

The motif of the double has been treated in detail in a study by O. Rank.[3] This work explores the connections that link the double with mirror-images, shadows, guardian spirits, the doctrine of the soul and the fear of death. It also throws a good deal of light on the surprising evolution of the motif itself. The double was originally an insurance against the extinction of the self or, as Rank puts it, 'an energetic denial of the power of death', and it seems likely that the 'immortal' soul was the first double of the body. The invention of such doubling as a defence against annihilation has a counterpart in the language of dreams, which is fond of expressing the idea of castration by duplicating or multiplying the genital symbol. In the civilization of ancient Egypt, it became a spur to artists to form images of the dead in durable materials. But these ideas arose on the soil of boundless self-love, the primordial narcissism that dominates the mental life of both the child and primitive man, and when this phase is surmounted, the meaning of the 'double' changes: having once been an assurance of immortality, it becomes the uncanny harbinger of death.

The concept of the double need not disappear along with this primitive narcissism: it may acquire a new content from later stages in the evolution of the ego. By slow degrees a special authority takes shape within the ego; this authority, which is able to confront the rest of the ego, performs the function of self-observation and self-criticism, exercises a kind of psychical censorship, and so becomes what we know as the 'conscience'. In the pathological case of delusions of observation it becomes isolated, split off from the ego, and discernible to the clinician. The existence of such an authority, which can treat the rest of the ego as an object – the fact that, in other words, man is capable of self-observation – makes it possible

to imbue the old idea of the double with a new content and attribute a number of features to it – above all, those which, in the light of self-criticism, seem to belong to the old, superannuated narcissism of primitive times.[4]

Yet it is not only this content – which is objectionable to self-criticism – that can be embodied in the figure of the double: in addition there are all the possibilities which, had they been realized, might have shaped our destiny, and to which our imagination still clings, all the strivings of the ego that were frustrated by adverse circumstances, all the suppressed acts of volition that fostered the illusion of free will.[5]

However, after considering the manifest motivation behind the figure of the double, we have to own that none of this helps us understand the extraordinary degree of uncanniness that attaches to it, and we may add, drawing upon our knowledge of pathological mental processes, that none of this content could explain the defensive urge that ejects it from the ego as something alien. Its uncanny quality can surely derive only from the fact that the double is a creation that belongs to a primitive phase in our mental development, a phase that we have surmounted, in which it admittedly had a more benign significance. The double has become an object of terror, just as the gods become demons after the collapse of their cult – a theme that Heine treats in 'Die Götter im Exil' ['The Gods in Exile'].

The other disturbances of the ego that Hoffmann exploits in his writings are easy to judge in accordance with the pattern set by the motif of the double. They involve a harking back to single phases in the evolution of the sense of self, a regression to times when the ego had not yet clearly set itself off against the world outside and from others. I believe that these motifs are partly responsible for the impression of the uncanny, though it is not easy to isolate and specify the share they have in it.

The factor of the repetition of the same thing will perhaps not be acknowledged by everyone as a source of the sense of the uncanny. According to my own observations it undoubtedly evokes such a feeling under particular conditions, and in combination with

particular circumstances – a feeling, moreover, that recalls the helplessness we experience in certain dream-states. Strolling one hot summer afternoon through the empty and to me unfamiliar streets of a small Italian town, I found myself in a district about whose character I could not long remain in doubt. Only heavily made-up women were to be seen at the windows of the little houses, and I hastily left the narrow street at the next turning. However, after wandering about for some time without asking the way, I suddenly found myself back in the same street, where my presence began to attract attention. Once more I hurried away, only to return there again by a different route. I was now seized by a feeling that I can only describe as uncanny, and I was glad to find my way back to the piazza that I had recently left and refrain from any further voyages of discovery. Other situations that share this feature of the unintentional return with the one I have just described, but differ from it in other respects, may nevertheless produce the same feeling of helplessness, the same sense of the uncanny. One may, for instance, have lost one's way in the woods, perhaps after being overtaken by fog, and, despite all one's efforts to find a marked or familiar path, one comes back again and again to the same spot, which one recognizes by a particular physical feature. Or one may be groping around in the dark in an unfamiliar room, searching for the door or the light-switch and repeatedly colliding with the same piece of furniture – a situation that Mark Twain has transformed, admittedly by means of grotesque exaggeration, into something irresistibly comic.

In another set of experiences we have no difficulty in recognizing that it is only the factor of unintended repetition that transforms what would otherwise seem quite harmless into something uncanny and forces us to entertain the idea of the fateful and the inescapable, when we should normally speak of 'chance'. There is certainly nothing remarkable, for instance, about depositing a garment in a cloakroom and being given a ticket with a certain number on it – say 62 – or about finding that the cabin one has been allocated bears this number. But the impression changes if these two events, of no consequence in themselves, come close together, so that one

encounters the number 62 several times in one day, and if one then observes that everything involving a number – addresses, hotel rooms, railway carriages, etc. – invariably has the same one, at least as part of the whole. We find this 'uncanny', and anyone who is not steeled against the lure of superstition will be inclined to accord a secret significance to the persistent recurrence of this one number – to see it, for instance, as a pointer to his allotted life-span. Or suppose one is occupied with the writings of E [wald] Hering,[6] the great physiologist, and that within the space of a few days one receives letters from two people named Hering, posted in different countries, although one has had no previous dealings with anyone of that name. An ingenious scientist has recently sought to show that such occurrences are subject to certain laws – which would necessarily remove the impression of the uncanny. I will not venture to pronounce on whether he has succeeded.[7]

How the uncanny element in the recurrence of the same thing can be derived from infantile psychology is a question that I can only touch upon here; I must therefore refer the reader to another study, now awaiting publication, which treats the subject in detail, but in a different context. In the unconscious mind we can recognize the dominance of a *compulsion to repeat*, which proceeds from instinctual impulses. This compulsion probably depends on the essential nature of the drives themselves. It is strong enough to override the pleasure principle and lend a demonic character to certain aspects of mental life; it is still clearly manifest in the impulses of small children and dominates part of the course taken by the psychoanalysis of victims of neurosis. The foregoing discussions have all prepared us for the fact that anything that can remind us of this inner compulsion to repeat is perceived as uncanny.

But now, I think, it is time to turn away from these relationships, which are in any case difficult to pass judgement on, and seek out unequivocal cases of the uncanny, which may be expected, once analysed, to determine the validity of our hypothesis once and for all.

In Schiller's poem *Der Ring des Polykrates* ('The Ring of Poly-krates') the guest turns away in horror because he sees his friend's

every wish instantly fulfilled and his every care at once removed by fate. His host has become 'uncanny'. The reason he himself gives – that whoever is excessively fortunate must fear the envy of the gods – still seems obscure to us, its meaning being veiled in mythology. So let us take an example from a much simpler setting. In the case history of a patient suffering from obsessional neurosis[8] I recorded that he had once visited a hydropathic institution and found that his health improved greatly. However, he was sensible enough to attribute this improvement not to the healing properties of the water, but to the location of his room, which was next to the office of a very kind nurse. So, on returning for a second visit, he asked for the same room, only to be told that it was already occupied by an old gentleman. Whereupon he gave vent to his annoyance with the words, 'Then he should be struck dead!' A fortnight later the old gentleman did suffer a stroke. My patient found this an 'uncanny' experience. The impression of the uncanny would have been even stronger if a much shorter interval had elapsed between his uttering the words and the untoward event that followed, or if he had been able to report numerous similar experiences. In fact, he was never at a loss for such corroboration. Indeed, not only this patient, but every obsessional neurotic I have studied, could tell similar stories about themselves. They were not at all surprised when, perhaps after a long interval, they ran into someone about whom they had only just been thinking. They would regularly get a letter by the morning post from a friend of whom they had said, only the night before, 'He's not been heard of for ages.' In particular, accidents and deaths rarely happened without having flitted through their minds a short while before. They would describe this phenomenon in the most modest terms, claiming to have 'presentiments' that 'usually' came true.

One of the uncanniest and most widespread superstitions is fear of the 'evil eye', which has been thoroughly investigated by the Hamburg oculist S. Seligmann.[9] It appears that the source of this fear has never been in doubt. Anyone who possesses something precious, but fragile, is afraid of the envy of others, to the extent that he projects on to them the envy he would have felt in their

place. Such emotions are betrayed by looks,[10] even if they are denied verbal expression, and when a person is prominent owing to certain striking characteristics, especially if these are of an undesirable kind, people are ready to believe that his envy will reach a particular intensity and then convert this intensity into effective action. What is feared is thus a covert intention to harm, and on the strength of certain indications it is assumed that this intention can command the necessary force.

These last examples of the uncanny depend on the principle that I have called 'the omnipotence of thoughts', a term suggested to me by a patient. We can no longer be in any doubt about where we now stand. The analysis of cases of the uncanny has led us back to the old *animistic* view of the universe, a view characterized by the idea that the world was peopled with human spirits, by the narcissistic overrating of one's own mental processes, by the omnipotence of thoughts and the technique of magic that relied on it, by the attribution of carefully graded magical powers (*mana*) to alien persons and things, and by all the inventions with which the unbounded narcissism of that period of development sought to defend itself against the unmistakable sanctions of reality. It appears that we have all, in the course of our individual development, been through a phase corresponding to the animistic phase in the development of primitive peoples, that this phase did not pass without leaving behind in us residual traces that can still make themselves felt, and that everything we now find 'uncanny' meets the criterion that it is linked with these remnants of animistic mental activity and prompts them to express themselves.[11]

This is now an appropriate point at which to introduce two observations in which I should like to set down the essential content of this short study. In the first place, if psychoanalytic theory is right in asserting that every affect arising from an emotional impulse – of whatever kind – is converted into fear by being repressed, it follows that among those things that are felt to be frightening there must be one group in which it can be shown that the frightening element is something that has been repressed and now returns. This species of the frightening would then constitute the uncanny, and it would

147

be immaterial whether it was itself originally frightening or arose from another affect. In the second place, if this really is the secret nature of the uncanny, we can understand why German usage allows the familiar (*das Heimliche*, the 'homely') to switch to its opposite, the uncanny (*das Unheimliche*, the 'unhomely') (p. 134), for this uncanny element is actually nothing new or strange, but something that was long familiar to the psyche and was estranged from it only through being repressed. The link with repression now illuminates Schelling's definition of the uncanny as 'something that should have remained hidden and has come into the open'.

It now only remains for us to test the insight we have arrived at by trying to explain some other instances of the uncanny.

To many people the acme of the uncanny is represented by anything to do with death, dead bodies, revenants, spirits and ghosts. Indeed, we have heard that in some modern languages the German phrase *ein unheimliches Haus* ['an uncanny house'] can be rendered only by the periphrasis 'a haunted house'. We might in fact have begun our investigation with this example of the uncanny – perhaps the most potent – but we did not do so because here the uncanny is too much mixed up with the gruesome and partly overlaid by it. Yet in hardly any other sphere has our thinking and feeling changed so little since primitive times or the old been so well preserved, under a thin veneer, as in our relation to death. Two factors account for this lack of movement: the strength of our original emotional reactions and the uncertainty of our scientific knowledge. Biology has so far been unable to decide whether death is the necessary fate of every living creature or simply a regular, but perhaps avoidable, contingency within life itself. It is true that in textbooks on logic the statement that 'all men must die' passes for an exemplary general proposition, but it is obvious to no one; our unconscious is still as unreceptive as ever to the idea of our own mortality. Religions continue to dispute the significance of the undeniable fact of individual death and to posit an afterlife. The state authorities think they cannot sustain moral order among the living if they abandon the notion that life on earth will be 'corrected' by a better life hereafter. Placards in our big cities advertise lectures that are meant to instruct

us in how to make contact with the souls of the departed, and there is no denying that some of the finest minds and sharpest thinkers among our men of science have concluded, especially towards the end of their own lives, that there is ample opportunity for such contact. Since nearly all of us still think no differently from savages on this subject, it is not surprising that the primitive fear of the dead is still so potent in us and ready to manifest itself if given any encouragement. Moreover, it is probably still informed by the old idea that whoever dies becomes the enemy of the survivor, intent upon carrying him off with him to share his new existence. Given this unchanging attitude to death, one might ask what has become of repression, which is necessary if the primitive is to return as something uncanny. But it is there too: so-called educated people have officially ceased to believe that the dead can become visible as spirits, such appearances being linked to remote conditions that are seldom realized, and their emotional attitude to the dead, once highly ambiguous and ambivalent, has been toned down, in the higher reaches of mental life, to an unambiguous feeling of piety.[12]

Only a few remarks need now be added to complete the picture, for, having considered animism, magic, sorcery, the omnipotence of thoughts, unintended repetition and the castration complex, we have covered virtually all the factors that turn the frightening into the uncanny.

We can also call a living person uncanny, that is to say, when we credit him with evil intent. But this alone is not enough: it must be added that this intent to harm us is realized with the help of special powers. A good example of this is the *gettatore*,[13] the uncanny figure of Romance superstition, whom Albrecht Schaeffer, in his novel *Josef Montfort*, has turned into an attractive figure by employing poetic intuition and profound psychoanalytic understanding. Yet with these secret powers we are back once more in the realm of animism. In Goethe's *Faust*, the pious Gretchen's intuition that Mephisto has such hidden powers is what makes him seem so uncanny:

Sie fühlt, dass ich ganz sicher ein Genie,
Vielleicht wohl gar der Teufel bin.

[She feels that I am quite certainly a genius, perhaps indeed the very Devil.]

The uncanny effect of epilepsy or madness has the same origin. Here the layman sees a manifestation of forces that he did not suspect in a fellow human being, but whose stirrings he can dimly perceive in remote corners of his own personality. The Middle Ages attributed all these manifestations of sickness consistently, and psychologically almost correctly, to the influence of demons. Indeed, it would not surprise me to hear that psychoanalysis, which seeks to uncover these secret forces, had for this reason itself come to seem uncanny to many people. In one case, when I had succeeded – though not very quickly – in restoring a girl to health after many years of sickness, I heard this myself from the girl's mother long after her recovery.

Severed limbs, a severed head, a hand detached from the arm (as in a fairy tale by Hauff), feet that dance by themselves (as in the novel by A. Schaeffer mentioned above) – all of these have something highly uncanny about them, especially when they are credited, as in the last instance, with independent activity. We already know that this species of the uncanny stems from its proximity to the castration complex. Some would award the crown of the uncanny to the idea of being buried alive, only apparently dead. However, psychoanalysis has taught us that this terrifying fantasy is merely a variant of another, which was originally not at all frightening, but relied on a certain lasciviousness; this was the fantasy of living in the womb.

Let us add something of a general nature, which is, strictly speaking, already contained in what we have previously said about animism and the superannuated workings of our mental apparatus, but seems to call for special emphasis. This is the fact that an uncanny effect often arises when the boundary between fantasy and reality is blurred, when we are faced with the reality of something that we have until now considered imaginary, when a symbol takes on the full function and significance of what it symbolizes, and so

forth. This is at the root of much that is uncanny about magical practices. The infantile element about this, which also dominates the mental life of neurotics, is the excessive stress that is laid on psychical reality, as opposed to material reality – a feature that is close to the omnipotence of thoughts. During the isolation of the Great War, I came across a number of the English *Strand Magazine*. In it, among a number of fairly pointless contributions, I read a story about a young couple who move into a furnished flat in which there is a curiously shaped table with crocodiles carved in the wood. Towards evening the flat is regularly pervaded by an unbearable and highly characteristic smell, and in the dark the tenants stumble over things and fancy they see something undefinable gliding over the stairs. In short, one is led to surmise that, owing to the presence of this table, the house is haunted by ghostly crocodiles or that the wooden monsters come to life in the dark, or something of the sort. It was a quite naïve story, but its effect was extraordinarily uncanny.

To conclude this collection of examples, which is certainly not exhaustive, I will mention an experience culled from psychoanalytic work, which, unless it rests on pure coincidence, supplies the most pleasing confirmation of our conception of the uncanny. It often happens that neurotic men state that to them there is something uncanny about the female genitals. But what they find uncanny ['unhomely'] is actually the entrance to man's old 'home', the place where everyone once lived. A jocular saying has it that 'love is a longing for home', and if someone dreams of a certain place or a certain landscape and, while dreaming, thinks to himself, 'I know this place, I've been here before', this place can be interpreted as representing his mother's genitals or her womb. Here too, then, the uncanny [the 'unhomely'] is what was once familiar ['homely', 'homey']. The negative prefix *un-* is the indicator of repression.

III

During the foregoing discussions, certain doubts will have arisen in the reader's mind; it is now time these were brought together and given a proper hearing.

It may be that the uncanny ['the unhomely'] is something familar ['homely', 'homey'] that has been repressed and then reappears, and that everything uncanny satisfies this condition. However, such a choice of material does not seem to solve the puzzle of the uncanny. Our proposition clearly does not admit of its logical converse. Not everything that reminds us of repressed desires, or of superannuated modes of thought belonging to the prehistory of the individual and the race, is for that reason uncanny.

Nor do we wish to discount the fact that for nearly every example we have adduced in support of our thesis an analogous one can be found to counter it. For instance, the severed hand in Hauff's fairy tale certainly has an uncanny effect; this we have traced back to the castration complex. But others will probably agree with me that the same motif produces no uncanny effect in Herodotus' story of the treasure of Rhampsenitus, in which the princess wants to hold on to the master-thief's hand, but is left holding the severed hand of his brother. The prompt fulfilment of the host's wishes in 'The Ring of Polycrates' certainly seems just as uncanny to us as it does to the king of Egypt. But our fairy tales teem with instantaneous wish-fulfilments, and there is nothing uncanny about these. In the tale of 'The Three Wishes', the wife is tempted by the delicious smell of a fried sausage to say that she would like one too. Immediately it is on the plate in front of her. In his annoyance, her husband wishes that it may hang from his meddlesome wife's nose, and in no time it

is dangling there. This is very striking, but not in the least uncanny. Indeed, the fairy tale is quite openly committed to the animistic view that thoughts and wishes are all-powerful, but I cannot cite one genuine fairy tale in which anything uncanny occurs. We are told that it is highly uncanny when inanimate objects – pictures or dolls – come to life, but in Hans Andersen's stories the household utensils, the furniture and the tin soldier are alive, and perhaps nothing is farther removed from the uncanny. Even when Pygmalion's beautiful statue comes to life, this is hardly felt to be uncanny.

The false semblance of death and the raising of the dead have been represented to us as very uncanny themes. But again, such things are commonplace in fairy tales. Who would go so far as to call it uncanny when, for instance, Snow White opens her eyes again? And the raising of the dead in miracle stories – those of the New Testament, for example – arouses feelings that have nothing to do with the uncanny. The unintended recurrence of the same thing has produced effects that are undoubtedly uncanny, yet in a number of cases it serves other, quite different ends. We have already mentioned one in which it is employed to produce a sense of the comic, and such instances could be multiplied. At other times it is used for emphasis, and so on. Moreover, where does the uncanny effect of silence, solitude and darkness come from? Do not these factors point to the part played by danger in the genesis of the uncanny, even though these are the conditions under which children are most often seen to express fear? And can we completely discount the element of intellectual uncertainty, given that we have admitted its importance in relation to the link between the uncanny and death.

So we should probably be prepared to assume that other conditions, apart from those we have so far laid down, play an important part in the emergence of a sense of the uncanny. One might of course say that these initial findings have satisfied any psychoanalytic interest in the problem of the uncanny, and that what is left probably calls for an aesthetic study. This, however, would open the door to doubts about the value we can actually claim for our finding that the uncanny derives from what was once familiar and then repressed.

One observation may point towards a resolution of these

uncertainties. Nearly all the examples that are at variance from our expectations are taken from the realm of fiction and imaginative writing. This suggests that we should distinguish between the uncanny one knows from experience and the uncanny one only fancies or reads about.

The uncanny of real experience has far simpler determinants, but comprises fewer instances. I believe that it invariably accords with our attempted solution and can be traced back every time to something that was once familiar and then repressed. But here too we must make an important and psychologically significant distinction within the material, and we shall recognize this most clearly with the help of suitable examples.

Let us take first the uncanny effects associated with the omnipotence of thoughts, instantaneous wish-fulfilment, secret harmful forces and the return of the dead. There is no mistaking the conditions under which the sense of the uncanny arises here. We – or our primitive forebears – once regarded such things as real possibilities; we were convinced that they really happened. Today we no longer believe in them, having *surmounted* such modes of thought. Yet we do not feel entirely secure in these new convictions; the old ones live on in us, on the look-out for confirmation. Now, as soon as something *happens* in our lives that seems to confirm these old, discarded beliefs, we experience a sense of the uncanny, and this may be reinforced by judgements like the following: 'So it's true, then, that you can kill another man just by wishing him dead, that the dead really do go on living and manifest themselves at the scene of their former activities', and so on. Conversely, for anyone who has wholly and definitively rejected these animistic convictions, this species of the uncanny no longer exists. The most extraordinary coincidence of wish and fulfilment, the most baffling repetition of similar experiences, in the same place or on the same date, the most deceptive sights and the most suspicious noises will fail to disconcert him or arouse in him any fear that might be called a fear of the 'uncanny'. It is thus solely a matter of testing reality, a question of material reality.[1]

It is rather different when the uncanny derives from repressed

childhood complexes, the castration complex, the womb fantasy, etc. – though there cannot be many real-life experiences that give rise to this variety of the uncanny. The uncanny we know from experience belongs mainly to the earlier group, but the distinction between the two is very important from a theoretical point of view. Where the uncanny stems from childhood complexes, the question of material reality does not arise, its place being taken by psychical reality. Here we are dealing with the actual repression of a particular content and the return of what has been repressed, not with the suspension of *belief in its reality*. One could say that in the one case a certain ideational content was repressed, in the other the belief in its (material) reality. But such a formulation probably stretches the concept of 'repression' beyond its legitimate bounds. It is more correct to take account of a perceptible psychological difference and to describe the animistic convictions of civilized man as having been – more or less completely – *surmounted*. Our conclusion could then be stated as follows: the uncanny element we know from experience arises either when repressed childhood complexes are revived by some impression, or when primitive beliefs that have been *surmounted* appear to be once again confirmed. Finally, we must not let our preference for tidy solutions and lucid presentation prevent us from acknowledging that in real life it is sometimes impossible to distinguish between the two species of the uncanny that we have posited. As primitive convictions are closely linked with childhood complexes, indeed rooted in them, this blurring of the boundaries will come as no great surprise.

The uncanny that we find in fiction – in creative writing, imaginative literature – actually deserves to be considered separately. It is above all much richer than what we know from experience; it embraces the whole of this and something else besides, something that is wanting in real life. The distinction between what is repressed and what is surmounted cannot be transferred to the uncanny in literature without substantial modification, because the realm of the imagination depends for its validity on its contents being exempt from the reality test. The apparently paradoxical upshot of this is *that many things that would be uncanny if they occurred in real life*

are not uncanny in literature, and that in literature there are many opportunities to achieve uncanny effects that are absent in real life.

Among the many liberties that the creative writer can allow himself is that of choosing whether to present a world that conforms with the reader's familiar reality or one that in some way deviates from it. We accept his choice in every case. The world of the fairy tale, for example, abandons the basis of reality right from the start and openly commits itself to the acceptance of animistic beliefs. Here it is impossible for wish-fulfilments, the existence of secret powers, the omnipotence of thoughts, the animation of the inanimate – all of which are commonplace in the fairy tale – to produce an uncanny effect, for, as we have seen, a sense of the uncanny can arise only if there is a conflict of judgement as to whether what has been surmounted and merits no further credence may not, after all, be possible in real life. This is a question that is wholly ruled out by the presuppositions underlying the world of the fairy tale. Hence, the fairy tale, which has furnished most of the cases that are at odds with our solution of the problem of the uncanny, confirms the first part of our thesis, viz., that many things that would be bound to seem uncanny if they happened in real life are not so in the realm of fiction. In the case of the fairy tale there are additional factors, which we shall briefly touch on later.

The imaginative writer may have invented a world that, while less fantastic than that of the fairy tale, differs from the real world in that it involves supernatural entities such as demons or spirits of the dead. Within the limits set by the presuppositions of this literary reality, such figures forfeit any uncanny quality that might otherwise attach to them. The souls in Dante's *Inferno* or the ghostly apparitions in Shakespeare's *Hamlet, Macbeth* or *Julius Caesar* may be dark and terrifying, but at bottom they are no more uncanny than, say, the serene world of Homer's gods. We adapt our judgement to the conditions of the writer's fictional reality and treat souls, spirits and ghosts as if they were fully entitled to exist, just as we are in our material reality. Here too there is no place for the uncanny.

Not so, however, if the writer has to all appearances taken up his stance on the ground of common reality. By doing so he adopts all

the conditions that apply to the emergence of a sense of the uncanny in normal experience; whatever has an uncanny effect in real life has the same in literature. But the writer can intensify and multiply this effect far beyond what is feasible in normal experience; in his stories he can make things happen that one would never, or only rarely, experience in real life. In a sense, then, he betrays us to a superstition we thought we had 'surmounted'; he tricks us by promising us everyday reality and then going beyond it. We react to his fictions as if they had been our own experiences. By the time we become aware of the trickery, it is too late: the writer has already done what he set out to do. Yet I am bound to say that the effect he achieves is not an unmixed success. We are left with a sense of dissatisfaction, of resentment at the attempt to deceive us. I felt this particularly keenly on reading Schnitzler's story *Die Weissagung* ['The Prophecy'] and similar works that flirt with the miraculous. The author may then resort to another device in order to overcome our resistance, while at the same time improving his prospects of success. For a long time he may prevent us from guessing the presuppositions that underlie his chosen world, or he may cunningly withhold such crucial enlightenment right to the end. On the whole, however, this illustrates the thesis we have just advanced – that fiction affords possibilities for a sense of the uncanny that would not be available in real life.

Strictly speaking, all these variations relate only to that species of the uncanny which arises from superannuated modes of thought. The variety that derives from repressed complexes is more resistant; with one exception, it remains as uncanny in literature as it is in real life. The other species of the uncanny, deriving from superannuated modes of thought, retains its character in real-life experience and in writings that are grounded in material reality, but it may be lost where the setting is a fictive reality invented by the writer.

The foregoing remarks clearly do not exhaust the possibilities of authorial licence and the privileges that fiction enjoys in arousing and inhibiting a sense of the uncanny. Towards real experience we generally adopt a uniformly passive attitude and succumb to the influence of our material environment. To the writer, however, we

are infinitely tractable; by the moods he induces and the expectations he arouses in us he can direct our feelings away from one consequence and towards another, and he can often produce very different effects from the same material. All this has been known for a long time and has no doubt been studied in depth by experts in aesthetics. We were led into this field of inquiry without any real intention because we yielded to the temptation to explain why certain instances of the uncanny conflicted with our thesis regarding its origin. Let us therefore return to one or two of these.

A while back we asked why the motif of the severed hand did not have the same uncanny effect in Herodotus' story of the treasure of Rhampsenitus as it did in Hauff's 'Story of the Severed Hand'. The question seems more significant to us now, since we have recognized the greater resistance of that form of the uncanny which derives from repressed complexes. The answer is simple: in the former tale our attention is concentrated not on the princess's feelings, but on the superior cunning of the master-thief. She may not have been spared a sense of the uncanny; we are even prepared to believe that she may have fallen into a swoon, but *we* have no sense of the uncanny, because we put ourselves in the place of the thief, not in hers. In Nestroy's farce *Der Zerrissene* ('The Torn Man') a different device is used to spare us the impression of the uncanny. A fugitive, convinced that he is a murderer, sees what he takes to be his victim's ghost rising from every trap-door he lifts, and cries out in despair, 'But I've only killed one man. Why this ghastly multiplication?' The audience, knowing what has led up to this scene, does not make the same mistake as the character; hence, what is bound to seem uncanny to him strikes us as irresistibly comic. Even a 'real' *ghost*, such as the one in Oscar Wilde's 'The Canterville Ghost', inevitably loses any claim to arouse even feelings of fright when the author amuses himself by ironizing it and exposing it to ridicule. We see how independent, in the fictional world, emotional effects can be of the choice of subject-matter. In the world of the fairy tale, feelings of fear, and therefore of the uncanny, are totally ruled out. We understand this and therefore ignore whatever occasions they afford for such a possibility.

As for solitude, silence and darkness, all we can say is that these are factors connected with infantile anxiety, something that most of us never wholly overcome. Psychoanalytic research has dealt elsewhere with the problem of such anxiety.

(1919)

Notes

I

1. 'Zur Psychologie des Unheimlichen', *Psychiatrisch-neurologische Wochenschrift* 1908, No. 22 and No. 23.
2. [Translator's note: On the meaning of *heimlich* see pp. 126ff; *heimisch* may provisionally be glossed as 'local, native, domestic; (feeling) at home', and *vertraut* as 'familiar'.]
3. I am grateful to Dr T. Reik for the following material.
4. [In the following excerpts bold type is used (a) for headwords as is customary in dictionary entries, and (b) for passages that Freud chooses to emphasize.]
5. [The phrase *an heimlichen Orten* occurs also in vv. 9 and 12. It is clearly equivalent to the AV's phrase 'with emerods' (i.e., haemorrhoids). In the modern Luther Bible, the phrase is replaced by *mit bösen Beulen* ('with grievous swellings'). The affliction is thus less specific. Similarly, in the New English Bible the 'emerods' of the AV are replaced by 'tumours'.]
6. [See Note 5 in this section.]
7. Here the text of the *Gesammelte Werke* has *mir* ('me'), not *uns* ('us').

II

1. On the derivation of the name, pointed out by Frau Dr Rank: *coppella* = 'assay-crucible' (the chemical operations during which the father meets his death); *coppo* = 'eye-socket'. [In the first edition of 1919 this note occurs where it does now, but in subsequent German editions (except the students' edition) it appears, no doubt erroneously, after the second mention of the name Coppelius in the previous paragraph.]
2. In fact, the writer's imaginative handling of his material has not thrown the constituent elements into such wild confusion that their original arrangement cannot be reconstructed. In the story of Nathaniel's childhood, his

father and Coppelius represent the father-imago, which, owing to its ambivalence, is split into two opposing parts; the one threatens him with blinding (castration), while the other, the good father, successfully intercedes for his sight. The piece of the complex that is most subject to repression, the death-wish directed against the bad father, finds expression in the death of the good father, for which Coppelius bears the blame. In Nathaniel's later life as a student, this pair of fathers is represented by Professor Spalanzani and the optician Coppola. The professor himself belongs to the father-series, while Coppola is seen as identical with the lawyer Coppelius. They once worked together at the mysterious brazier; now they have collaborated in constructing the doll Olimpia; the professor is also called her father. This twofold collaboration reveals them as two parts of the father-imago, which means that both the mechanic and the optician are the fathers not only of Olimpia, but of Nathaniel too. In the frightening childhood scene Coppelius, after refraining from blinding the boy, had proceeded, by way of experiment, to unscrew his arms and legs – to work on him, in other words, as a mechanic would work on a doll. This strange feature, which falls quite outside anything we know about the Sand-Man, brings a new equivalent of castration into play; it also points to the inner identity of Coppelius and his later counterpart, the mechanic Spalanzani, and prepares us for the interpretation of Olimpia. This automaton cannot be anything other than a materialization of Nathaniel's feminine attitude to his father in his early childhood. Her fathers, Spalanzani and Coppola, are merely new versions – reincarnations – of Nathaniel's two fathers. Spalanzani's otherwise incomprehensible statement that the optician had stolen Nathaniel's eyes (see above) in order to set them in the doll becomes significant as evidence of the identity of Olimpia and Nathaniel. Olimpia is, so to speak, a complex that has been detached from Nathaniel and now confronts him as a person; the control that this complex exercises over him finds expression in his senseless, compulsive love for Olimpia. We are justified in describing such love as narcissistic, and we understand that whoever succumbs to it alienates himself from his real love-object. Yet the psychological truth that a young man who is fixated on his father by the castration-complex becomes incapable of loving a woman is demonstrated by many analyses of patients, the content of which, while less fantastic than the story of the student Nathaniel, is scarcely less sad.

E. T. A. Hoffmann was the child of an unhappy marriage. When he was three, his father left his small family and never lived with them again. The evidence that Grisebach assembles in his biographical introduction to

the works shows that the writer's relation to his father was always one of the sorest points in his emotional life.

3. O. Rank, 'Der Doppelgänger', *Imago* III, 1914.

4. I believe that when poets complain that two souls dwell in the human breast, and when popular psychologists talk of the splitting of the human ego, what they have in mind is the division under discussion, belonging to ego-psychology, between the critical authority and the rest of the ego, rather than the opposition, discovered by psychoanalysis, between the ego and whatever is unconscious and repressed. True, the difference is blurred because the derivatives of what has been repressed are foremost among the things that are condemned by self-criticism.

5. In H. H. Ewers' story *Der Student von Prag* ['The Student of Prague'], which supplies Rank with the starting point for his study of the double, the hero promises his beloved that he will not kill his opponent in a duel, but on his way to the duelling-ground he meets his double, who has already dispatched his rival.

6. [In the *Gesammelte Werke* this writer is wrongly given the initial 'H'.]

7. P. Kammerer, *Das Gesetz der Serie* (Vienna 1919).

8. 'Bemerkungen über einen Fall von Zwangsneurose' ['Notes upon a Case of Obsessional Neurosis'] [II.B] (*Gesammelte Werke*, vol. VII).

9. *Der böse Blick und Verwandtes* (2 vols, Berlin 1910/1911).

10. [In German 'the evil eye' is *der böse Blick*, literally 'the evil look'.]

11. On this topic see Freud's study *Totem und Tabu* ['Totem and Taboo'] (1913) section III of which deals with animism, magic and the omnipotence of thoughts. Here the author remarks, 'It seems that we ascribe the character of the uncanny to those impressions that tend to confirm the omnipotence of thoughts and animistic thinking in general, though our judgement has already turned away from such thinking.'

12. Cf. op. cit. on 'taboo and ambivalence'.

13. [Literally the 'thrower' (of bad luck), or 'the one who casts' (the evil eye).]

III

1. Since the uncanny effect of the 'double' also belongs to this species, it is interesting to learn how our own image affects us when it confronts us, unbidden and unexpected. E. Mach reports two such experiences in his *Analyse der Empfindungen* ['Analysis of Feelings'] (1900), p. 3. On the first occasion he was not a little alarmed when he realized that the face he saw was his own. On the second occasion he passed a very unfavourable

judgement on the apparent stranger who boarded his omnibus, and thought to himself, 'What a shabby-looking schoolmaster that is, the man who's just getting on!' I can tell of a similar adventure. I was sitting alone in my sleeping compartment when the train lurched violently. The door of the adjacent toilet swung open and an elderly gentleman in a dressing gown and travelling cap entered my compartment. I assumed that on leaving the toilet, which was located between the two compartments, he had turned the wrong way and entered mine by mistake. I jumped up to put him right, but soon realized to my astonishment that the intruder was my own image, reflected in the mirror on the connecting door. I can still recall that I found his appearance thoroughly unpleasant. Hence, instead of being frightened by our 'doubles', both Mach and I simply failed to recognize them. Or was the displeasure we felt at seeing these unexpected images of ourselves perhaps a vestige of the archaic reaction to the 'double' as something uncanny?

FOR THE BEST IN PAPERBACKS, LOOK FOR THE

In every corner of the world, on every subject under the sun, Penguin represents quality and variety—the very best in publishing today.

For complete information about books available from Penguin—including Penguin Classics, Penguin Compass, and Puffins—and how to order them, write to us at the appropriate address below. Please note that for copyright reasons the selection of books varies from country to country.

In the United States: Please write to *Penguin Group (USA), P.O. Box 12289 Dept. B, Newark, New Jersey 07101-5289* or call 1-800-788-6262.

In the United Kingdom: Please write to *Dept. EP, Penguin Books Ltd, Bath Road, Harmondsworth, West Drayton, Middlesex UB7 0DA.*

In Canada: Please write to *Penguin Books Canada Ltd, 90 Eglinton Avenue East, Suite 700, Toronto, Ontario M4P 2Y3.*

In Australia: Please write to *Penguin Books Australia Ltd, P.O. Box 257, Ringwood, Victoria 3134.*

In New Zealand: Please write to *Penguin Books (NZ) Ltd, Private Bag 102902, North Shore Mail Centre, Auckland 10.*

In India: Please write to *Penguin Books India Pvt Ltd, 11 Panchsheel Shopping Centre, Panchsheel Park, New Delhi 110 017.*

In the Netherlands: Please write to *Penguin Books Netherlands bv, Postbus 3507, NL-1001 AH Amsterdam.*

In Germany: Please write to *Penguin Books Deutschland GmbH, Metzlerstrasse 26, 60594 Frankfurt am Main.*

In Spain: Please write to *Penguin Books S. A., Bravo Murillo 19, 1° B, 28015 Madrid.*

In Italy: Please write to *Penguin Italia s.r.l., Via Benedetto Croce 2, 20094 Corsico, Milano.*

In France: Please write to *Penguin France, Le Carré Wilson, 62 rue Benjamin Baillaud, 31500 Toulouse.*

In Japan: Please write to *Penguin Books Japan Ltd, Kaneko Building, 2-3-25 Koraku, Bunkyo-Ku, Tokyo 112.*

In South Africa: Please write to *Penguin Books South Africa (Pty) Ltd, Private Bag X14, Parkview, 2122 Johannesburg.*

CLICK ON A CLASSIC
www.penguinclassics.com

The world's greatest literature at your fingertips

Constantly updated information on more than a thousand titles, from Icelandic sagas to ancient Indian epics, Russian drama to Italian romance, American greats to African masterpieces

•

The latest news on recent additions to the list, updated editions, and specially commissioned translations

•

Original essays by leading writers

•

A wealth of background material, including biographies of every classic author from Aristotle to Zamyatin, plot synopses, readers' and teachers' guides, useful web links

•

Online desk and examination copy assistance for academics

•

Trivia quizzes, competitions, giveaways, news on forthcoming screen adaptations

"Freud ultimately did more for our understanding of art than any other writer since Aristotle."
—Lionel Trilling

The Schreber Case
Translated by Andrew Webber
Introduction by Colin MacCabe

In 1903, Judge Daniel Schreber, a highly intelligent and cultured man, produced a vivid account of his nervous illness dominated by the desire to become a woman, terrifying delusions about his doctor, and a belief in his own special relationship with God. Eight years later, Freud's penetrating insight uncovered the impulses and feelings Schreber had about his father, which underlay his extravagant symptoms.

ISBN 0-14-243742-5

The "Wolfman" and Other Cases
Translated by Louise Adey Huish
Introduction by Gillian Beer

When a disturbed young Russian man came to Freud for treatment, the analysis of his childhood neuroses—most notably a dream about wolves outside his bedroom window—eventually revealed a deep-seated trauma. It took more than four years to treat him, and "The Wolfman" became one of Freud's most famous cases. This volume also contains other case histories, all of which show us Freud at work, in his own words.

ISBN 0-14-243745-X

The Joke and Its Relation to the Unconscious
Translated by Joyce Crick
Introduction by John Carey

In a rich collection of puns, witticisms, one-liners, and anecdotes, Freud answers the question "why do we laugh?" *The Joke and Its Relation to the Unconscious* explains how jokes provide immense pleasure by releasing us from our inhibitions and allowing us to express sexual, aggressive, playful, or cynical instincts that would otherwise remain hidden.

ISBN 0-14-243744-1

The Psychopathology of Everyday Life
Translated by Anthea Bell
Introduction by Paul Keegan
Starting with the story of how he once forgot the name of an Italian painter—and how a young acquaintance mangled a quotation from Virgil through fears that his girlfriend might be pregnant—*The Psychopathology of Everyday Life* brings together a treasure trove of muddled memories, inadvertent action, and verbal tangles. Freud's dazzling interpretations provide the perfect introduction to psychoanalytic thinking in action. *ISBN 0-14-243743-3*

The Uncanny
Translated by David McClintock
Introduction by Hugh Haughton
Freud was fascinated by the mysteries of creativity and the imagination. His insights into the roots of artistic expression in the triangular "family romances" (of father, mother, and infant) that so dominate our early lives reveal the artistry of Freud's own writing. Freud's first exercise in psychobiography, his celebrated study of Leonardo, brilliantly uses a single memory to reveal the childhood conflicts behind Leonardo's remarkable achievements and his striking eccentricity.
ISBN 0-14-243747-6

Coming in 2004

The Psychology of Love
Translated by Shaun Whiteside
Introduction by Jeri Johnson
This volume brings together Freud's illuminating discussions of the ways in which sexuality is always psychosexuality—that there is no sexuality without fantasy, conscious or unconscious. In these papers Freud develops his now famous theories about childhood and the transgressive nature of human desire. *ISBN 0-14-243746-8*